Economic Nutrition

fogo island inn

NIGHTLY STAY (ACTUAL 2017)	WHERE THE MONEY GOES
Labour	**49%**
Food, Room Supplies	**11%**
Commissions, Fees	**5%**
Operations, Admin	**16%**
Sales, Marketing	**4%**
Contribution to Shorefast Foundation	**15%**

Reinvested in the community of Fogo Island

Economic Benefit Distribution

Fogo Island	63%	Canada	24%
Newfoundland	7%	Rest of World	6%

Economic Nutrition is a certification trademark of Shorefast Foundation, used under license by Shorefast Social Enterprises Inc.

1

Contents

Cover Image
Bent René Synnevåg: THE BRIDGE
STUDIO IN DEEP BAY
Inside Front Cover
Cauliflower: SHOREFAST'S
CAULIFLOWER PROGRAM
Inside Back Cover
Steffen Jagenburg: ROCKS
Back Cover Image
Steffen Jagenburg: COD

What do we know?
What do we have?
What do we miss?
What do we love?

Brigitte Oetker & Nicolaus Schafhausen:

ISLANDS ARE SPECIAL PLACES: PLACES THAT EMBODY HUMAN DREAMS. THIS HAS NOTHING TO DO WITH NOSTALGIA

Brigitte Oetker (based in Berlin) is an art historian, curator, writer, editor, and professor at the Institute of Culture and Media Management in Hamburg. She was the director of the Cultural Committee of German Business within the BDI e.V. in Cologne and for the ARA, the Association for Cultural Affairs in Foreign Countries (1984–1990). She holds honorary appointments with the Art House, Villa Romana, and Kunsthistorisches Institut, Max-Planck-Institut, both in Florence; and the Büro Friedrich e.V., Humboldt University, and Charité Foundation, in Berlin.

Nicolaus Schafhausen (based between Berlin, Fogo Island, and Brussels) is a curator, writer, editor, and lecturer at the Higher Institute for Fine Arts in Ghent. He has led renowned arts institutions—such as the Künstlerhaus Stuttgart, the Frankfurter Kunstverein, the Witte de With Center for Contemporary Art, Rotterdam, and Kunsthalle Wien. He is currently curating a nine-month exhibition project and program at the Munich Documentation Centre for the History of National Socialism. Schafhausen is the strategic director of Fogo Island Arts.

Fogo Island isn't exactly easy to get to. It lies off the coast of New-foundland, itself an island in the Atlantic forming part of Newfoundland-Labrador, the last province to join Canada in 1949. The provincial capital, St. John's, is located about 400 kilometers from the island, however it feels much further away than it is largely due to the time it takes to travel there. The distance to Gander is around 100 kilometers. This town (pop. ca. 11,700) at the heart of the island became a major crossroads following the construction of Gander International Airport, later downgraded to regional status. Gander was in the global spotlight in 2001 when, due to the closure of American airspace after the 9/11 attacks, the airport was host to over 6,500 passengers and crew from thirty-nine transatlantic flights for several days.

It was in Gander that we began our joint journey to Fogo Island in June 2018, a venture that always involves taking the ferry *MV Veteran* from a port with the melancholy name Farewell. Fogo Island belongs to the northeasternmost territory in North America. "If you're lucky and the weather's good, you'll see plenty of icebergs in the spring," mentioned the taxi driver who took us from the airport to Farewell, proudly referring to the island's proximity to Iceberg Alley: "But there are more of them every year. Is that a good thing? I don't know. We're feeling climate change here, too." Around 90 percent of the icebergs off the coast of Newfoundland-Labrador are from the glaciers of western Greenland, the rest from glaciers in the Canadian Arctic.

In the seventeenth and eighteenth centuries, Fogo Island mainly attracted settlers from Ireland and England. Between 1610 and 1854, Newfoundland became first an English, then British colony, that later transformed into becoming a self-governing crown colony within the British Empire. In 1907, the island obtained the status of a dominion, resulting in its newfound independence while maintaining close economic and military ties to the United Kingdom. In 1949, Newfoundland became a province of Canada.

Fogo Island was rich in tradable goods such as sealskins and other furs, timber, and of course, cod. According to the oral history, cod was why people settled there, why they fell for the place. Over time, the islanders became increasingly specialized in processing dried cod—primarily because this was the product most in demand to trade beyond Fogo Island around the world. From roughly 1850 until the 1990s (by which time stocks had been largely exhausted by industrial fishing) cod was the island's chief source of revenue. In recent years, although cultural and geo-tourism has come to play an increasingly important role in the local economy, fishing remains the foundation that structures the life of the island and its inhabitants—there is no future without the fish.

As in all peripheral regions, the general standard of life is lower than in urban centers. (Although we must question what this means, and if that really is the case, what is a general standard of life?) In rural areas,

the challenges of a globalized world include a growing lack of jobs or prospects, prompting young people in particular to leave these regions in search of other opportunities in cities. Although the long-term negative impact of this is beyond doubt, economic and cultural measures to support rural communities tend to be politically controversial. (This also prompts the question of whether digital technologies will bring positive and sustainable changes for the future—or not? We do not know.) What is often underestimated by decision-makers in such cases is that people who live on the land have a different relationship to nature, and their knowledge and experience differs to that of the urban population. Programs of state support and funding can offer stability on a temporary basis, but they rarely create durable possibilities for development. The complex economic, cultural, and political challenges faced by the provinces cannot be mastered by transfer payments alone.

This year's edition of the Jahresring, *What do we know? What do we have? What do we miss? What do we love?*, focuses on the questions, voices, and activities of Fogo Island Arts (FIA). As a residency and think-tank program for contemporary art, FIA offers artists, filmmakers, writers, musicians, curators, designers, and thinkers from around the world a place to think and confront another reality of life and nature that is in contrast to their usual surroundings, as most of the artists live in urban centers. FIA was founded in 2008 as one of the first projects in the context of Shorefast, an initiative to promote the island's economic and cultural life. Shorefast's business model is based on the principle of social entrepreneurship: while sustainable cultural projects and geo-tourism creates new jobs, prospects are also created for the island's economic future.

FIA programs offer alternatives to traditional international residency formats and public art initiatives in North America. This is due mainly to the ingenuity, hospitality, and unwavering creativity of the inhabitants of Fogo Island, who represent, support, and act as an important frame of reference for the organization's activities.

Furthermore, FIA is embedded within a network of social business initiatives funded and managed by Shorefast. FIA is thus a perfect example of the way in which people from fields of art and business can work together successfully, a partnership that depends on an awareness of the ethical and social responsibilities to counteract the negative effects of globalization with alternative concepts.

When selecting authors, photographers, and the artists for this edition, we invited people linked to Shorefast initiatives: artists who have stayed on the island or who now live there; researchers, designers, architects, and curators without whom FIA would not exist in its current form. The publication is mainly a view of the island from the outside and as such claims to give neither a complete nor a neutral picture. Instead, it should be read as a subjective snapshot. The true impact

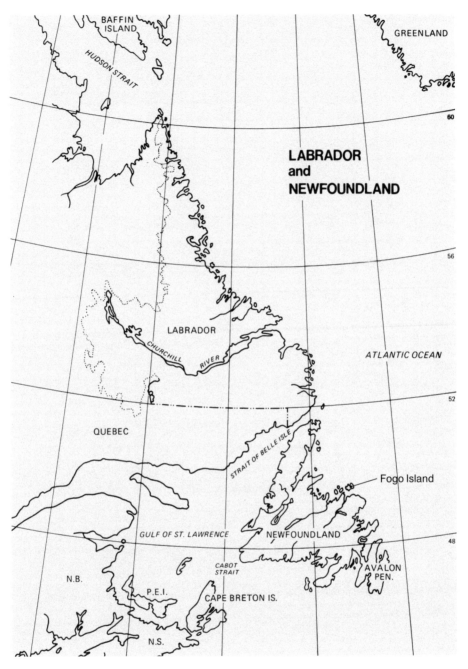

Fogo was going to survive, it would have to survive by developing the fishery.

In addition, the National Film Board and Memorial University's Extension Service were involved in what was then a highly imaginative innovative process that used sophisticated techniques, such as 16 mm film. Eventually known as the Fogo Process, the people produced a series of films which gave them an opportunity of both seeing themselves and their situation more clearly as well as sorting out their priorities for a plan of action. The films were used to pressure government to support a new concept, known as rural development, which would eventually replace the old concept of resettlement. Gradually as people began to work together for a common goal, they began to think of themselves as Fogo Islanders rather than as Barr'd Islanders.

While the bulk of credit for the island's rehabilitation must go to the people of the island themselves, the help of various outside agencies helped. The Extension Service continued its involvement and the co-operative movement helped organize and establish the Fogo Island Shipbuilders and

Producers Co-operative, an organization that was to prove to be the cornerstone for future development. Already burned once when the merchants took leave, a resolve grew that the power to control the island's fate should not rest in the hands of a private company in the future.

Early on in the game, the realization dawned that hope for the future was linked to breaking the island's dependence on the mercurial inshore fishery. Bigger, better equipped boats, capable of pursuing high value fish in deeper waters, were needed and the Co-op decided the boats should be built on the island. A shipyard was established at Shoal Bay and the vessels produced there are still catching fish today. Although the shipyard was later phased out amid considerable controversy, it did serve its basic purpose ... the creation of a longliner fleet capable of going offshore. It gave the island's fishery another badly needed string to its bow.

In additoin to the co-operative and the development of a middle water fishery, the people of Fogo Island pressed for the first Integrated High School on the Island. This did much to break down old factions and get people

to think of themselves as a cohesive group rather than individual communities or religions.

Surprisingly enough, the people of Fogo Island seem to harbour no resentment today for those who tried to pressure them off their island. In fact, when times get tough as they did again in 1972-73, residents have been known to quietly whisper the word "move" among themselves.

Despite the arrogance implicit in telling people who have lived all their lives in a place that it isn't fit to live in, the people of Fogo seem to have forgiven those who would have turned the island into an uninhabitated rock. But it's a safe bet that they haven't forgotten the days when the "experts" decided they had to go.

"I do remember," says Rebecca Jane Coles, an 83-year-old resident of Deep Bay. "A man came out here talking about resettlement, but he said he wasn't going to force people to leave their homes. I told him he'd never get me to leave Deep Bay; none of the people in Deep Bay wanted to leave. We all had good homes here and I still couldn't leave today. This is my home."

The Co-op worked
because it had to work

Co-operative; an organization (as for marketing or production of goods), an apartment house, store, etc. owned collectively by its members who share in its benefits).

That's how Webster's New World Dictionary defines a co-operative, but it's safe to assume it won't come as any great news to the people of Fogo Island. They've been living and working, buying and selling co-operatively since December 1967, when the Fogo Island

Shipbuilders and Producers Co-operative was formed.

The intention was to create a vehicle for economic development which could carry the island's population away from bad times and the spectre of resettlement.

Today, the Co-op that started more than a decade ago with 127 chartered members and less than $700 dollars in share capital is a multi-million dollar business, still owned by the fishermen, plant workers and

co-op employees and servicing much of Notre Dame Bay. For Eugene Collins, operations manager of the Co-op that fact is of paramount importance.

"You can't take anything away from the people because they own the business," states Eugene and he adds, as a way of illustration, "Let's say the fishery was slow and there were six fork lifts at one of the plants. If a private company owned the operation, they might

An article from 1978 in *Decks Awash* magazine about Fogo Island and the formation of the cooperatives, published by Memorial University Extension Service, Newfoundland and Labrador

8

of FIA's activities for the inhabitants of Fogo Island now and in the future will probably only begin to become apparent in ten or twenty years' time.

The story of the island's future is closely tied to Zita Cobb, an eighth-generation Fogo Islander and co-founder of Shorefast. Cobb invested in the Fogo Island Inn that opened in 2013. All of the profits from the inn flow into a fund used by Shorefast to support businesses on the island, creating jobs as well as co-funding scientific and cultural nonprofit organizations.

New York, summer 2018: the artist Liam Gillick arranged to meet Zita Cobb at his apartment. The meeting was driven by the question of what prompted her to found Shorefast. Gillick, who grew up in the suburbs of London, always found the link between the economy and society highly abstract and the underlying system "endlessly complicated," far removed from everyday reality. For Cobb, by contrast, the dialectic of money and society was directly tangible. "On Fogo Island, you could actually watch a society going through fundamental changes," remarks Gillick, to which Cobb replied that this was linked to the loss of a formerly functioning system: "I saw money arrive in the guise of these terrible giant fishing boats that caught all of the creatures that would now be referred to as *sacred capital*.[1] By which I mean capital that has a unique essence, an intrinsic value," going beyond mere economic value.

Every day, FIA asks itself (must ask itself) questions: *What can art achieve in a context like Fogo Island? Should art achieve anything?* These and other aspects are addressed by Alexandra McIntosh, FIA program and exhibition director, in her text "An Island without Boundaries," which gives an overview of the history, structures, strategies, and prospects of Shorefast and FIA. She fittingly proposes: "Much like Fogo Island's vernacular architecture that is shaped by use and altered over time, Fogo Island Arts should be nimble and adaptive, responsive to site and open to the world."

Today, the relationship between art and society is as ambivalent as ever. Art—and the chain of bodies that support and bring it into being (from artists to galleries, institutions, and museums)—is more and more confronted with the demand to be openly political or outright politically engaged, not only to reflect critically on political issues but to propose concrete solutions. To what extent does this involve the instrumentalization of art? To what extent do artists force such demands on themselves, their artistic practice and their work? In their interview, artists Janice Kerbel and Silke Otto-Knapp, who recently bought a second home on the island, discuss their active as well as passive responsibilities—as (temporary) inhabitants of Fogo Island, and for the processes of change taking place there. Otto-Knapp: "One of the aims of Shorefast is to promote tourism in the spirit of economic and ecological sustainability. Some people see that as a contradiction because visitors have to fly many hundreds of miles to get to Fogo Island—and that applies to all groups of visitors, from wealthy hotel guests to artists taking part in the residency program." Kerbel adds:

"Yes! But to return to this supposed contradiction: it's a reality that has to be faced up to. Even just keeping the island supplied with basic materials like medicines, milk, bread, or other products can't be justified in purely ecological terms. But this shouldn't be taken as a reason to stop supporting the island in its struggle to survive."

How do today's inhabitants of Fogo Island relate to its past? Is there something akin to a "spirit" of the island? Art critic Chantal Pontbriand in "Telegraphic Experiments" addresses precisely these topics. Using the motif of the *genius loci*, she delves into the checkered history of Fogo Island and the region, reigniting and shining a light on the cultural continuities fostered by initiatives today.

Dynamic enterprises are raised in architectural theorist Fabrizio Gallanti's essay "Remote Architectures," in which he relates Fogo Island to other islands that he views as facing similar challenges: "Islands are one to one laboratories: they are the perfect location for conducting experiments. […] Their relative isolation tends to permit greater precision in the measurement and analysis of conditions and in the conclusions drawn from a scientific study. In historical terms, it has always been easier to calculate and visualize the relationship between import and export—between what arrives in a place and what leaves it."

Residency programs for artists now exist all over the world, including regions far from global hotspots. In these remote locations, they do not always cultivate links with the local context. In their interview, curator Kitty Scott and artist Willem de Rooij discuss the diverse implications of these developments, and ponder on the meaning and content of such platforms.

As the editors of this ambitious and provocative publication, we too aim to ask and address within the book how staying in such a remote place would affect the way artists work. What does it mean to pursue one's personal artistic practice when cut off from one's familiar urban infrastructure? For the artist Thomas Bayrle and his partner, filmmaker Helke Bayrle, who spent a month on the island in the summer of 2018, it was productive. Thomas remarks: "There's something wonderfully boring about the island—boredom considered as a positive container. […] Thanks to the quietness you can think differently, because there's less nervousness."

The original Jahresring 65, *Was wissen wir? Was haben wir? Was fehlt uns? Was lieben wir?* (German edition), was published in December 2018. For the subsequent English edition (published in February 2019) we have chosen to include additional contributions from a selected number of artists, most of whom are alumni of the FIA international residency program. In their own words, they have provided poignant statements relating to their experiences as well as their thoughts on the broader issues at stake. Abbas Akhavan, Assemble, Brenda Draney, Ieva Epnere, Leon Kahane, Zac Langdon-Pole, and Kate Newby share personal insights, from reflections on their individual practices, their diverse engagements, as well

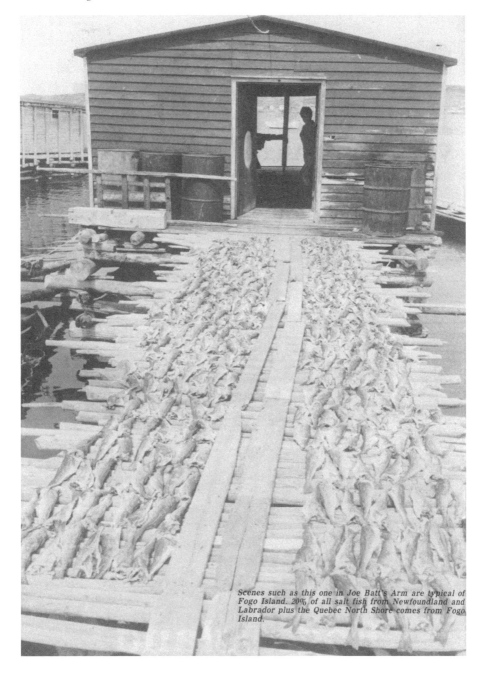

Scenes such as this one in Joe Batt's Arm are typical of Fogo Island. 20% of all salt fish from Newfoundland and Labrador plus the Quebec North Shore comes from Fogo Island.

An archival photo from 1978 in *Decks Awash* magazine showing salt fish production in Joe Batt's Arm

The Cod Catch – Landings

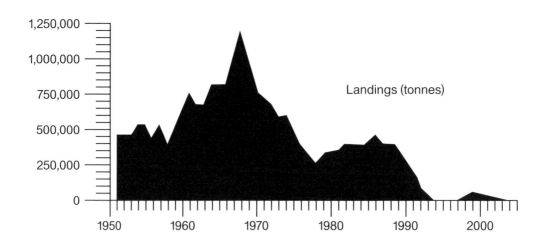

The Cod Catch – Biomass

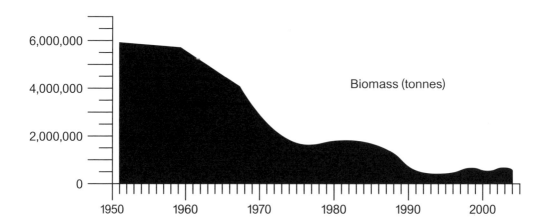

as their reservations about the project, to impressions from the community, in addition to prospects for different potential paths.

In the age of Instagram and other social media platforms, the landscape of Fogo Island generates great visual attention. All the more so when it forms the backdrop for stunning architecture. In their discussion, architects Roger Bundschuh and Todd Saunders—the latter designed both the Fogo Island Inn and the FIA studios—debate the pros and cons of landmark or signature architecture. Roger Bundschuh: "This type of architecture tends to be perceived more as a purveyor of attention in the service of city and regional marketing, rather than as an architectural space that can actually be used. I think it would be dishonest to claim that landmark architecture or so-called signature architecture is wholly unrelated to marketing strategies." Todd Saunders responds: "The starting point of the project was simple. None of it was intended as signature architecture. That is the result of the circumstances: in such a beautiful place, almost anything you might build would look like signature architecture—in the midst of these endless landscapes. It was definitely not our intention—but for outsiders it may look as if we were deliberately trying to locate signature architecture in this place."

The designer Bruce Mau, who teaches architecture and city planning at the Pratt Institute in New York, situates the initiatives of Shorefast and FIA within the broader world of design. His contribution outlines approaches to a holistic design practice that examine problems not in isolation but embedded in an ensemble of diverse political, cultural, and ecological factors. In this view, the local is always also an element and reflection of what is global. He also raises thoughts on increasing advancements to the digitization of the world: "While automation has many promising aspects, some things just cannot, and should not, be made routine: creativity and invention, for instance."

In her essay, "Is Shorefast an Artwork?," art historian Monika Szewczyk examines the business strategies of artists and relates them to the artistic strategies of Shorefast. Among other things, she looks at the way specific resources within each field can be deployed in the other for sustainable policies going beyond neoliberalization and environmental destruction. "Artists usually file tax returns the same as small businesses, creating a distance between the private individual and the company that deals with the production, promotion, and sale of the artwork." In structural terms, this opens up a possibility for different sections of society to learn and benefit from one another.

The largest challenge for the future of FIA and the other initiatives on Fogo Island linked to Shorefast is to find ways of harmonizing individual and collective interests, and rendering them productive in the long term. The direct impact can already be gauged: the population has stabilized at around 2,500, the schools are reporting increased registrations, and tax revenues are on the rise.

Since 2011, thirty small businesses and restaurants have set up on Fogo Island, including startups that market their products online, demonstrating the potential of digitization for rural communities. More and more families are deciding to move (back) to the island. One example is Susan Cull, who grew up on Fogo Island and who, after studying politics and developing a career in the Newfoundland-Labrador province, moved back to the island with her family. Today she works as the operation manager, organizing the internal workflows at Shorefast with its staff. What Shorefast has given Fogo Island to date, says Cull, is "confidence in its independence. Ten years ago, many people could not imagine earning a living on the island in the long term. Large numbers of people moved away, a steady flow, and they didn't come back. The possibilities disappeared, I couldn't see a future here. But in these ten years, things have changed dramatically: now there are job opportunities, cultural events, leisure activities. Things I didn't grow up with."

What can art achieve precisely in places like Fogo Island? (Admittedly, the question cannot be easily answered in such general terms.) To an extent, FIA is unable to provide an answer. Nonetheless, FIA shows how actors from different sections of society (business and art) can join forces to develop solutions for social problems that remain in constant dialogue with the conditions and possibilities of their local context. Fogo Island is a special place, marked by unique geographical, cultural, and economic conditions. In spite of its peripheral location, the island has and continues to seek contact with the world at large. This is another aspect with which FIA identifies: bringing the world to Fogo Island and carrying the idea of Fogo Island out into the world. This shared concern impacts positively on the cooperation between the different initiatives of Shorefast, bringing together the various publics that meet within the framework of the Shorefast's work and aspirations.

Shorefast is dedicated to consistently question and interrogate preexisting structures, systems of control, power, and ways of thinking. *What do we know? What do we have? What do we miss? What do we love?* We are all florets of the same cauliflower sharing the same stem, the same roots. The cauliflower serves as a perfect metaphor for the fragile and complex organic system of growth, development, and nourishment of the world. Just as a flower blossoms, a cauliflower grows and bears its head. FIA and Shorefast are only beginning to show the colors and crop of their labors. Forging pathways that flourish like the fractals of a cauliflower, Shorefast intends to further change by working together to navigate global—and Fogo Island's specific—social and geopolitical histories in order to recognize and reflect on our present circumstances, and most fundamentally: relate, reposition, and redefine our future.

49° 37′ N, 54° 12′ W

Sacred Capital[1]

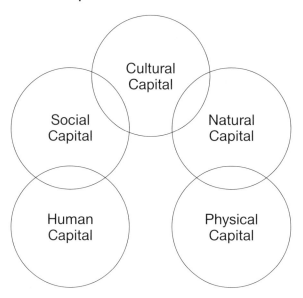

*What is the relationship between
Sacred Capital and Financial Capital?*

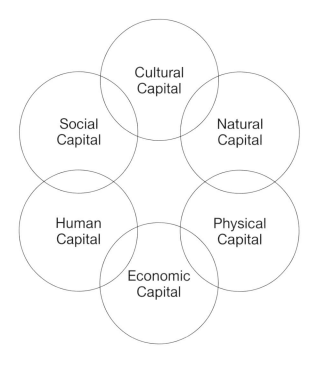

1
Sacred Capital is here used with reference to
the economist E.F. Schumacher, and generally
describes entities that are historically grown—
certain types of cultural as well as natural
heritage—and therefore cannot (or only to a
very limited extent) be technically reproduced.
In Schumacher's thought "sacred" refers to
organisms and things that are, as he puts it,
"ends-in-themselves," as opposed to most
products of human labor which he defines
as "means-to-ends." E.F. Schumacher, *Small
Is Beautiful: A Study of Economics as if People
Mattered* (New York: Harper Perennial, 2010).

Brenda Draney:
I WONDERED IF MY WORK WAS RELEVANT TO THIS PLACE

Brenda Draney (based in Edmonton) is an
artist. She is Cree and a member of Sawridge
First Nation. Her practice is based on her
experiences and the relationships formed
between her current hometown and the
northern community of Slave Lake where she
was raised. She studied painting at Emily Carr
University, won the RBC Canadian Painting
Competition in 2009, was shortlisted for the
2013 Sobey Art Award, and won the 2014 Eldon
and Anne Foote Visual Arts Prize.

While I was on Fogo Island, people would often ask which house I was staying in. The question indicated their intimate knowledge of the residency houses on the island and their knowledge too, that my stay would be temporary. I would tell them and they in turn would tell me about their personal relationship to the house.

When I arrived, I was thinking about and painting about my stories in a place where their context could not be known or assumed. I thought about how these stories are so different from the ones on Fogo Island, and how they are also similar. In my loftiest ideals, the narratives I use, the memories I deal with, are about the human condition.

I would walk in the house tracing the floorboards, some perhaps indicating where a wall might have been. I would imagine the other forms this house took. It was an indication of a history that I had no knowledge of. I thought about the history of the trail I walked to the studio every day. The way the trail was older than the studio and led to important places that no longer function the way they once did.

I wondered if my work was relevant to this place. When my work is seen by other people from my hometown, there is a specific reaction I sometimes get. They recognize a shared history. This can be seductive. Now I wonder if I purposely sought the reaction. On Fogo Island, this became apparent—and it was startling. Like a small, needed crisis. It was a crisis because that resonance is powerful and can stay with a person. That resonance can make a person feel seen. This is of no small importance.

We hold the potential within our artistic practices to connect to disparate or different parts of the world. We can communicate in ways that might be like scaffolding—or hope—to another way of being in the world which we may not have otherwise considered. In other words, it is important for me to be able to speak to people who may have had different lives and histories.

There is a part of my work that I don't want to articulate. I don't want to become too specific in the ways in which my work operates.

Perhaps it is a way of avoiding the very problem that was underscored on Fogo Island: eliciting a specific response. I want to communicate indirectly, allowing for ambiguity. This desire runs counter to the seduction of resonance.

I received a message from someone. He said he used to live in the house I was assigned. His family used to live there, and he is familiar with the history of the place. Reading his message so long after I returned home was a bridge suddenly built that could take me back to that place.

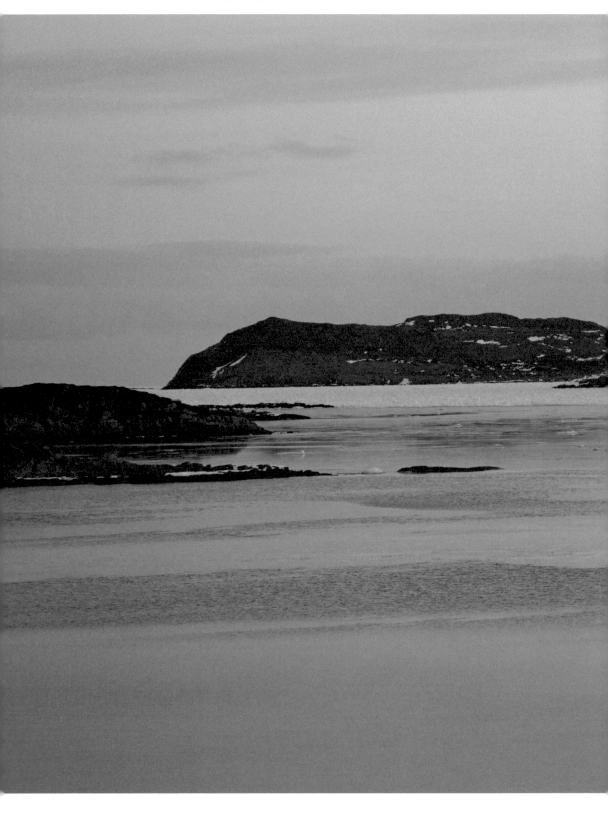

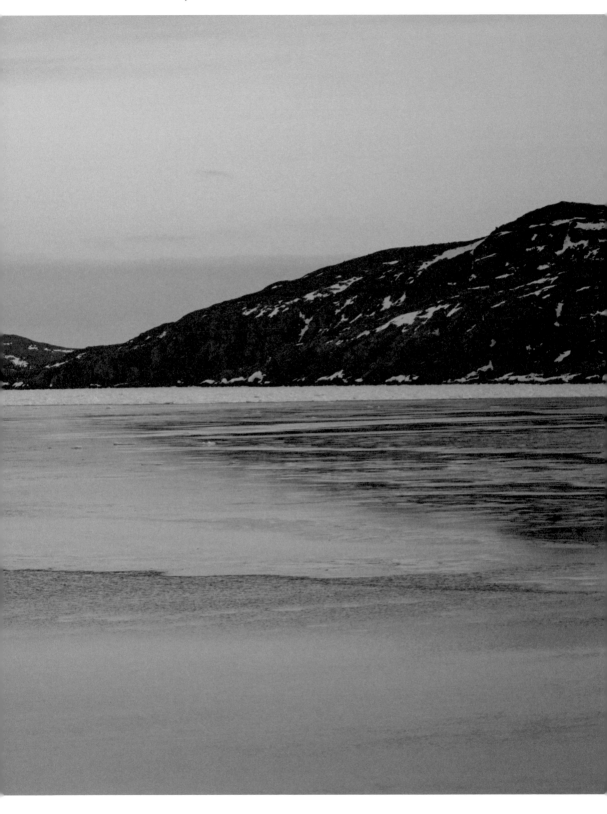

Zac Langdon-Pole:
I WAS STRUCK BY HOW PRESENT SUCH AN ABSENCE CAN BE

Zac Langdon-Pole (based in Berlin) is an artist
whose work is underpinned by questions
of belonging, translation, and identification.
He studied at Elam School of Fine Arts,
Auckland (2007–10), and at the Städelschule,
Frankfurt (2014–15). He was awarded the ars
viva Prize for Visual Arts in 2017, and is the latest
recipient of the BMW Art Journey Prize (2018).

Much can be made of Fogo Island's remoteness: traveling from Berlin, I took three flights over the course of two days, a night in a motel, a bus ride, and a ferry ride before arriving on the island. Located at the easternmost tip of Canada's coastline, surrounded by the Labrador Sea and North Atlantic Ocean, Fogo Island might seem like one of the most isolating locations in the world. As it turned out, this wasn't my experience during my participation in the Fogo Island Arts residency program for artists.

Upon arrival, I was immediately taken by the dynamism of the landscape. With erratic rock formations undulating at various angles across the island's surface, I could see clearly how the landscape is composed of a complex series of ever-moving, ever-changing interdependent relations between the elements. During a walking tour with the geologist-in-residence Jane Wynne, she pointed out two bodies of sedimentary rock that, having collided with each other over millions of years, had peeled away each other's layers in a swirl of interlocking lines. While deep time is encased in pebbles and cliffs at every turn, there are other histories that are haunting in their invisibility. The Beothuk who were indigenous to Fogo Island and Newfoundland were completely wiped out following first contact with European settlers in the sixteenth century. With few physical traces remaining of them, I was struck by how present such an absence can be.

Many of the dwellings built on the island, I learned, are made by repurposing wood from older structures and sometimes parts of boats that have exceeded their lifespan. This detail speaks not only of the vital ties between land, sea, and people on Fogo Island, but also between its past and present. Perhaps my most lasting impression of the island and its manifold small communities was its connectedness. Following a fishing trip with a neighboring fisherman, our quota haul of cod fish would be fluently dispersed among the locals. As with many small island communities, speaking to one person feels like speaking to many. News spreads fast, big or small; one easily becomes a node of communication amongst the island's events. Despite the residency offering ample time and truly incredible environments to work in solitude, it was through a sense of intimacy at this scale that I could more clearly appreciate connections that are so easily severed in urban living.

Living in a society and creative industry driven by individualism, it becomes easy to mistake one's own life for the world. FIA's residency program offered me not only estrangement from myself and my familiar contexts, but immersion in a lucid awareness of interconnected relations. Ties between past and present, environment and people, individual and community, local and global are so vitally present on Fogo Island. Through its context and its generosity, FIA can provide artists with a sense of the self in relation rather than an isolated unit; that supposedly remote islands are in fact anything but.

Zita Cobb & Liam Gillick: DOES IT MATTER WHO OWNS WHAT?

Zita Cobb (based between Fogo Island
and Ottawa) is the co-founder and CEO of
Shorefast, innkeeper of Fogo Island Inn, and
social entrepreneur whose experience as
a successful tech-executive informs her current
approach to realizing cultural and economic
resilience for places on the peripheries.

Liam Gillick (based between New York and
London) deploys multiple forms to expose the
new ideological control systems that emerged
at the beginning of the 1990s, the dysfunctional
aspects of a modernist legacy in terms of
abstraction and architecture when framed
within a globalized, neoliberal consensus.

Liam	Could you describe your cultural, social, and philanthropic activities on Fogo Island?
Zita	I manage Shorefast, which is a registered charity in Canada. The team established and own four social businesses. Surpluses or profits from these businesses go back to the charity and are reinvested into the community of Fogo Island through a broad set of programs, such as art, geology, and heritage projects such as boat building. We also have a micro-lending fund. I think about it as the money coming from the businesses being invested in one way or another in knowledge: knowledge preservation, knowledge-making, and knowledge-sharing.
Liam	So things are flowing all the time from one entity to another.
Zita	Yes, from one wing (the social business wing) to the other (the charity wing).
Liam	I ask because I think most people assume that foundations and trusts start with an accumulated lump sum of money and slowly give it away.
Zita	We took all of the money at the beginning and put it into local economic assets. For example, we built artists' studios for an artists-in-residence program. We built an inn on Fogo Island. We took the initial money and turned it into physical assets that could in some way support the community.
	The fishery is owned by a local cooperative and the inn is owned by a charity (Shorefast) whose beneficial owners are Fogo Islanders. So effectively, the community of Fogo Island owns its major economic assets, and the vast majority of small businesses are owned and operated by local residents.
	Once the local control of economic assets is in place, the rest is up to the community and individuals to decide how they want to shape and organize life.
Liam	Do you see other similar models for what you are doing?
Zita	We are aware of other places that are working to strengthen their communities in various ways either through such models as the cooperative or philanthropy by NGOs and others. We are not aware of another instance where philanthropic funds have been used to create economic assets that are designed to produce long-term gains for a community with business approaches and disciplines. Nor are we aware of other cases using an integrated "wholeness" strategy spanning business, philanthropy, culture, art, architecture, design, hospitality, and the environment—all at an appropriate scale and all with the intention to promote and support the community.

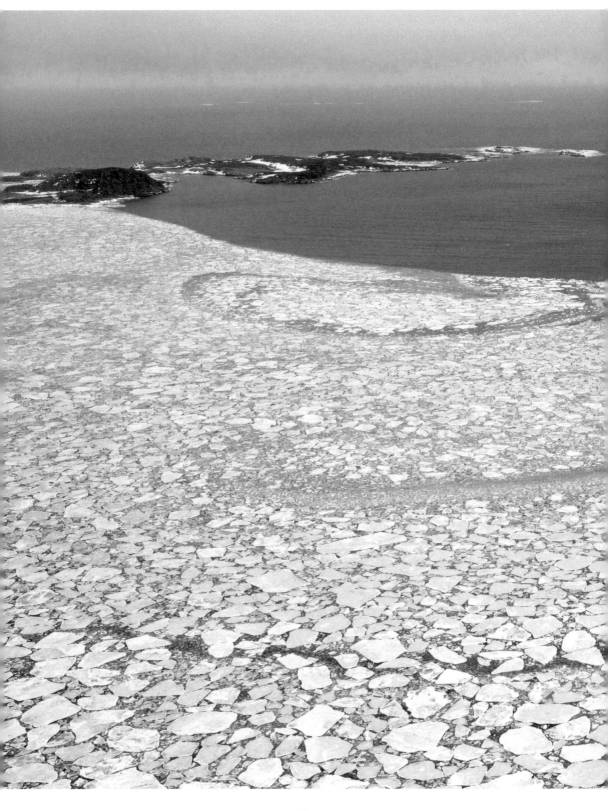

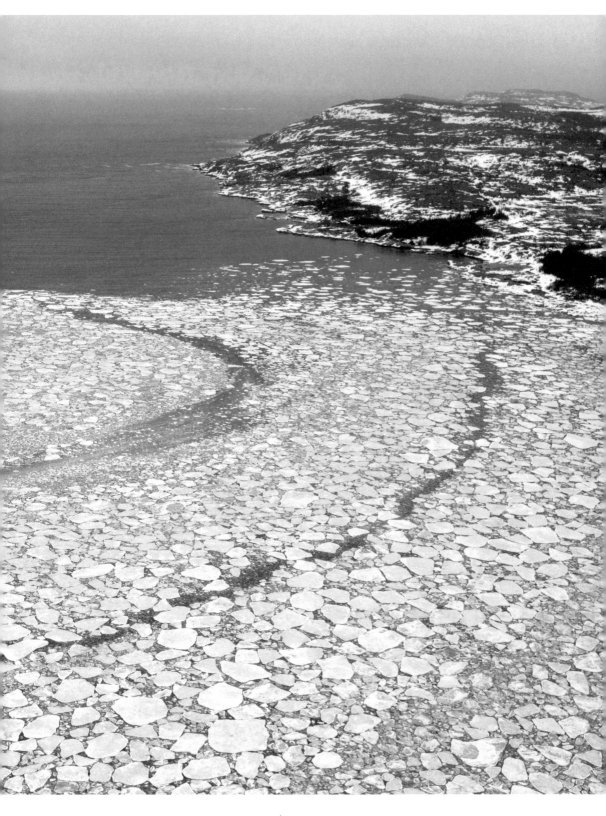

We do know that other people and places are interested in understanding what we do and how we do things. We feel that we may, indeed, have something useful to contribute to the national and international conversations taking place around the big ideas and challenges of the economy, and the well-being of society. We are currently considering how best to structure our participation in that global conversation. Perhaps an Institute of Community Economics.

Liam Let's go back to the beginning: Didn't that make you feel nervous? Due to the fact that you were building an infrastructure without really knowing if it would work. Something without a reference point?

Zita Absolutely. I'm an eighth-generation Fogo Islander, which makes me a relative newcomer on an island where people settled from England and Ireland from 1640 onwards! We have always been a one-industry set of communities, but there are ten different communities on the island.

It was all about the fishery, and in particular the cod fishery. The fishery had been in trouble for hundreds of years. We had managed to hold on until industrialization and by the late 1960s, the inshore fishery collapsed. This was a really difficult moment for all of us.

At that time, the province of Newfoundland decided to respond to this in the most reductionist way that you could imagine. They looked at the dire economic situation in the whole region, passed the Resettlement Act, which began the forced resettlement of isolated fishing communities.

Liam When precisely would this have been? I mean, when did this act pass?

Zita The act was passed in 1965, but it was rolled out over the next two or three years. Hundreds of small communities along the coast of Newfoundland were resettled. People went from being self-reliant and independent to finding themselves living inland, in some town where, if they were lucky, they got a job, however many didn't.

For the people who found employment, those jobs didn't last. They went from being self-sufficient, to employed, and then unemployed, all within a couple of years. People were really stranded, high and dry. But it didn't happen that way on Fogo Island because of an intervention in the form of film.

At that time the National Film Board of Canada had a program called Challenge for Change. It was an attempt to try

30

to understand poverty and whether it was specific to cities or rural places. The NFB got together with the university in St. John's, which had a community development wing, or what they called an "extension service."

They came to the island with the purpose of trying to understand what was happening. I was a kid but I remember all of this—it was like a miracle. The adults were asking, "Where are we going to end up?" Suddenly these funny people showed up and were asking new questions.

Liam The National Film Board is an important organization.

Zita It's super-important.

Liam I knew about it as a teenager in Britain. You'd be watching something interesting and see it was funded by the National Film Board, or it was a co-production with them.

So what did the arrival of the filmmakers do in your opinion? Did it show you that cultural work can bring attention to something, and at least change the focus?

Zita Completely. Have you ever gone out to look for worms to go fishing?

Liam Not recently.

Zita If you go out and stand there looking around for worms, there are no worms. If you turn over a rock, you're probably going to find worms. If you dig a little bit, you're almost certainly going to find worms. So that's what they were doing, they were coming and turning over rocks.

The crazy thing about this island, which is four times the size of Manhattan, is that at that moment there were only around 5,500 people spread among ten communities. They didn't have any so-called social capital. These different communities didn't know each other. They certainly didn't trust one another because there were religious differences. Protestants and Catholics. I grew up Catholic, and the priests did their level best to make sure we didn't talk to the Protestants. So when we were faced with this near certain resettlement, it wasn't as though we were going to get together and work out what to do.

We stuck to ourselves, everybody was frightened. And along come these strange film people, asking very simple questions about what people were thinking and asking, "What matters to you?" I remember my parents having these incredible conversations about what might be possible in the future.

There's a Northwestern University professor and author named John McKnight, who coined the phrase "asset-based

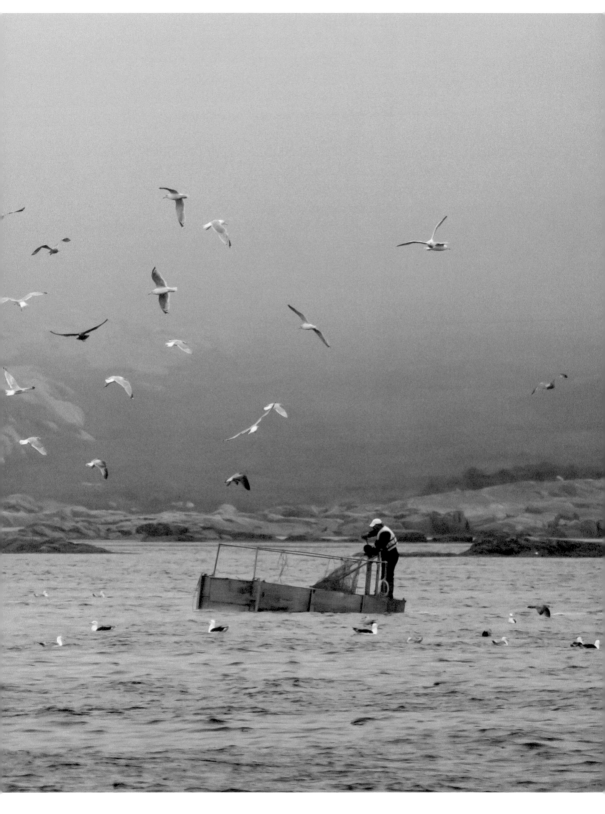

community development," and established that methodology. He asks, "If you knew that your neighbors would help you, what would you do for your community?" I think the NFB asked similar questions.

It is a very different question to ask in a small community than, "What would *you* do alone?" Colin Low was the main filmmaker—he passed away last year—but I got to know him and his family. At least two of his sons are also filmmakers.

When he came he was already a respected filmmaker, and his wife says that when he arrived, he thought, "Wow this is like some kind of a paradise that's been lost and I'm going to make a career filming here." His wife, Eugenie, who's still very much alive and lives in Montreal, said to him, "You were not invited here to make a career. You were invited to figure out what might happen for these people and their futures."

Low became the guy going around turning over rocks. At times he gave the cameras to people to take home, and he showed them how to use them, and they would film conversations they thought were significant. Importantly he built an unbeliev-able trust with the people. He assured them, "If you don't like it, it will never be used and you will see it first." So then people were perfectly relaxed to have these conversations. Anyway, he made twenty-seven little films that you can find online.

Liam Benefactors who support the arts often have a originating myth, especially in the US. They came from either nothing or everything. A lot of people talk about the ideas you talk about— the periphery, the edge and the center, the collapse of industry, and ecology, but they didn't really experience it. You are coming at this after witnessing something momentous taking place and witnessing people trying to address it, or even understand what was happening. It's very unique.

Zita Yes, I experienced all of this first hand, through the plight of my parents. My father was extremely angry and my mother full of despair about the inevitability of being forced to leave Fogo Island. My father came from a long history. A highly knowledge-able person who didn't have any formal education at all. He had been a very confident person who could make a living on the North Atlantic, build a boat, build a house. Overnight he was being perceived as utterly useless and incompetent.

Liam At the time things felt culturally insensitive everywhere. I re-member the bulldozing of all these beautiful buildings in London, all these marvelous Georgian houses. I'm old enough to remember

the very late '60s and early '70s when there was a lot of governmental thinking along the lines of, if we knock down all the houses and move everyone somewhere else, it'll fix all our problems.

You're also trying to fix and change something. Not in the sense of brutal social planning. But you're trying to plan, and to implement some kind of infrastructure, create cultural exchange, and a new way of thinking about Fogo. So you've got to do some planning, right? You've got to take some risks but at the same time you've got to be sensitive.

Zita

My old boss used to say, the most important thing is people and their knowledge. The government failed to see the knowledge on Fogo Island. If we just keep shuffling everybody around to a different corner of the earth like refugees, we'll just get dumber and dumber. The sum of all that lived experience adds up to something called culture, which contains knowledge.

Building on knowledge requires us to organize our (human) media so that we can allow people to continue, have a continuity in a place. Culture is a response to place, and if you break that relationship and break that continuity, knowledge is lost.

If you go back to 1968, this is what Colin Low and Donald Snowden were doing; they were focusing on the questions "A, B, C, D": *What do you know? What do you have? What do you miss? What do you love?*

People came together across all ten communities and began to think, what can we do about the situation? They formed the Fogo Island Improvement Committee, then they started a Cooperative and they took over the fish plant. There wasn't any more cod than there had been before, but now they had actually organized themselves into some kind of a structure that could get something done.

The provincial government realized these people were not going to leave without a fight, so they helped by building a small shipyard so we could build slightly bigger boats. There were cod in the mid-shore area, even though they weren't inshore any longer. Over the years that cooperative, which still owns the fishery, has adapted to fish crab, shrimp, and other species.

Colin Low showed the films to the different communities on the island. We would all gather at the church hall. We saw people in the film with totally different accents to ours—from Deep Bay on the other side of the island for example—but we responded to them in such an emotional way, because you could see they were a little nervous on camera.

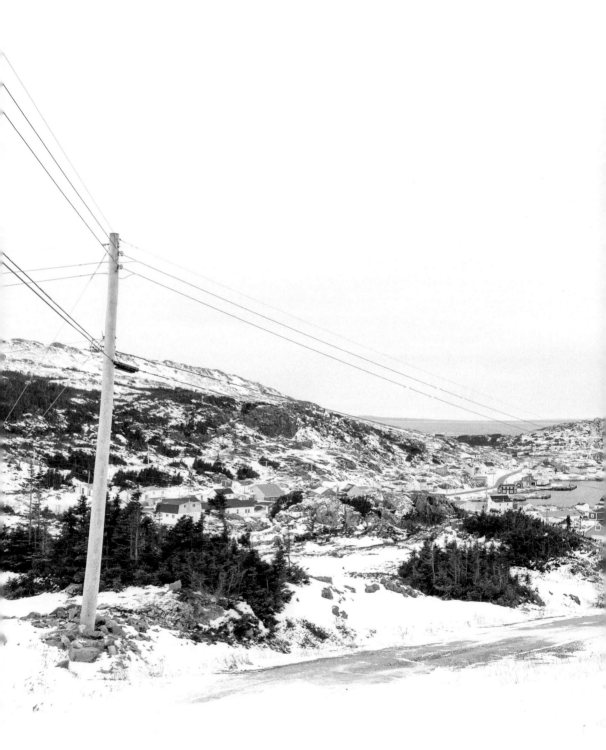

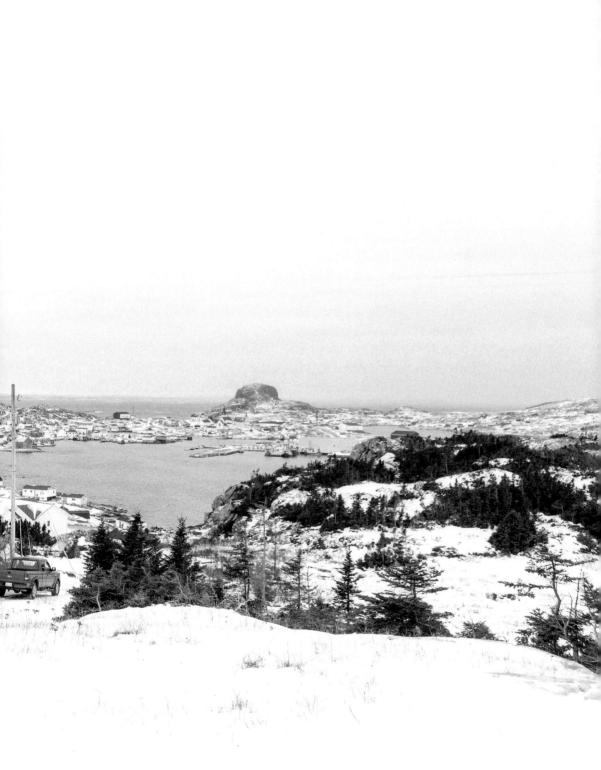

Despite all of the little details about how they were dressed, and how they sounded, we were kind of in the same pickle. It was really powerful and it all came from asking questions.

Liam Does it mean that the way you deal with everything on Fogo Island is completely affected by that awareness? A shared bond about the situation? Recognizing that everyone was, so to speak, in the same boat?

Zita Yes, absolutely. Initially my father did not understand the new presence of the factory fishing boats that appeared off our coast. He wondered why anyone in their right mind would fish twenty-four hours a day, every day of the year? Didn't they realize they were going to deplete the supply of fish? Then he finally understood that they were turning fish into money. This was a strange notion to us because remember we didn't have a bank—there was almost no cash. It was pretty much a cashless society.

Liam How does a cashless society work in this case?

Zita There was a merchant who provided salt and tea and molasses and other goods, and we traded our fish with the merchant. We were salt-fish people, so we dried the fish all summer and traded in the fall. When Joey Smallwood came to power he brought us into Canada in 1949. He brought a *baby bonus* for the island. It was the only cash that ever came to Fogo Island at the time. The only other cash my dad ever got was when he went sealing. But cash was kind of meaningless, there were no bank accounts.

Liam So, by the 1960s, the island still operated in much the same way it had done from the beginning.

Zita Yes, it was still a place of trade with the merchant—who was a de facto monopolist.

Liam You witnessed a system in a moment of change. Growing up where I did in the suburbs of London, socio-economics were an abstraction right from the start. Everything seemed to be a big abstraction. The system was infinitely complicated.

Zita Like the air, where does it start and where does it end?

Liam Yes, but on Fogo you could actually see a society in fundamental transition.

Zita I saw the arrival of money as represented by these mean monster factory fishing ships that were catching all of the creatures that would now be considered, or are considered, "sacred capital." I mean sacred capital as capital that has a unique essence that has intrinsic value.

Liam Give me an example.

Zita Fish. Culture. People. The little buildings we built to live in on the island were the sum of our lived experience. Nature is a sacred form of sacred capital. And at the highest level of abstractions money is completely generic. It has no essence and all it does is interact with sacred capital in the hope of making more money, and sometimes, that's really bad for the sacred capital.

When it's unchecked and unbounded, money will take every last fish out of the ocean. So my dad was right. To me what's interesting is, how do we use money, which is just a thing that we invented and we control, how do we use it to make more fish? Which we can. So I think what we're doing now on Fogo Island, is using money to make fish.

Liam So, to follow the analogy, you're saying you're currently making fish—using capital to make "sacred" capital? How then do things operate today, in your opinion, in relation to the existence of the artist's studios and the inn? What do they do? What's their function?

Zita The quality of our lives or the quality of any of human system starts with the quality of awareness and that is the crucial aspect. The inn has a number of jobs to fulfill. One job is the obvious one, to provide economic activity for the island so that the community can continue, and to create employment for people that is meaningful.

The key questions are: How do you practice hospitality? What kind of chair do you give someone to sit in and what do you feed them? All of that is inherently made of the fabric of yourself, as long as it's not invented bullshit that somebody brings in from somewhere else as a signal or token of luxury. The inn provides a way for us to welcome people into a community that is still intact yet an ongoing concern for quite a long time and has adapted.

Architecture is a funny thing, but one of the challenges of architecture is to carry time. Every new building we create should be in some kind of a relationship or a conversation with the ones that came before. When you think about relationships, you start by thinking about meaning. How do people make meaning, because it doesn't just fall out of the sky into your breakfast bowl?

Meaning comes from relationships, and those relationships include our relationships with people, but also with the past, and even with people who are dead. I actually think that dead people have rights too. It also comes from our relationship with objects, because objects can help us make meaning. So a studio

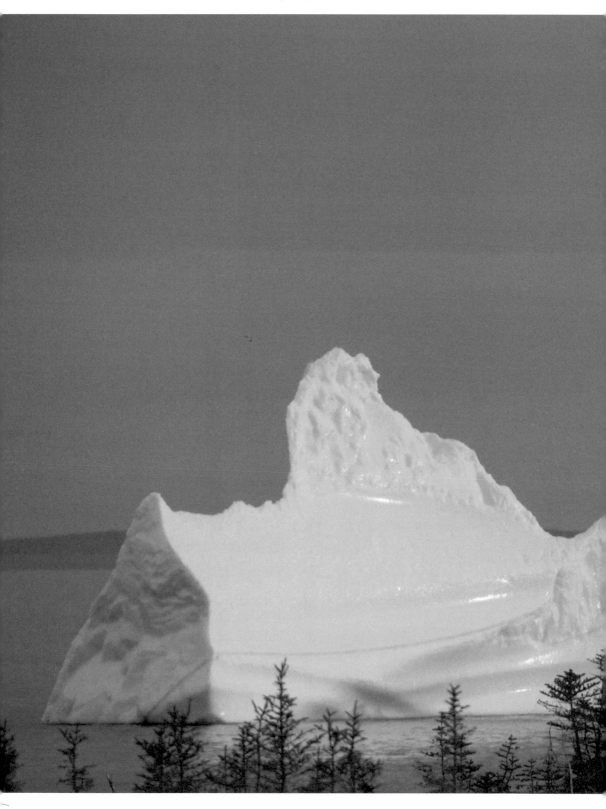

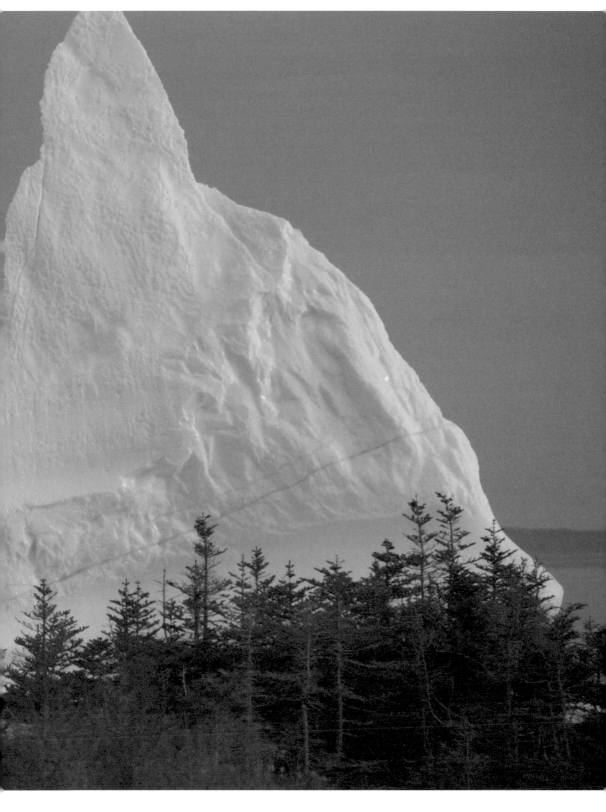

is in a conversation with all these wooden fishing stages, which we actually don't need anymore because we're no longer inshore fishing people.

We still use the fishing stages as part of recreational fishing, but the commercial fishing boats don't land at them anymore. If you make use of processes of remembering you are holding onto relationships and it orients you in time. I think the sum of the whole project on Fogo Island is to improve the livelihood of the communities based there, through revitalizing the economy, while improving the environmental impacts and ecological awareness in a sustainable way. The studios are part of this. And the work that's done in those studios is a part of adding to what we know.

Liam	It's quite a radical decision to do that, because the way we're supposed to think about questions like ecology, creativity, localness, and so on, doesn't always involve putting up quite striking bits of contemporary architecture in the landscape. Only someone who's actually from Fogo Island would have the nerve to do that.
Zita	We can talk about the studios separately from the inn, because the scale obviously is completely different. We actually started by building the studios.
Liam	You started following this chronology?
Zita	We began with art because you've got to start with knowledge. I think of art and culture as a form of resistance against business and against money. We started with the studios and the brief that we gave to Todd Saunders, the architect, a Newfoundlander living in Norway, was to figure out how to express in a contemporary way the sum of the learning of the last four hundred years in this place.

It was like asking what would these people build now, if these same people from the past were still around. The other thing that we were preoccupied with was that we were a "maker culture." There were no designers, and so the craftsperson was the designer, and we made really beautiful things before Confederation. After Confederation, it kind of got ugly because we started copying mediocrity from other places.

Somehow, design became a profession unto itself, and it quickly became the handmaiden of business. Traditional crafts-people around the world have been absolutely left behind. So we were interested in architecture as a form of design brought to bear in a way that is in service of all of these dead people, and what the sum of their lives was.

Fogo Island had been steadily shrinking, and we understood that we probably had one chance at this. Starting little B&Bs, and this and that, wasn't going to create enough of a reset for people. We wanted people from Fogo Island, people from Newfoundland, people from the world to kind of see and understand that in places like Fogo Island there is something that you might want to pay attention to.

Liam You talk about the specificity place, history, and memory. How does this relate to the recent rise of nationalism in Europe and the USA? Is this a question of scale? Where does community pride end and nationalism begin?

Zita I don't think it's as simple as community pride morphing into nationalism—there are a lot more factors at play. Our human relationship with "the local," the local geography which helps us hold on to the specificity of our local history, our local ways of knowing and doing, the local community, the local body we live in—are all crucial to our sense of self, our orientation to the bigger world and our orientation in time. I don't think that healthy, self-determining communities resort to or fall victim to nationalism. Healthy, self-determining communities are confident, open places with healthy respectful relationships that are very open to the world and in these days of digital technology are well networked to the rest of the world.

Liam While we're on that topic, may I briefly ask how, in your opinion, digital life has changed Fogo Island?

Zita Well it has certainly made us more aware of what's going on in the bigger world. It has clearly given the community a greater capacity to connect with each other on an "information" level, and given us the ability to form alliances with others around the world. However, it's also made us less social in the sense that personal and relationship-building interactions are likely to be less frequent. Before the digital world we socialized more—for entertainment and to find out what was going on. Now we are much more likely to be at home than out visiting neighbors.

On the other hand, the arrival of the digital world has made it easier for us to collaborate and organize on the island. For example when residents were unhappy about the ferry schedule last year, it took nothing more than a few posts on Facebook to mobilize citizens to come out for a protest.

Liam Yes, I guess these issues—the ups and downs of being "connected" but socializing less, of mobilizing citizens but at the same time risking manipulation—are problems (relating to

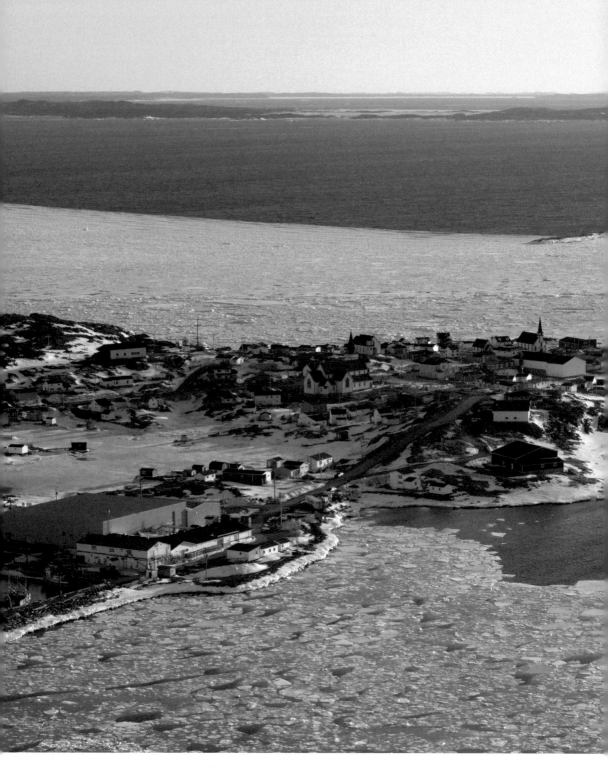

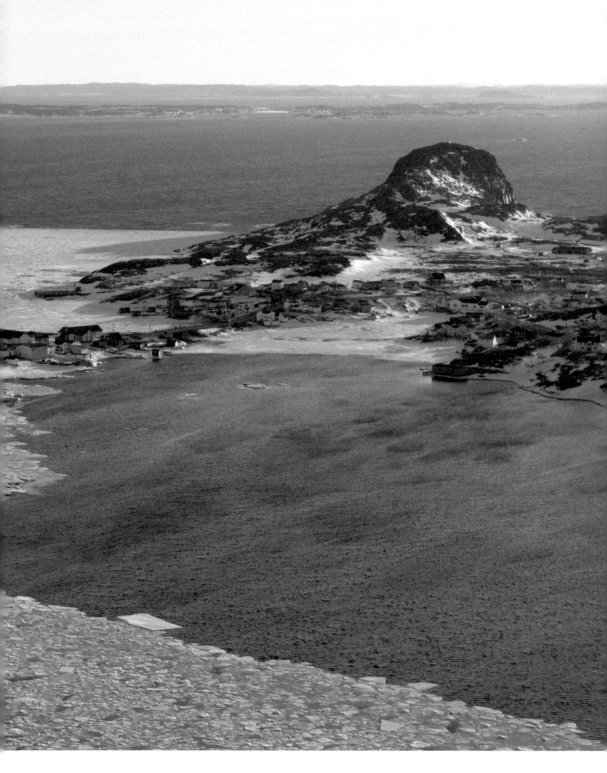

"digital life" or the "internet-age") that contemporary societies at large are increasingly facing. Returning to my previous question, and the relations between smaller communities and rising nationalism, what do you have to say about communities that promote national values?

Zita The trouble usually starts when communities lose agency, feel powerless and unable to shape their own (local) lives. This most frequently happens when they lose control of their economic assets and any sense of economic self-determination. If every business, every shop in a community is owned by someone or something far away, if decisions about the community economy are made far away, the fabric of the community will become frayed. People become anxious and angry. That's the fertile ground for the emergence and ferment of radical and destructive thinking and behaviors. And if they were insular communities in the past (feeling threatened and powerless economically) they are probably more likely to become even more insular.

At the other end of the spectrum of course are communities (and nations) that may feel so self-determining and self-sufficient that they feel threatened by "outsiders," especially those whose culture and histories are different. In that circumstance, the same remedies apply with different emphasis: sharing versus local ownership and control; dialogue and understanding across seemingly wide cultural distances; an openness to other ideas. Human communities or tribes are in constant struggle with themselves and others—whether economic, cultural or political. What should and can moderate the extremes are a semblance of common values and a leadership cadre that causes us humans to act on our better natures, rather than incite our baser instincts.

I don't think nationalism or any other political movement comes from focusing on strengthening the local, strengthening communities; quite the opposite, it comes from not focusing on strengthening communities, and in particular not focusing on the need for some degree of local economic self-determination and some common societal values.

Liam How do you ensure this in your project? Particularly, how do visiting artists, in your opinion, contribute toward the strengthening of communities into confident, self-determined, and functional societies? For the artists, they are invited to a special place, in a specific location. In the beginning, did you know who these artists would be?

Zita I had done a little bit of visiting around the world to different residency programs. I wanted to understand how the other programs organize themselves what they built and how they built it, as well as what works and what doesn't. So out of that early survey, we decided that this shouldn't be an artist colony.

I wouldn't have gone that way anyway because I really wanted to create a place where the artists join the community for a while. When an artist shows up it usually takes about ten minutes before somebody comes over to the house and says, "Hey I'm your neighbor." So back to the question, the most important question, what are we optimizing for? We're optimizing for knowledge and community.

Liam Sometimes you use language I don't completely understand. So please could you say it again, what are we "optimizing" for? What do you mean?

Zita What are we optimizing for means, in other words; what is our intent? What are we trying to achieve? In our Shorefast projects, we're optimizing for knowledge and I think the best receptacle of knowledge is a human community.

Liam I can't imagine anyone thinking anything otherwise, but it's quite obvious that many people in the world clearly do not care. The word reminds me of "tech-lingo," or terminology used in a business context when in reference to efficiency and productivity, namely, within a system forcing a pressing need and desire upon individuals for optimization. Do you think that humans are just collateral fallout from the economic procedures of the world?

Zita Yes, but that's just the wrong-headed approach. You know, I don't want to go all "Schumacher" on you, but you can't avoid Schumacher in this. Nature and culture are the two great garments of human life. Business and technology are the two great tools that can and should serve them.

Liam It seems to me that you want to both enact that idea literally, and also to show a model of it.

Zita Exactly. I want to show how this can work.

Liam How do you judge success or failure? Or is this a too simple binary?

Zita There are many possible ways to measure success or failure like the amount of earned income versus government transfer payments and how that is changing over time; how many jobs have been created, the labor force participation rate and unemployment rate; population changes and school enrolments. And beyond these traditional measures and equally, if not more

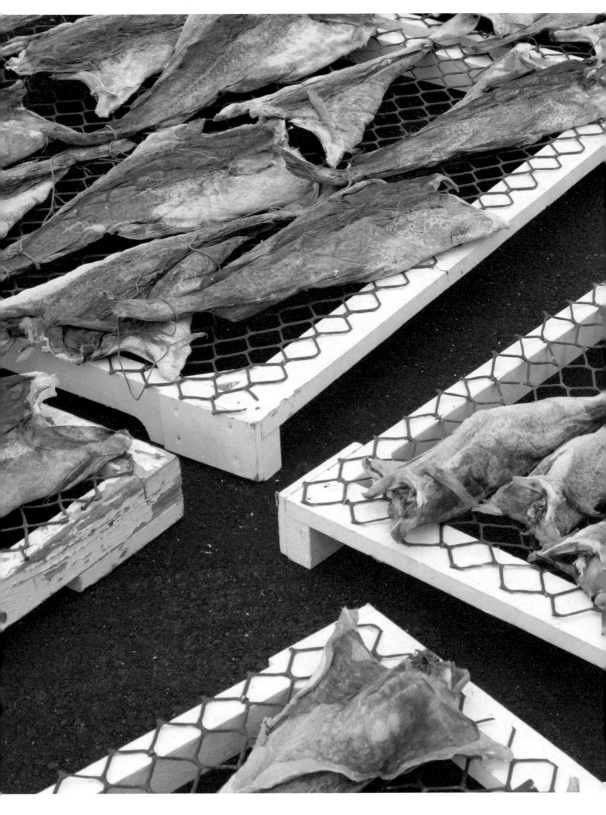

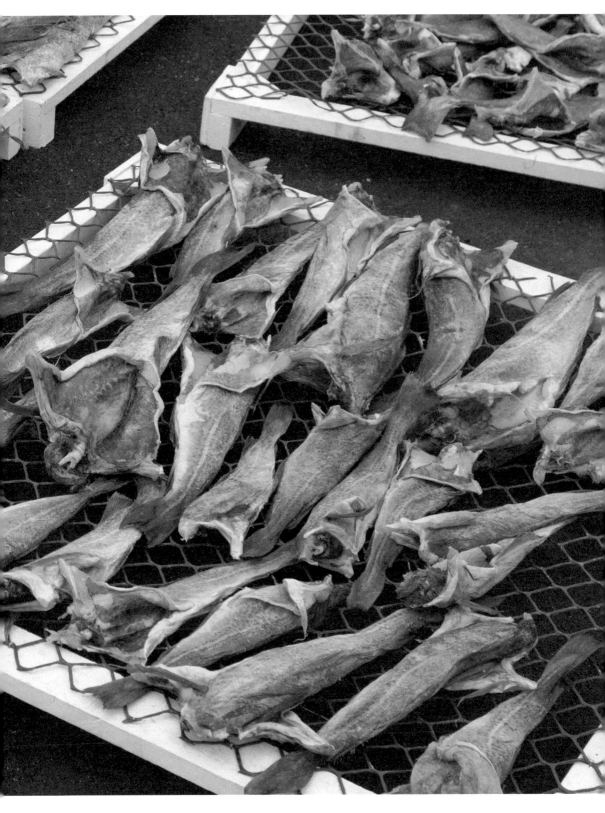

important, are things like the pride that residents have in their community; the hope they have for their own and their children's futures here on Fogo Island; and whether they still feel safe and secure enough to leave their house and vehicle doors unlocked— night and day.

Liam So there's a kind of double thing going on here.

Zita Right. Yes, absolutely. There's a double thing going on. Left alone, money will eat life. People either don't see it or don't care. But money interacts with sacred capital. The biggest problem we have in the world now is that there's too much money, and 85 percent of the money that leaves bank accounts does not go into the real economy. It stays in the speculative economy, and it just moves around from existing asset to existing asset in some way that is hopeful of making more money. So therefore money is not doing the job that it should be doing to actually develop real assets. Most investment isn't development. So now let's talk about development. For example, most people who call themselves real estate developers are not really developers. That is a wrong use of the word. Real development looks at the intrinsic assets of people and place, and figures out how to strengthen them, give them life, give them a possibility in a way that serves a purpose, other than the making of money. That's development.

Liam Which political instruments do you think are there to make initiatives such as yours more effective and likely to happen in future? I mean the fact that there are real estate developers that don't develop concrete assets isn't just due to their lack of resolve and goodwill. How could, for example, the Canadian (and international) tax code be improved to help communities and cultural work?

Zita In a Canadian context, I am encouraged that social enterprise is entering the lexicon and consciousness of the policy makers. However, I believe that both federal and provincial governments in Canada might give more attention and focus to creating a regulatory and tax environment to facilitate the development of social enterprises. Based on our work here on Fogo Island, we believe that every business can, at some level, be a social business. We think that the framework systems that govern business behavior and operations, including tax codes, could and should be changed and encourage for-profit companies to also become social businesses. We further believe that in the not too distant future, companies will compete in large part on the basis of how much of their profits get released into the public domain (helping solve social problems) versus how much goes into the pockets

of shareholders (who deserve a reasonable financial return on their investments).

Liam Right, so it's a matter of distributing the profits equitably, a matter of balance, so to speak. So what you envision is a balanced (capitalist) economy, ecologically as well as socially. Where does this really locate you in philosophical terms? Who are the people that are important for you? You mentioned the economist E.F. Schumacher, right?

Zita Schumacher, certainly, Schumacher. I mean I would love to give everybody a pill so that we all wake up tomorrow morning and we just stop believing in money. Just stop. It has no more use to any of us. Then let's re-organize ourselves. It's because we're all kind of money drunk in some weird way, and it's a disease of our connective tissue. We can't see it and it makes us cynical. It makes us deeply cynical.

I think our lives are lived in the local, and I think the degree of influence or agency we feel in our local lives, that's what affects the quality of our life more than anything. I think it's about ownership of our own lives, of our own economic assets. So when all of that is taken away and we become in some way serfs, that makes us really sad. That makes us despair.

Liam Strong bonds formed between people can be said to relieve such symptoms of despair and cynicism. Tell me about the relationship between the different communities on the island today?

Zita We have helped to weave a new architecture for the society to operate in a post-merchant economy. Several crazy things have happened as a result of that. So now we have to get along, to cooperate in the cooperative. So in the cooperative there are fishermen and there are plant workers, and their interests don't align. The plant workers are paid by the hour, and the fishermen are paid by their catch.

Both are on the board and both are shareholders, and there is a constant struggle with trying to keep fairness. What matters to Fogo Islanders more than anything is whether something is fair. That is the most important thing, and that's always ongoing. I really believe that a community can only be strong to the extent that it controls its own economic assets. The assets are owned by someone who lives in the community and is accountable to the community, because if you live in a community you feel a degree of accountability to those people.

Liam There's a lot of awareness now that art has been instrumentalized by various players to either do good social work or

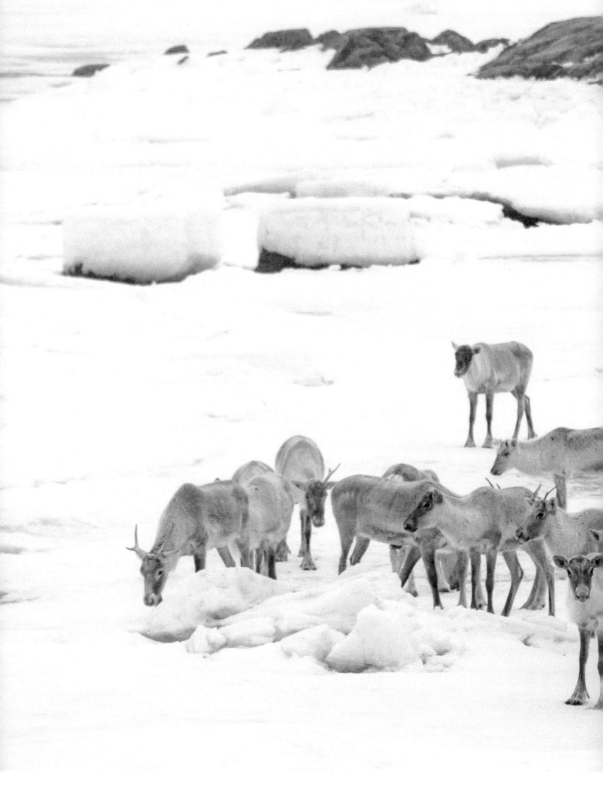

"art wash" urban development. So, how much pressure do you put on artists—does every artist have to be all happy, helpful, and contribute to the community?

Zita They have to do at least one community-related engagement. They must have an open studio or they have to do one talk. With some artists, obviously we do shows, but not the majority of them. That was one of the things that I had learned from going to Pace in San Antonio. When I arrived they were opening a show, everyone who goes into residence there has to participate in a group show at the end. I thought that was like organized torture.

Liam Why contemporary art? Why not have a place where political scientists can come and sit in a postmodern hut for three months.

Zita Because somehow that seems like too small a box.

Liam When places like Fogo really work I always think about how it affects artists as much as it might affect the communities.

Zita I would say artists are as different to each other as any human beings are. But for artists, being here is like cutting a hole in the fabric of time. Because there's nobody on Fogo from the art world, whatever that is. All of their daily interactions are utterly different than any interactions they would have ever had anywhere else.

Liam And what about the future of the community?

Zita Every community is trying to figure out what is the past, where are we now and what is the future. You get to the whole by starting with the sum of all the little parts. We are embodied creatures. Place matters. Ethics, morality, and all of that stuff is local. I think a successful community needs 80 percent of its householders to be year round residents. I would say we humans are living through a crisis of belonging, because communities are falling out of the world every day. The crisis of belonging is a disease of the connective tissue—meaning money—that's gotten into our systems in a weird way. That's causing a crisis of meaning and at the root of it all, is a crisis of value.

We've lost track of the relationship between things that have inherent value and what their financial value is. When you lose any relationship to ecological embeddedness, the only way you can measure value, the only way you can understand value is through money, and that's a very shallow pool to live in.

If we, as Fogo Islanders, were merely taking care of the second or third homes for people who live away, waiting for them to come back so they will spend money and make our lives possible, that would be an awful situation. Instead, we own

an inn as a community, and when people walk in that door, we are all welcoming them; we feel we are welcoming them into our homes. And that's a year round undertaking.

Liam　　So it's not cultural tourism?

Zita　　Hospitality at the inn is practiced in the way that Fogo Islanders culturally practice hospitality. There's a lot of pride in being able to say this is a community. But tourism can be a dance with the devil, and a lot has been written about what sustainable tourism is. There are two requirements at least. One is that it can't be the only industry.

If it's the only industry you may as well pack up and leave because you're really bringing despair down on the people that are there. The second thing is the scale has to be right for the size of the community. So we built an inn with twenty rooms not 300 rooms. And other than a small rest in January, our inn is open all year round. If we just waited around during winter for people to come back, that wouldn't be successful or meaningful.

Liam　　Let's wrap up. So you are saying it matters who owns what?

Zita　　Yes, absolutely, it matters a lot.

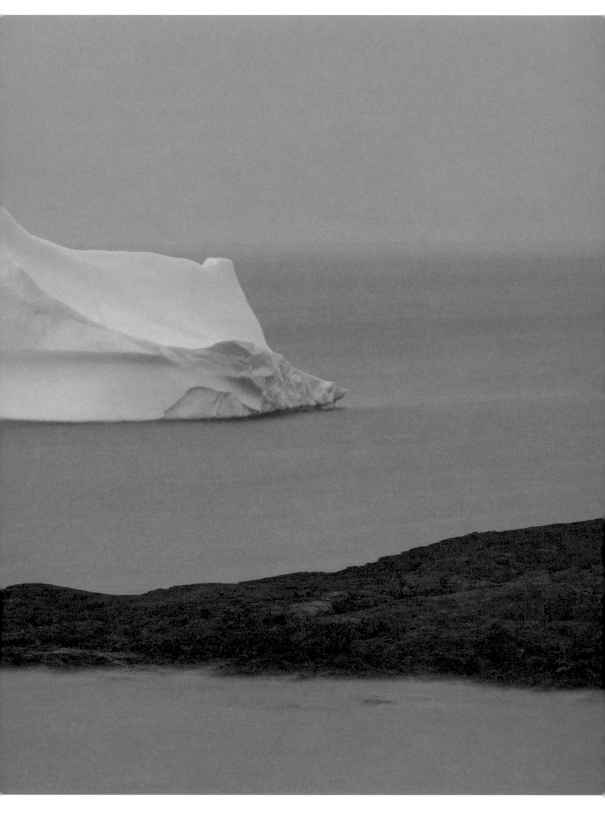

Alexandra McIntosh:
AN ISLAND WITHOUT BOUNDARIES

Alexandra McIntosh (based on Fogo Island)
is a writer, editor, curator, and member of the
artist collective Centre de recherche urbaine
de Montréal (CRUM). She was a curator at the
Illingworth Kerr Gallery, Calgary, and visual
arts program manager at the Banff Centre for
Arts and Creativity; coordinator of special
projects and cultural affairs at Concordia
University, as well as editor of CCA Online at
the Canadian Centre for Architecture (CCA).
Since 2015, she has been director of programs
and exhibitions at Fogo Island Arts.

A shorefast is the line and mooring that tethers a vessel to the shore. When eighth-generation Fogo Islanders Alan, Anthony and Zita Cobb conceived of a foundation with a mission to preserve and stimulate Fogo Island's culture and economy, they named it Shorefast, evoking the traditional fishing term's connections between land and sea, community and culture, individual and place.

Like all Fogo Islanders, the Cobb family's livelihood and well-being depended on the fishery and its firmly established system of assigned roles and trade. Men fished from June to September on small wooden boats called punts, casting off from the community wharf and staying out for hours on the open water. At the end of each day, fish were cleaned and filleted in fishing stages—small wooden sheds built on stilts over the water—and the guts and carcasses tossed back into the sea. Women and children had a hand in drying and salting the cod, which would eventually be traded to local merchants for credit. Fishermen were offered a price by the pound for their catch that was set by the merchants, who then exported the fish to Europe, the Caribbean, and North and South America. This exchange situated Fogo Island within a vast triangular trade network across the globe that flourished from the sixteenth to nineteenth centuries. Along the journey, Fogo Island saltfish was traded for sugar, molasses and rum, once-exotic materials that became intertwined with local fare. Over the winter, boats, nets and other equipment were repaired and maintained in anticipation of the next season, and the cycle would begin again.

This way of life remained in place for 400 years, until the 1950s, when a process of industrialization of fishing began, setting cod on a course for extinction and decimating Fogo Island and Newfoundland's economies in the process. The advent of offshore factory trawlers—large ships with on-board freezing and processing capabilities—and gillnetting, meant that vast quantities of cod were fished from the seas around Newfoundland, the Grand Banks, and the Gulf of St. Lawrence. With dwindling fish stocks in their local coves, Fogo Islanders moved from a local, inshore fishery further out to sea, requiring bigger boats and new techniques. Overfishing and ever-diminishing catches continued through the 1960s and subsequent decades until 1992, when the Canadian government imposed a moratorium on cod fishing, closing the once-rich waters to all. Almost overnight, a stable and sustainable way of life ended with no recourse in sight.

Until this point, Fogo Islanders had fished according to need, taking enough to eat during the season, and enough to see them through the winter. When the cod fishery collapsed, Zita Cobb's father, like other fishermen, was told to make the transition to catching different species, a task that proved impossible without the capacity

to read or write. The Cobb family moved to Toronto in 1975. "It wasn't the fish that let us down," Lambert Cobb told his daughter. When Zita was old enough to attend university, she studied business, seeking to understand what had happened to her family and to her island.

Zita Cobb was born in 1958, the only girl among eight siblings. She has described her experience as one of growing up in three centuries. Her childhood was situated in the nineteenth century, on an island with no electricity or running water and parents who couldn't read or write. With the advent of bottom-dragging trawlers and the extreme intensification of fishing over three decades, she was squarely in the twenty-first-century, with its unfettered pursuit of profit and resource extraction to the detriment of natural and human costs. Cobb eventually pursued work in the technology sector.[1] Towards the end of her thoroughly twenty-first century career she became increasingly motivated to find new ways of creating capital without the destruction of community and environment.

Cobb retired in 2001, at the age of forty-two, and returned home to Fogo Island with "more than her fair share of money,"[2] and the intention to help her community. Shorefast was formed as a registered Canadian charity in 2007 to "build economic and cultural resilience on Fogo Island."[3]

Using a holistic approach to development, Shorefast encompasses a suite of interconnected social businesses—deploying business strategies toward socially beneficial ends—and charitable programs.

Surpluses from Shorefast's social businesses, chief among them—the Fogo Island Inn—are reinvested in the community of Fogo Island through charitable programs that include art, geology and academic residencies; microlending; ocean sustainability and resource management initiatives; vernacular architecture and boatbuilding heritage programs; and an economic development partnership between key local stakeholders.

The largest and most visible of Shorefast's charitable programs is Fogo Island Arts, an international contemporary art organization that operates an artist residency program on the island as well as a series of interconnected programs and initiatives.

The Fogo Island Inn was conceived to be the main economic driver of Shorefast activities. Opened in 2013, the inn was funded primarily by Cobb's assets from the fibre optics industry, along with comparatively modest contributions from the governments of Newfoundland and Canada.

The inn is a form of contemporary philanthropy, a business without a board of trustees, or shareholders seeking a return. With all surpluses returned to Shorefast for reinvestment in the community, Fogo Island as a whole is the "beneficial owner" of the inn. The philosophy and values of Shorefast are woven into the very structure of the inn

1
Cobb became CFO of JDS Fitel, and then senior vice-president of strategy for fibre optics manufacturer JDS Uniphase.
2
Zita Cobb, D3 video presentation, Association of Professional Fundraisers, Toronto, 2014.
3
Shorefast website: www. shorefast.org. The Charity was first incorporated as Frangipani Foundation in 2004, and the name was changed to Shorefast Foundation in 2007. In 2018, the name was shortened to Shorefast.

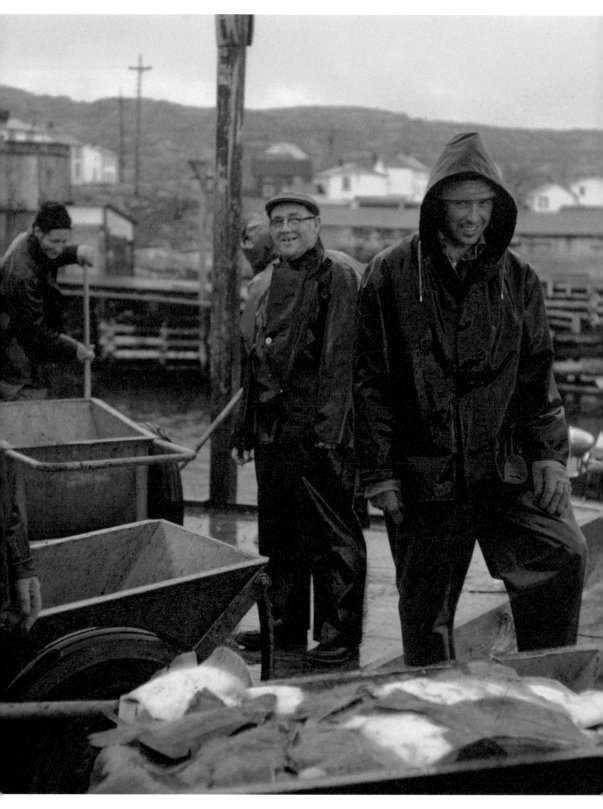

and its furnishings, built into every architectural component and material detail. All construction and interior materials were sourced from Fogo Island where possible, and then from Newfoundland and the rest of Canada, moving out in concentric circles to the island's traditional trading partners, and always from places with basic labor and environmental protection laws. As much as possible, furniture and other objects are made on the island by local craftspeople.

Shorefast's projects as a whole balance the preservation of local knowledge and culture with a search for ways to connect to the world beyond. The inn builds on Newfoundlanders' innate hospitality and history of exchange with other parts of the world. Equally for Shorefast's other businesses and charitable programs, this balancing of preservation and connection has been a question of renewing the relevance of certain activities and ways of being. For example, an artisans' guild was established to maintain the standards of quality and uniqueness of Fogo Island's textile traditions. Quilting, rug-hooking, knitting and other activities were driven for years by necessity and undertaken with leftover or repurposed materials. As such, they risk being lost to subsequent generations who have options beyond making their own pieces.

Similarly, concerned for the disappearance of knowledge required to make the wooden fishing punts that are characteristic to Fogo Island and neighboring Change Islands, Shorefast commissioned a new vessel from each of the few remaining boatbuilders. It also initiated "The Great Fogo Island Punt Race—To There and Back," an annual boat race that has drawn attention and competitors from locals and visitors alike.

Through boatbuilding, the guild, and the commissioning of quilts and soft furnishings for every room of the Fogo Island Inn, Shorefast has not only helped preserve specific skills but generated a broader interest in and celebration of these forms of knowledge and material culture. Significantly, this has translated into sales of textiles to inn guests and other visitors, bringing revenue to the island and creating opportunities for some makers to sustain a living through their practice.

What is key to Shorefast's mission and initiatives is that Fogo Island's challenges are not unique. Rural areas around the world face similar issues of a loss of economic independence, aging populations, outward migration of young people, and a struggle to find a place within the global economy. Shorefast projects can be taken as potential models for elsewhere, templates for action that may be reimagined according to other communities' specific needs.

What Shorefast aims for, echoing the philosophy of Gill-Chin Lim, is to move towards a global network of intensely local places. Driving all of its initiatives is the fundamental conviction that individuals are shaped by place, that our knowledge, culture and capacity to relate

to one another depend on the specificity of our surroundings. Before we belong to the world or develop any sense of global connectedness, we belong to what is local, to what is *here*.

BELONGING TO A PLACE

So what is here, now? Fogo Island is situated in the North Atlantic; it is an island of fewer than 2,500 inhabitants whose ancestors came from Europe and settled to wrest a livelihood from the sea. It is important to note that at the time of European contact in the sixteenth century, Fogo Island and Newfoundland had been home to the Beothuk, Algonquian-speaking hunter-gatherers. The year-round settlement of French and English migratory fishermen in the seventeenth century signalled a drastic change. Increasingly isolated, prevented by settlers from accessing the natural resources that had sustained them for thousands of years, and likely ravaged by European disease, the Beothuk population was decimated. The last known Beothuk, Shanawdithit, died in St. John's, Newfoundland in 1829.[4] Fogo Island had been a summer home to the Beothuk, and archeological traces and artifacts have been uncovered in numerous sites across the island.

The contemporary society and culture of Fogo Island, largely homogeneous, has been shaped by centuries of living in close proximity to the sea. Proper to any population closely entwined with its surroundings are forms of knowledge derived from and embedded within the environment. As John Durham Peters has noted, "There is a heavily folded genius to both nature and things. There is intelligence in every form of matter. As in earthworm practices, so in those of human makers. Gathered in a single clock, knife, or shoe are many lifetimes of practical knowledge."[5] The capacity of fishermen to navigate by landmark, to read ocean currents, predict the weather and the proclivities of fish were essential tools of both surviving and thriving. The skills required to select an angled tree root that defines the shape of a punt, to drive wooden shores for a fishing stage into the seabed, or to piece scraps of material into a warm and visually creative quilt emerged as practical responses to necessities but became markers of specificity. Such forms of knowledge are preserved and communicated from one generation to the next through practical application and tuition as well as music, storytelling, art, and language.

Indeed, language is fundamental to the expression and delineation of identity. Newfoundland-based artist Marlene Creates has compiled an inventory of over eighty terms specific to the province that convey close observation and a sustained engagement with the land and the sea.[6] Some of the terms derive from seventeenth-century English brought by settlers, while others are specific to fishing and other occupational activities. Her film *From the Ground Tier to a Sparrow Batch: A Newfoundland Treasury of Terms for Ice and Snow,*

4
Newfoundland and Labrador Heritage website: https://www.heritage.nf.ca/articles/aboriginal/beothuk.php. The Canadian Encyclopedia website: https://www.thecanadianencyclopedia.ca/en/article/beothuk/.
5
John Durham Peters, *The Marvelous Clouds* (Chicago: University of Chicago Press, 2015).

6
Marlene Creates was artist-in-residence with Fogo Island Arts in 2017. Her solo exhibition, "To the Blast Hole Pond River," was presented at the Fogo Island Gallery the same year.

Blast Hole Pond River, Winter 2012–2013 maps the diversity of terms over a season, and denotes a precision and richness of language in relation to place. A distinction is carved out with language that is used across Fogo Island and in some cases, the specific language used by the community of Joe Batt's Arm. Creates's film demonstrates that we are entangled with the landscape, deriving meaning and a sense of identity from our environment.

Working to preserve such forms of knowledge is a question of identifying what is at risk of being lost and seeking ways to find relevance within our contemporary setting. In this way, Shorefast's philosophy and business model draws from Asset-Based Community Development (ABCD), an approach to sustainable development that identifies and builds upon a community's existing strengths.[7] Or, in the words of Cobb, "what do we have, what do we know, what do we love, what do we miss, and what can we do about it?"[8]

"Let's let people know what we are capable of doing, and what we know, otherwise we'll never be known."[9]

So how do we hold on to what we know and what we have while embracing what lies beyond?

The answer, for Shorefast, lay in art. Understood as a way of knowing and belonging to the world, art provided new ways of thinking through Fogo Island's struggles and celebrating its uniqueness. Fogo Island Arts was founded in 2008 as an international artist residency program on Fogo Island, and a cornerstone of Shorefast's cultural and economic resilience initiatives. Today, FIA continues to welcome exceptional emerging and established contemporary artists, filmmakers, writers, musicians, curators, designers, and thinkers from around the globe. The organization also curates exhibitions, produces a publication series, and presents public and educational programs on the island, in cities across Canada, and abroad as part of its international outreach.

Shorefast's decision to open a series of interconnected social and economic programs with an artist residency program was not unfounded. In 1967–68, people on Fogo Island were immersed in an artistic initiative that would have a profound effect on Fogo Island. Between 1967 and 1980, the National Film Board of Canada (NFB) created Challenge for Change / Société Nouvelle, a participatory project that used film as an instigator of social change. Filmmakers and filmmaking equipment were sent to rural and urban places across Canada, providing disenfranchised communities with the tools and means of expression to address vital concerns such as poverty, unemployment, access to education and health care, Indigenous self-governance, and social activism.

7
See John P. Kretzmann and John L. McKnight, *Building Communities from the Inside Out: A Path Toward Finding and Mobilizing a Community's Assets*, 3rd ed (Chicago: ACTA Publications, 1993).
8
Zita Cobb in conversation with the author, September 6, 2018.
9
Colin Low, *Andrew Brett at Shoal Bay*. National Film Board of Canada (NFB), 1967, 14 min.

In 1967, the NFB partnered with Memorial University of Newfoundland Extension Service to send celebrated filmmaker Colin Low to Fogo Island. The outcome was the Fogo Process, a collection of twenty-seven short films that document Fogo Islanders' way of life and shared concerns. Despite little interaction between the island's ten communities at the time, all struggled with the loss of the inshore fishery, welfare dependency, and the looming threat of resettlement to the main island of Newfoundland that was faced by many outport communities across the province.[10] The Newfoundland government first initiated a community resettlement program in the mid-1950s in response to the province's economic woes and diminishing populations in rural areas. Over the next twenty years, 300 communities would be abandoned and almost 30,000 people moved to centralized growth areas such as St. John's and Corner Brook.

Filmed with minor intervention and screened across the island, the Fogo Process films range from conversations about the fishery, adult education, consolidating the school system and the roles of women within the community, to family gatherings and celebrations. The films spurred a series of larger collective discussions about the challenges facing Fogo Island and where its future lay. Significantly, *The Founding of the Cooperative* (1967) records the founding meeting and unanimous vote to establish the Fogo Island Ship Building and Producer Cooperative. While the creation of the cooperative was the culmination of years of work by the Fogo Island Improvement Committee, as Susan Newhook has noted, the film nonetheless marks a turning point in a process through which locals developed a collective approach to managing the fishery and ultimately took ownership of Fogo Island's economy. [11] Community members would also vote against resettlement and remain on Fogo Island.

In its capacity to build consensus and spur collective action, the Fogo Process empowered the island's separate communities to overcome their differences and act together to determine their future. To this day, it is celebrated as a groundbreaking example of community-based filmmaking and its potential as a tool for social activism and participatory democracy.

Cobb, who appears as a nine-year-old in the film *A Wedding and Party* (1967), was deeply affected by the films and their powerful influence on Fogo Island. "We went from a situation of total despair, with no one asking any questions and accepting their fate as inevitable, to suddenly having people soliciting opinions and asking what *might* be possible," recalls Cobb. "Almost overnight, there was a change in how it felt to be alive."[12] The decision to structure Shorefast's first initiatives around art is thus rooted in her experience as both witness and party to art as an instigator of social change.

10
"Outport" is the term given to small coastal communities in Newfoundland and Labrador; they are some of the oldest European settlements in Canada.

11
Susan Newhook, "Six Degrees of Film, Social, and Cultural History: The Fogo Island Film Project of 1967 and the 'Newfoundland Renaissance'," *Acadiensis*, vol. 39, no. 2 (Summer/ Autumn 2010): 48–69.

12
Zita Cobb, September 6, 2018.

Fogo Island Arts was conceived from the outset as an international program, with the intention to bring diverse artists from around the world to live and work on Fogo Island for months at a time. Having surveyed the best practices of artist programs around the world, Cobb and her team drew a key distinction between a residency and an artist colony or retreat. As a residency, participating artists would be offered the potential to engage with community and place. An immersion in the nature and culture of Fogo Island was essential to creating meaningful and productive experiences for artists. Of equal importance was establishing a framework in which Fogo Islanders could encounter divergent perspectives and cultures resolutely not their own.

The international nature of the program was essential to fruitful exchange, a cross-fertilization of perspectives, and crucially, to participating in a global conversation. Contemporary art is both language and currency within an interconnected world. While it may not offer solutions to the very real problems of unstable economies, forced and voluntary migration, environmental degradation, and human rights abuses, among so many others, art can offer alternative perspectives or ways of understanding our shared plight. As a way of knowing, learning, and making sense of the world, art is an essential form of knowledge production.

ARCHITECTURE BY DESIGN

To begin with art also necessitated a concerted investment in architecture and design. Norway-based architect Todd Saunders was commissioned to design six artist studios for Fogo Island Arts, four of which have been built to date. Originally from Gander, Newfoundland, Saunders was already celebrated for site-sensitive gestures and an inventive use of natural materials. The brief provided by Shorefast was to "take 400 years of lived experience and express it in a contemporary building."[13] The vernacular architecture of outport Newfoundland—saltbox houses, fishing stages, stores and sheds, flakes for drying salt cod—has been shaped by a deep-rooted knowledge of the landscape, climate, and available resources. Structures are built according to specific needs with materials at hand. Yet they are infinitely adaptable: if something exceeds its use value, it is converted, reused or altered to take on a new life and purpose.[14]

The Bridge, Long, Squish and Tower Studios are situated on hiking trails across Fogo Island.[15] Each is a contemporary reimagining of traditional architecture, materials and building techniques as well as relationship to site. While the latter three studios are located along the ocean shoreline, Bridge Studio overlooks an inland pond. Its location pays tribute to Newfoundland's culture of retreating from the sea and all its implications of labor and livelihood to be at leisure in small cabins that dot the island interior. The Bridge, Long,

13
Cobb, *D3*, 2014.
14
FIA alumnus Augustas Serapinas explored the adaptable nature of Fogo Island vernacular structures and the resourcefulness of builders in his project *Four Sheds*, commissioned by FIA and presented at the Fogo Island Gallery in 2016–17.
15
The studios opened in 2011, with the exception of Long Studio, which was completed in 2010.

and Squish Studios make use of shores, traditionally wooden posts used to prop up fishing stages over water or on uneven terrain. All of the studios are clad with wooden boards on the exterior and interior in reference to the aesthetics and materials of vernacular buildings. Resolutely contemporary, the studios are nevertheless in conversation with history; the new makes sense in relation to the old. Saunders would later return to Fogo Island to design the Fogo Island Inn, which employs similar strategies in homage to the traditional outport Newfoundland aesthetic.

As bold geometric forms that sit lightly on the landscape, the studios are at once striking and simple, otherworldly and rooted to place. They were (and continue to be) powerful strategic tools to infiltrate global networks. In the months following their construction, the circulation of heroic, breathtaking imagery of the studios in print and online platforms resounded across the globe. Quite suddenly, Fogo Island had a place within the collective imagination.

Architecture, design, tourism and lifestyle imprints rushed to feature the studios as examples of a bold creative vision, seductive aesthetics, or desirable destination. While some articles featured a nuanced explanation of the initiatives and intentions behind the studios, countless others traded images like currency. Indeed, in several instances, photographs of the studios and the Fogo Island "brand" as a whole have been co-opted to favorably color commercial merchandise by association. FIA continues to receive requests from retailers for fashion shoots, and inquiries about holding weddings and private parties in the studios, all of which are respectfully but firmly denied.

The use of architecture and design as a strategic conveyer of intent, then, has its dangers. With such iconic imagery and its easy circulation comes the risk of reducing Fogo Island Arts, Shorefast, and the island as a whole to an image. The stark, elongated black and white form of Long Studio set against a dramatic rocky shoreline with crashing waves is easily and readily consumed, subject to the whims of taste and popularity, next-best-thingism, and Instagrammable moments. Less readily discernible is the fundamental mission of Fogo Island Arts as an instrument to build cultural and economic resilience. Nonetheless, the contemporary architecture of the studios was essential in establishing awareness of FIA and Shorefast. Like a scaled-down version of the Bilbao effect, the studios and inn have brought attention to the island, and they persist as landmarks and destinations for visitors.

In the intervening years, FIA has purposefully curtailed the use of architectural images to communicate its programs. This stems from a desire to cultivate an awareness of the organization that moves beyond its exceptional architecture. It also aims to convey a fuller

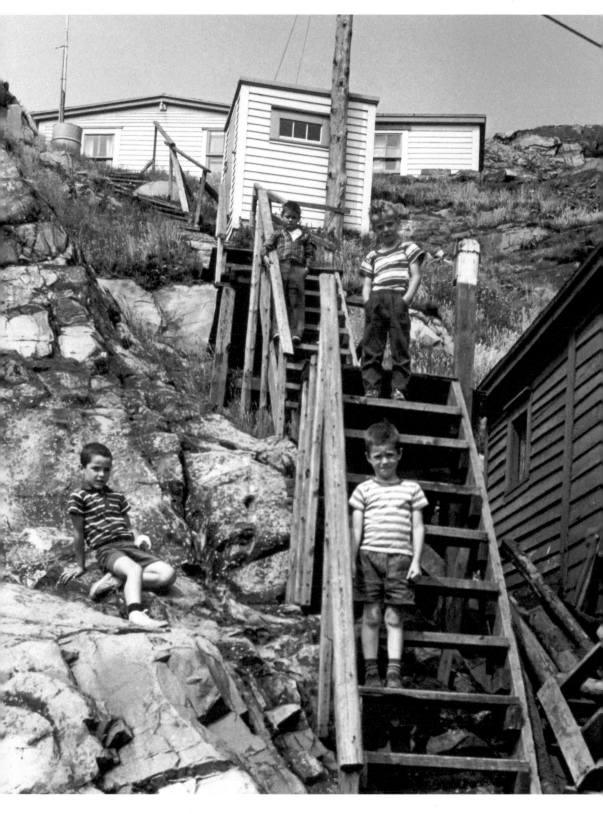

sense of FIA as a comprehensive and salient program of exhibitions, publications, and public programs in addition to its foundation as an artist residency.

ART BY DESIGN

Fogo Island Arts Corporation, as it was initially known, was established in 2008 as a semi-autonomous entity of Shorefast. In this case, Cobb visited numerous artist residencies across the globe and sought advice on how to structure and program the Arts Corporation. Through her travels, Cobb met Elisabet Gunnarsdottir, who had previously led the Nordic Artists' Centre in Norway. As an Icelander who had lived in Scandinavia, Gunnarsdottir already possessed a capacity for insight into the related geography and culture of Fogo Island. She became the organization's first director and moved to Fogo Island in 2009 to oversee year-round operations and the program. Through Gunnarsdottir, Cobb would meet established figures from the field of contemporary art, such as curators Kitty Scott and Nicolaus Schafhausen. Both would later become board members and, in Schafhausen's case, strategic director to Fogo Island Arts.

In his role as strategic director of FIA, Schafhausen acts as a navigator, identifying both the needs of artists and what FIA should offer them. This requires an in-depth knowledge of individual artists and the shifting landscape of contemporary art, as well as the stakes and situation of life on Fogo Island. Accordingly, the strategic director is also involved with, and advises Shorefast and its tentacular initiatives.

At the outset, the Arts Corporation's principal focus was the residency program, which was split into residential and production or commissioning components. The first artists arrived in 2009 for site visits: stays of three weeks that would provide a sense of where they were coming to and what they might embark on during a longer residency. The residencies began in 2010. Seven artists hailing from Canada, Germany, India, Norway, Scotland, and the US came to the island for several months each.

Gunnarsdottir left the organization in 2011. Following her departure, the structure of the Arts Corporation evolved. Schafhausen, who was director of Witte de With Center for Contemporary Art in Rotterdam at the time, took the lead in shaping artistic decisions, and Jack Stanley, who had previously joined the organization in 2009, worked to oversee on-the-ground operations and contributed to the artistic program. Toronto-based writer Rosemary Heather joined as director of communications in 2012, managing FIA's publication series and overall communications strategies. Under Schafhausen's direction, the parallel streams of residencies and production were folded into one, and "Corporation" was dropped from the title of the organization, becoming Fogo Island Arts.

The year 2012 signaled the start of a new phase in Fogo Island Arts' evolution. With the design and construction of the Fogo Island Inn well underway, FIA began planning for a gallery space that would be part of the new building. The gallery was intended to provide opportunities for solo exhibitions as well as major commissions from alumni of the program. The inaugural exhibition at the Fogo Island Gallery was New Zealand artist Kate Newby's "Let the other thing in," in 2013. The publication series, produced in collaboration with Sternberg Press, was launched in tandem, offering contextual and critical interpretation of an artist's work in a format that was exportable internationally.

The Fogo Island Dialogues were also initiated as a major interdisciplinary conference series to discuss issues related to the livelihood and renewal of rural locations. Held in partnership with international institutions, the first editions took place in Berlin (2012) on Fogo Island and in Vienna (2013), and brought together key artists and arts professionals, academics, economists, geographers, planners, and architects. Subsequent editions have been held in Toronto, Vancouver, St. John's, and Chicago. The Dialogues continue to bring together leading artists, thinkers, professionals and researchers from a variety of disciplines to address issues of crucial contemporary importance, such as sovereignty and decolonial practices, situating the meaning of "contemporary" in current artistic practice, and examining the intersections of art and money in rebuilding communities. Each edition of the Dialogues continues to focus on how art can influence social change, exploring the role that art and artists can play in such initiatives.

By mid-2014, Shorefast's financial situation had become somewhat precarious due to the Herculean efforts and resources required to build and operate the Fogo Island Inn. All Shorefast programs were tasked with finding additional sources of support and ways to become sustainable on a long-term basis. Stanley had also announced his intention to leave FIA. The organization thus found itself in a position of self-reflection, with a desire to refocus its mission and activities. I joined FIA in March 2015 as director of programs and exhibitions, a new position involving overseeing operations on the island as well as shaping residencies, exhibitions, publications and programs in close collaboration with Schafhausen. A significant part of my role at the outset was to participate in redefining the organization's structure and program in response to its history and current financial situation.

With a substantial budget cut in 2015, FIA scaled back residencies and programs and embarked on a sustained effort to solicit external private funding through individual patronage, and, while remaining independent, to develop corporate and institutional partnerships. The FIA Patrons Program was launched in 2016. Much of its initial

success was due to the efforts and support of advisory board member and Belgian-born, Toronto-based collector Elisa Nuyten, who was instrumental in creating awareness of FIA among influential circles.

As part of this process, FIA formally joined Shorefast as a charitable program, rather than an arm's length not-for-profit entity. This was in part motivated by the requirement to offer charitable receipts to donors. Of equal importance was the desire to consolidate the respective elements of Shorefast to encourage greater alignments and mutual support.

In FIA's current program model, approximately fifteen to eighteen artists from around the world come to live and work on the island for several months at a time. FIA's other programs have expanded, with the introduction of an annual "Artist Talk Series" in 2015, the "Emerging Artist Exhibition" program (Leander Schoenweger in 2015–16 and Augustas Serapinas in 2016–17), as well as off-site exhibitions ("Belonging to a Place," at Scrap Metal, Toronto, 2017, and the Art Gallery of the Canadian Embassy in Washington, D.C. in 2018).

FIA Film (2016–17) was conceived by FIA alumnus Goran Petrović Lotina during his residency as a series of socially and politically engaged films that drew inspiration from Fogo Island's significant relationship to film. After two modest yet well-received programs, a new, more ambitious film series was launched in 2018 entitled Fogo Island Film: Resistance and Resilience. Curated by myself and Petrović Lotina, Fogo Island Film is devoted to international films that consider the diversity of relationships between nature and society.

The Fogo Island Dialogues, in some ways FIA's flagship international export, continues to expand. The 2018 edition in Chicago was the first of three North American Dialogues supported by Chicago-based philanthropists Vicki and Bruce Heyman that aim to highlight progressive ideas, social enterprise, and cultural and community building initiatives.[16] Preparations are underway for a conference edition of the Dialogues in Portugal in 2019.

As of 2018, FIA has welcomed over 100 artists to Fogo Island for residencies, programmed eleven solo exhibitions at the Fogo Island Gallery, two off-site group exhibitions, seven volumes in the publication series, six Fogo Island Dialogues, and countless artist talks, film screenings, workshops, and related events on- and off-island.

POLITICS AND THE CONTEMPORARY ARTIST

FIA residency candidates are selected largely through invitation, a process involving the participation of the strategic director, the director of programs and exhibitions, and input and support from FIA's advisory board.[17] A smaller number of artists are offered residencies through partnerships with foundations and corporations, and through a biennial open call.

16 Bruce Heyman served as the United States Ambassador to Canada under President Barack Obama from 2014 to 2017. During this time Vicki Heyman acted as an American cultural envoy, leading cross-border programs related to the arts, social innovation, and youth engagement.

17 FIA advisory board members are: Zita Cobb, Eleanor Dawson, Paul Dean, Fabrizio Gallanti, Elisa Nuyten, Silke Otto-Knapp, Willem de Rooij, Nicolaus Schafhausen, Kitty Scott, and Monika Szewczyk.

While FIA residencies are open to artists practicing in all disciplines and have few established parameters, partnership residencies in some cases have specific criteria. The FIA-Hnatyshyn Foundation Young Curator Residency program, for example, is intended for Canadian curators between the ages of twenty-five and thirty. FIA's partnership with the Kulturkreis der deutschen Wirtschaft im BDI e. V. (Association of Arts and Culture of the German Economy at the Federation of German Industries) entails the awarding of three residencies to the winners of the prestigious *ars viva* Prize for Visual Arts.

In late 2016, FIA initiated The Islands, a partnership with Art Metropole, Toronto, to encourage arts writing and criticism in contemporary art. The two-part residency offers arts writers and artists with a writing practice one month on Fogo Island, and two weeks on Toronto Island, followed by the development of a small publication produced by Art Metropole. The Islands was a new form of partnership that made use of both organizations' expertise and specific modes of operating, in order to create something greater than the sum of its parts.

FIA launched its first open calls in 2011 and 2012. The 2013–14 call, specific to artistic projects with an educational component, received 120 applications. The subsequent open call in 2015 received almost 1,000 applications—an unequivocal indicator of FIA's growing presence within the international contemporary art scene. The 2017 call received 900 applications from fifty-eight countries despite added constraints of designated time periods, and a modest application fee to cover administrative costs. Six candidates were selected for residencies in 2018 and 2019.

Notwithstanding the extremely low acceptance rate, and the challenges of assessing a high volume of applications, the open call has been deemed essential by FIA staff and board members as a way to reach beyond established networks, and offer opportunities to artists whom we might otherwise have never encountered.

The decision to invite the majority of residency artists, however, continues to be fundamental to FIA's model. This stems in part from a recognition that the conditions and location of the residency are not suited to all artists. The complexity involved in traveling to the island, the remoteness and homogeneity of its community, the slow internet speeds and limited amenities can be trying for some artists accustomed to the pace and variety of urban life. Of greater importance, the work of each artist is taken into consideration in terms of its potential alignment with FIA and Shorefast's overall mission, and the variety of experiences the residency has to offer.

Above all, we look for artists who are engaged in the contemporary world intellectually, aesthetically, and politically. This does not necessarily imply overt declarations or political statements, or the suggestion that artists must aim to "solve" the world's problems. Nor does it bely

opportunities for poetic or humorous work. Ultimately, our selection process is driven by the conviction that the most meaningful and relevant art of today engages in some way with the world around us.

PRODUCTIVE WITHDRAWAL

The value in taking part in an artist residency generally lies in the capacity to distance oneself from the day-to-day, to carve out space and time dedicated to reflection, thinking, and making, or thinking through making. In their ideal form, residencies can offer a productive, positive form of retreat or withdrawal, a rejection of cycles and markers of progress that allows for experimentation and exploration.

There are, of course, countless artist residencies around the world, many of which are in beautiful, unique places. What, then, makes FIA significant?

FIA residencies are not necessarily production-driven given the remote location, availability of materials and expense of shipping, but they are certainly oriented toward intellectual production and meaningful engagement with place.[18] The programs offered by FIA also stand in opposition to the notion of "residency-hopping" that has become commonplace within contemporary artistic practice. Artists must have a resolute conviction to come to Fogo Island, as well as a desire to immerse themselves in the experience. It is not a question of "collecting" the exotic location and the perfect view, but of coming to terms with living in proximity to the sea and at the whim of the elements, and in engaging with a close-knit fishing community that is nonetheless shaped by centuries of exchange.

As each artist completes the parentheses of a FIA residency and returns to their daily existence, our hope is that a small part of Fogo Island and its story is woven into other parts of the world.

This desire for artists to engage with Fogo Island's communities and convey something of our mission, however, must be tempered by an awareness of the risks of instrumentalization on all sides. Artists are not in the service of FIA, and nor are community members fodder for artistic production. We do not expect or direct artists to take on projects that directly involve community, but those that do so in meaningful, equitable ways are welcomed. Ultimately, we have no interest in artists whose approach may patronize or take advantage of locals, or romanticize aspects of Fogo Island culture. Rather, we seek to facilitate meaningful engagement that is based on reciprocal exchange.

To do so, FIA encourages organic connections between artists and community members through orientation and community host programs, whereby artists spend time with locals to learn about specific aspects, techniques, or activities proper to the island, such as hand-lining cod, quilting and rug hooking, geology, as well as native plants and fauna. A strong network of Fogo Islanders who are supportive of FIA

18
Nonetheless, many FIA artists make objects of all scales and media, and FIA has commissioned major productions through its exhibition program.

programs, as well as the simple generosity and openness of neighbors has also been hugely significant in ensuring visiting artists feel welcomed and supported during their time in residence.

The local reaction to the presence of visiting artists on Fogo Island has changed over the course of almost a decade. After a few years of bemused responses, lack of attention or actual engagement with artists, there is a broader awareness, acceptance, and interest from locals in their presence. A wonderful indicator of this is that the profession of "artist" has been cited as a career option by local students, a distinct change from Cobb's childhood when career day suggestions were limited to stereotyped gender roles such as a "nurse" for girls, and a "police officer" for boys.

For the artists themselves, FIA residencies have helped to propel numerous careers and expand international networks. Many have spoken about the transformative effects of a FIA residency, and the uniqueness of the program as a whole. New Zealand artist Zac Langdon-Pole noted during his 2018 residency that he felt no need to "perform" being an artist-in-residence. Contrary to previous experience at other well-established, "luxurious" residencies, he did not have the sense of being placed on a pedestal and beholden to certain expectations. Instead, he felt a sense of hospitality and interest from local residents towards him firstly as a human, and afterwards as an artist.

After several years of cultivating a sense of mystery, inadvertently or not, around access to FIA programs within Newfoundland and the rest of Canada, the organization has embarked on a series of initiatives that foster connections within the region and across the country. These include presenting events off-island and forging program collaborations with other provincial and national artistic organizations.

International awareness of FIA initiatives remains strong, particularly within Western Europe, but there is the continued aspiration for global outreach and connectedness through events and program partnerships. There is also a desire to broaden existing networks and reach beyond established centers of artistic and intellectual exchange. For example, we aim to work with more artists and ideas stemming from the Global South, as well as other areas subjugated by capitalist globalization. In this, there is admittedly much to be done.

What FIA aims for over the long-term is to establish a community of artists and thinkers who respond in some way to our complex and ever-changing world. Politically, economically, ecologically, aesthetically… This is perhaps what distinguishes FIA from other residencies around the world.

DEFINING THE QUESTIONS

FIA and Shorefast have a common goal to position Fogo Island as a site for ideas, and for our place-driven initiatives to serve as templates for action to ensure sustainable, thriving communities. We wish to

find a common ground and language among artists, academics, professionals, and business people, as well as those without academic or professional affiliations, to address issues of vital contemporary importance that affect each of us. Through the establishment of a "discursive landscape," Shorefast and FIA aim to shape a momentum of resistance to forces that cast citizens as taxpayers and individuals as consumers, and that flatten cultural specificity in the name of global conformity.

How Fogo Island Arts should continue to contribute to this conversation and framework in meaningful ways, and how it should consider its future are ongoing, fundamental questions. Even our definition of "international" bears examination. The majority of FIA alumni to date have come from North America and Europe, as well as the Pacific region and the Middle East. So far, we have welcomed only a small number of artists from Asia, and none yet from Africa, but we hope to expand these networks. Our goal of working with individuals and organizations from the Global South, as previously stated, is a real one. The question of whether our programs hold relevance for all artists, however, and whether we can negotiate divides of language and cultural norms to create opportunities that are beneficial for all parties remains to be seen.

Equally important, should FIA expand? What does expansion mean and what are the measures of success?

During his 2018 residency, artist Thomas Bayrle spoke of his long-standing engagement with Portikus, the gallery of the prestigious art academy Städelschule in Frankfurt am Main, and its history as an institution. Over more than thirty years and three different locations, Portikus has remained modest in size, with a gallery space suited for one or two artists, and a small number of dedicated staff. In this Bayrle noted a steadfast refusal to conform to capitalist notions of progress and the idea of growth as expansion. Such goals were prevalent in arts organizations during the late twentieth and early twenty-first century, when many museums in cities transformed into large-scale institutions bound up with tourism, a desire to increase attendance figures, and speak to the broadest audience possible. The alternative, pursued by Portikus and, I would argue, shared by FIA, is the sense of growth as maturity, a deeper, more sophisticated engagement with people and place.

In an era of increasing nationalism and political isolation, one could argue that many countries are mimicking the physical attributes of islands, cut off from their surroundings. And yet, the status of being an island, whether physical or metaphorical, can be beneficial if one chooses to celebrate specificity while remaining open to external influence. An expansion of FIA may mean sustaining and taking care of our initiatives on the island while creating engaging programs elsewhere as part of a focused global outreach, founded on a conscious awareness of what we understand to be "global." Much like Fogo

Island's vernacular architecture that is shaped by use and altered over time, Fogo Island Arts should be nimble and adaptive, responsive to site and open to the world.

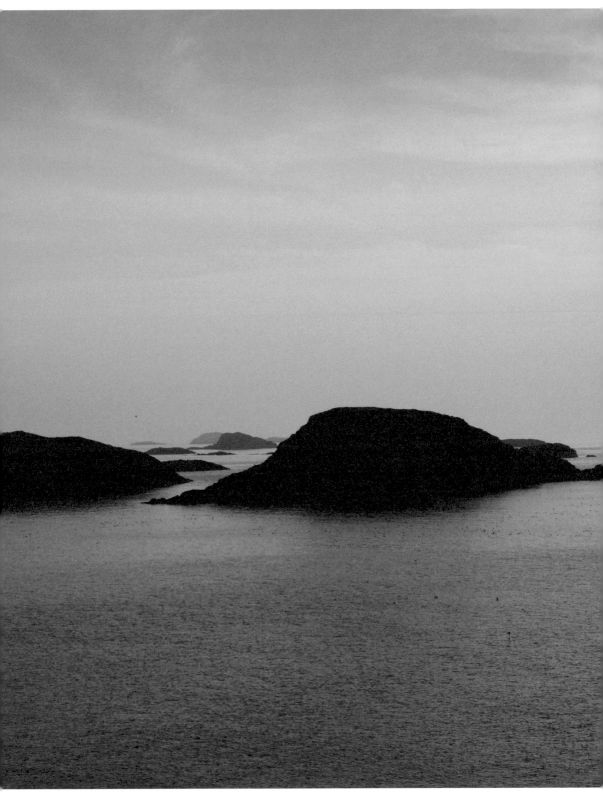

Silke Otto-Knapp & Janice Kerbel:
ON THE RELATION BETWEEN NOSTALGIA & PROPERTY

Silke Otto-Knapp (based between Los Angeles and Fogo Island) is an artist whose practice deals with the construct of the stage. She is professor of painting and drawing at the University of California, Los Angeles (UCLA). She serves on the advisory board of Fogo Island Arts.

Janice Kerbel (based between London and Fogo Island) is an artist who works with a range of material—including print, type, audio recording, and more recently, light. She was a Sobey Art Award finalist in 2006, and nominated for the Turner Prize in 2015. She is currently reader in fine art at Goldsmiths College, London. She serves on the advisory board of Fogo Island Arts.

Silke Over the last eight years that I've been visiting Fogo Island, and following the developments of Shorefast and FIA, I know that I can only gauge a particular view of change. Mostly it seems to me that life goes on as always—people make a living in the fishery, or as teachers, nurses, civil servants, construction workers, running the ferry, and their lives are relatively unaffected by the influx of visitors.

Janice I first came to the island seven years ago, in 2011, when Shorefast began to have a visible presence, though work had begun long before that. While frequent visits afford a certain amount of perspective, I also recognize it can lead to a skewed impression. It's tricky to describe how the face of the island and its communities have changed since then. Perhaps I see changes in less subtle, more striking ways.

Silke Something I've noticed that I can confidently say affects everyone is the summer ferry line-up—there is more and more traffic each year. Another aspect is that the products on offer at the local supermarket have switched to many more locally produced foodstuffs, and a much greater variety of goods are available. A lot of people are now growing their own vegetables in the short season once the ground defrosts. This year also saw a new coffee shop and a restaurant open—both run by people who have recently moved to Fogo Island. The bakery at the center of the island seems to have closed down for good though after changing owners a few times. It was locally owned and will be very missed.

Janice Better food at Foodland! I say this in jest, but changes to the available food and attitudes to local produce does mark a shift. It's hard to know where and how this process began though. Change is difficult—if not impossible—to map. What I may detect as significant, may not appear to be so to a full-time resident.

Silke I agree but it's certainly obvious to both residents and returning visitors that in the last few years a lot more houses have had "for sale" signs in the window; this past summer people talked about the rise of property prices to the extent where it would be hard for local people to buy. Some communities—Joe Batt's Arm and Tilting in particular—have had a significant number of new houses constructed, often three or four stories high. This is a big change from the traditional, modestly-sized saltbox houses that define the local architecture.

Janice Of course, are these immediate differences such as new and larger houses being built, as well as old houses continuing to fall

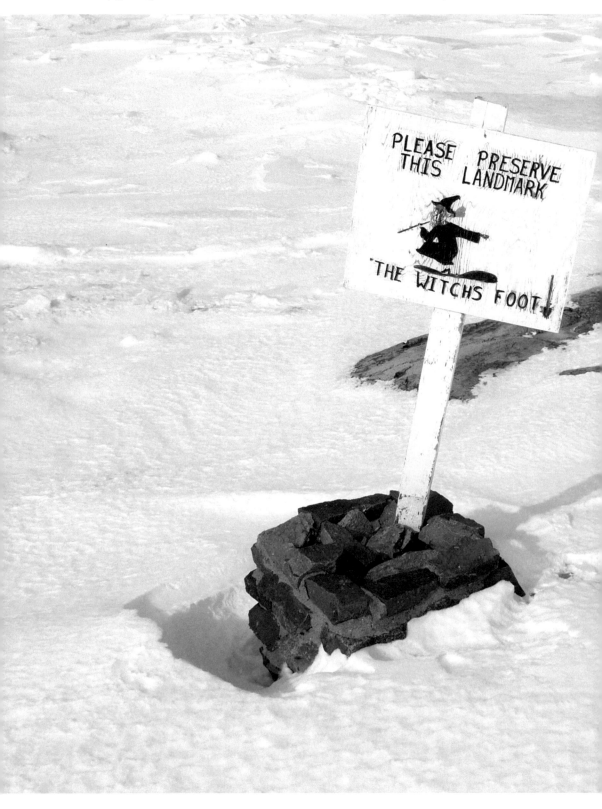

to the ground. There is also a new café, for instance, and tourists arriving from further afield. When I've been away for a long period of time, I sometimes notice that there are more people around. But what really has changed is my understanding of Fogo. The more time I spend there, my awareness of these transformations becomes more nuanced. Perhaps real change is something that can only be understood in retrospect, particularly by the people who have lived through these developments. When I first started going to the island only one studio was built, and the ground had just been broken for the Fogo Island Inn. Change in that respect was already underway. But one kind of change can't be seen in isolation from another. 1992 marked the moratorium on cod and the collapse of the Atlantic northwest cod fishery, which was the livelihood of Fogo Island. I wasn't visiting the island during those developments, but the effects of the collapse of the cod fishery are still felt today.

Silke As much as I said that life goes on as usual, the activities of Shorefast seem to bring an alternative perspective to Fogo Island, as if a different door had been opened. It's a back and forth between Shorefast's specific vision—and the social and political reality on the island. A sense of place is very strong on Fogo Island. The past is present in stories and songs—this is without sentimentality, it is a part of everyday life. I am on the board of Fogo Island Arts and have met a lot of the artists in residence. Many of them have researched the history of the island and the Shorefast project before they arrive and often think they know what to expect. Every artist engages with the opportunities the residencies have to offer in divergent approaches—some are rather solitary while others make the most of all that the island has to offer and meet a lot of people in the process. I think mostly all of them are surprised by the experience and find that they respond to it in a ways they could not have predicted. It seems to me that the residency program and Shorefast projects are continuously evolving but the exchange between the visitors, the people and the place is always at the heart of the project.

Janice I think the people of Fogo Island are used to adapting—to the weather, to ferry schedules, to a form of ruthless governance. Shorefast and FIA are mostly run by people from the island, rather than from off island, which to some extent enables a vision in line with need. However, in saying this, better health care is still required. Improvements to transportation on and off the island are in demand. There is no daycare possibilities. The school and library could do with help. A pool is needed

so that kids can learn to swim. I sometimes wonder how transparent Shorefast and FIA's agenda is in the face of these very basic requirements for change.

Silke One of Shorefast's goals is to establish sustainable tourism, in the sense of economic as well as ecological sustainability. It's often raised that this aspiration is regarded by some as a contradiction due to the number of airline miles required in order to get to Fogo Island—be it the international roster of artists participating in the residency program, or the affluent guests of the inn. I believe initiatives to sustain and improve the everyday life of people from Fogo Island—by the people of Fogo Island—is a necessity beyond the reaches of tourism. It is still only a relatively small number of people that undertake the journey to Fogo Island which takes almost always more than a day and involves things like staying the night *en route*; waiting for a ferry; perhaps not getting aboard because of traffic or delays due to bad weather—not common in today's fast-paced travel economy. Once on the island, the length of the journey influences the experience of the visitor. There isn't pre-packaged, consumable tourist experiences available. The outside perspectives of the visitors can be valuable and shine a light on the knowledge specific to a place that might be forgotten or lost. In recent years, younger families are moving back to Fogo Island, or in fact not leaving in the first place and instead choosing to remain—a reversal from the situation a few years ago.

Janice Yes! But returning to this perceived contradiction, this seems to be a reality that must be balanced against other challenges. Even getting basic necessities such as medication, milk, bread or other produce to the island is not ecologically sound, although it would be inappropriate to argue that this is a reason not to support the survival of the island—as the government incentive for resettlement failed to do in the '60s. Efforts have been made by Shorefast / FIA to encourage small-scale businesses and initiatives to grow. Islanders have long had practices of self sustenance—fishing, salting, hunting—many of which have changed over the years. More recently other practices are being adopted or reclaimed—I think the return to vegetable gardening, that you mentioned earlier Silke, is probably a development that I've noticed the most. However there still somehow seems to be a long way to go. Rekindling lost connections to past practices are happening but it is difficult as times have changed too. I don't think we can underestimate the effect that the loss of cod supplies has had on the community.

Silke	It's important to strengthen the local economy so that it is not wholly dependent on tourism. However I also think that hotels, bed and breakfasts, shops, and restaurants catering to tourists is just one aspect of the manifold transformations.
Janice	I'm unsure about the necessity at this stage to regulate or limit the tourism—the island's remote location, challenging travel options, and the often inhospitable weather conditions appear to do a healthy job of that. It would be peculiar to imagine controlling or managing it in other ways, especially as the island's regeneration, in many respects, is founded on the notion of hospitality. I learnt this year about the possibility for a new flight to be introduced from Gander direct to Fogo. I was suspicious. But then, if it improves life for Fogo Islanders—is sustainable, accessible, and affordable—it is likely a positive development, even if it is at odds with my idealized vision of a remote island. I suppose my experience of Fogo is in fact tied up with contradictions between the fantasy and reality of the place. Life on Fogo is tough in ways that I am not used to. This makes for a simpler way of being, of course, but it can also pose a limit on basic needs. So while better connections may bring more tourism, it will also provide better access to other demands to the people of Fogo. So long as tourism feeds back into the island, I can see it as a healthy development. What needs to be regulated—and feverishly—in my opinion, is a culture of visitors that do not feed back into the island's economy, take from the island's resources, or leave rubbish behind. This would be a problem.
Silke	Right now there is a lot of talk in the art world about the political and moral instrumentalization of art. Art is increasingly confronted with the expectation of being positioned politically, even to have concrete political effects.
Janice	This would not only have problematic consequences for the aesthetic quality of art but also for our concept of the political… and I know, placing FIA within the context of this debate, that there's this same issue of instrumentalization raised about artists involved in the program.
Silke	I truly think that one of the main strengths of FIA is that it does not instrumentalize the artists to further a specific agenda. I would also say that it's the artists who are affected by the island, who learn from the people about their way of life simply by living in the community, meeting neighbors, and managing the day-to-day features of their stay.
Janice	It seems more likely that an artist's vision—or impression, idea, or general outlook—may shift, however slightly, as a result

of time spent on Fogo, as opposed to their own being instrumentalized for specific aims. This is in part a credit to the way FIA grants time and freedom to the artists in residence. No claims are made on either the artist or their work. In that respect, I think that the residencies function with the same kind of openness as the islanders. It is a way of life that is shared. What the artists give back to the community is perhaps a more complicated question. My introduction to the island was through the artist residency program: I found the natural environment, the pace of daily life, the studios of FIA, and the self-sufficiency afforded to residents totally conducive to working. But now I come here specifically NOT to work! In time, this will probably change again for me, but for now it's the elemental simplicity (perhaps it's romantic) that I keep returning to the island for.

Silke The relationship between the locals and the artists on the island is very positive too. In my own experience, the most important encounters were actually those that could not be planned or organized by the residency program: for instance someone inviting me to go fishing, or talking about the changes in the fishery and the effect this has had on the island. Or the opportunity to go bake-apple picking on Little Fogo Island, and learning about the history of outport communities along the way. The people I've met on Fogo Island have invited me into their homes, and shared their traditions very proudly, while also being curious about mine. I have cooked Swiss chard for them (but they remain unconvinced!) and I have never eaten a piece of cod as fresh and well-prepared as in a Fogo Island kitchen. Nor tasted better partridge berry jam, freshly picked bakeapples, or blueberries. Different economic backgrounds don't seem to matter in these situations. They do matter however in how restaurants and cafés price their dishes, if they cater to tourists or to local customers. It matters in property prices too—which are indeed rising in response to an outside economy and visitors wanting to buy second homes.

Janice As it is a small island, the range of cultural and economic backgrounds of the islanders is narrow, which is highlighted when considered in relation to the diversity of places that the artists in residence come from. Diversity is such an urgent question at the moment. When I come to Fogo, I immediately feel like an outsider, despite repeated visits over the past seven years. But as an outsider I am almost always treated with uncanny generosity. This has taken the form of cabbages, potatoes, fish, moose,

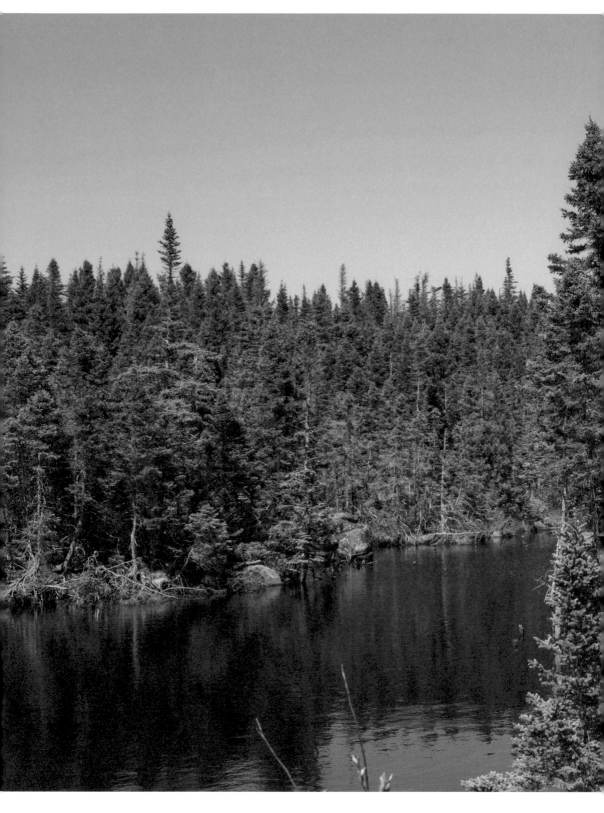

caribou, plumbing, tools—the list goes on—and often by people I have hardly met. This kind of sincerity effects interactions, and alters my preconceptions of difference. It's an experience I keep learning from.

Silke We both recently bought property on the island…

Janice It seemed a fantasy when we began discussing a house. There were many historic, empty houses on the island that in time would fall to the sea.

Silke It's actually four years ago now that we decided to buy a house together. Sharing a house made sense for both private and economic reasons. The residency houses are all restored traditional homes and we wanted to do something similar—save an old house that was in need of restoration. We were lucky to find a house that fit this description and worked with a local architect and builder on the project.

Janice Yes it was an old, collapsing house and we sought to restore it. We had no experience and limited knowledge about what this meant at the time. It's a curious thing to restore a house in a place that you're not from, when the local trend of the island is otherwise. Perhaps it was also partly romantic.

Silke Restoration is time consuming and expensive—this was where different economic backgrounds first became a factor— for a local buyer it would be much more practical to build a new house than to invest money in an old building. However, even though the community we live in has responded very positively to the old house having a new life, it is obvious that we are a part of a changing relationship to property on the island.

Janice Yes, we are very aware of the glaring spike in housing prices this year.

Silke When we started looking for the right house, people didn't think of houses so much as a financial asset, but as something to keep in the family for generations. This seems to be changing, as Janice mentioned, due to the increased interest from outside buyers and the high prices they are willing to pay for property on Fogo Island.

Janice I wonder and worry how our, and other people's choices, to restore an old property on the island may have contributed to this trend. Whether this marks the beginning of a new phase in the development of Fogo, if it leads to an undesirable process of gentrification and segregation.

Silke I hope not. At the moment most of the newly built and renovated homes are owned by people that live and work on

the island. I do hope that this continues to be the case—in order for people to build their lives on the island long-term, the local economy has to be in contact with the outside. How to find a balance and stop communities from being deserted in the winter is the pressing question. I recently visited Farö Island in Sweden, a small island with 500 permanent residents. In 1960 they were able to live independently through fishing and farming, they had a few stores, a school, a nurse, and a post office. A trip off the island was only necessary on special occasions. Today the strongest leg of the economy by far is tourism, mostly sustained by visitors building second homes for the summer. The school and post office closed, there is one store, and the bakery and restaurants almost all close in September. Fogo Island seems a long way away from a scenario like that, and perhaps its remoteness is protecting it to some degree, but it is hard to be sure.

Janice I can't imagine it leading to this, but then of course one never knows. I came to the island first as an invited artist, then as a visitor, and now I'm a part-time resident. There are a few other people who have done the same. Beautiful and welcoming as Fogo is, it is also a harsh place. It is hard to get to. It's hard to get off. Distances are vast and summer is the only time with significant tourism. As new things open—such as another café or a new restaurant—I agree that it seems vital that they cater to everyone, both tourists and locals. This is not necessarily viable.

Leon Kahane:
WE SHOULD LEARN HOW TO READ THE WORLD

Leon Kahane (based between Berlin and
Tel Aviv) is an artist whose video works,
photographs, and installations address topics
such as migration, identity, and debates around
majorities and minorities in a globalized
society. His own experiences, and biographical
references, play an important role in his
artistic practice. He studied photography at
the Ostkreuzschule für Fotografie, Berlin, and
fine arts at Universität der Künste, Berlin.

I remember the moment when I was heading towards Fogo Island on the ferry. It felt like signing on to the crew of a ship. It has some similarities, since you won't reach mainland, but a uniquely remote place. It has all of the perfect ingredients for a romantic fantasy to escape our turbulent modern world with all of its challenges.

In a way, that's not just a romantic idea, but also another reality that made me think about Fogo Island as a microcosm, which helps you understand the macrocosm a bit better.

The romanticized idea of an island with a self-sufficient, sovereign, and independent self-society is an image—one that I have come across quite often recently. Especially by the rise of right-wing movements in the countries of the Global North that have successively re-established this destructive phantasm. Closed borders, the intensification of migrant policies, and economic protectionism are popular again. What would those, who believe in such a segregated world, give to be as remote as Fogo Island, one might ask.

What I realized immediately after a few days on Fogo Island, was the very visible dependency on a functioning infrastructure. If the communities are detached due to snowy and icy roads, one might have trouble to gain access to primary care. When the pack ice floats along the shores of the island, the people of Fogo Island are literally living at the mercy of the waves.

One day, I interviewed a Royal Canadian Mounted Police Officer, who told me how he and his colleague were trapped in one of the communities, because the road—there is only one—was snowed in when they were on patrol. The people of the community took good care of them but still they were cut off from the other communities, and thereby from possible distress calls.

I guess the awareness of problems is in most cases bound to their visibility, or their direct impact on a society.

We are all affected by the same issues, we just don't see them all at the same the time.

The supply of food and medicine, or the internet, is something that we take for granted in the societies of our globalized world, so much so that we tend to forget how much effort it takes to maintain a community. In this respect, a word like gentrification has a totally different meaning at a place like Fogo Island.

I didn't really produce a new piece of art on Fogo Island, but through Fogo, I learned a lot about my own approach towards the city that I live in.

So, in a paradoxical way, Fogo Island might be a perfect antidote for the isolationists and protectionists that dominate our everyday newsfeeds nowadays, because it does not fulfil their romantic isolationism at all.

A certain saturation might let one forget how hard the advantages of modernity have been fought for. That doesn't mean that we should let the world collapse to get a feeling for ourselves again. Quite the opposite. We should learn how to read the world through places like Fogo Island, FIA and Shorefast's innovative projects, and, most importantly, the people behind them.

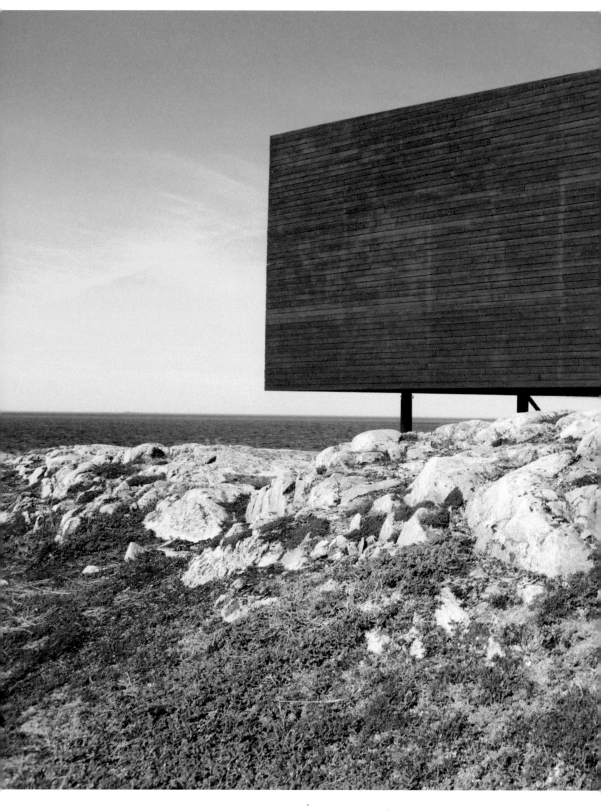

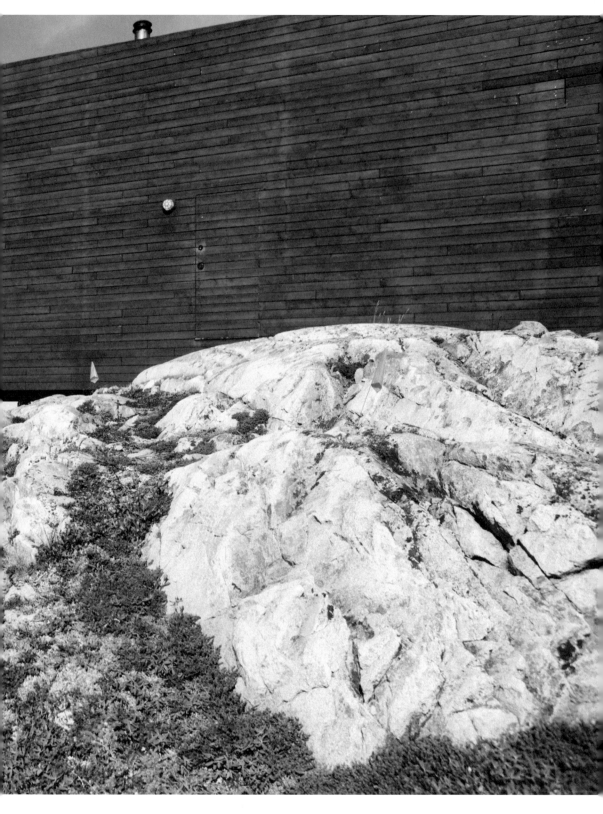

Chantal Pontbriand:
TELEGRAPHIC EXPERIMENTS

Chantal Pontbriand (based in Montreal) is a
writer, critic, and curator. She was the director
and founder of the contemporary art magazine
PARACHUTE (1975–2007). She chaired and
ran the Festival FIND in Montreal (1982–2003),
and founded the company PONTBRIAND
W.O.R.K.S. She has served on the board
of several art committees including the IKT
(International Association of Curators of
Contemporary Art), and was the CEO of the
Museum of Contemporary Canadian Art
(MOCA) in Toronto.

That tells the waters or to rise, or fall;
Or helps th' ambitious hill the heav'ns to scale,
Or scoops in circling theatres the vale;
Calls in the country, catches opening glades,
Joins willing woods, and varies shades from shades,
Now breaks, or now directs, th' intending lines;
Paints as you plant, and, as you work, designs.
– Alexander Pope, *Epistles to Several Persons: Epistle IV*
To Richard Boyle, Earl of Burlington

Fogo means "fire" in Portuguese. The word that designates a remote island off the shores of Eastern Canada immediately recalls the history of the place. Fogo Island has been visited and settled over millenniums and centuries by diverse peoples of the earth. The Beothuk, a gathering and hunting people formed around AD 1500 in the territories of current day Labrador and Newfoundland, were still on the island when Europeans ventured there. These were attracted by the cod fishing-banks off the shores of the island, situated in Notre Dame Bay. The Portuguese, Spanish, French, English, Scottish, and Irish, were drawn to the site, and became regular visitors starting from the sixteenth century until the British colonization at the end of the eighteenth century, bringing many Irishmen who settled there, leaving strong traces until today.

Why designate a place by the word fire? Fire is a strong thread in the human imaginary evoking light and heat. It generates attraction, and points to survival. It also is a sign of life. As new visitors were approaching the coast of the island, it is probable that they could have seen bonfires lit by the Beothuk. Since the island, as we know it today, has been the locus of several waves of arrivals and departures, it has entertained the light.

This is its *genius loci*. This island has a sense of seemingly endless time. Its geology is striking as it visibly carries the imprint of the earth's history. Impressive geological formations highlight the barren landscape, bringing one's mind to distant prehistoric times. Fogo Island is old, worn down by millenniums of winds crossing the land and smoothing rock formations, even though the younger ones show resistance and still surge out of the ground as though some violent natural phenomenon had just occurred. Trees are scarce, a few clusters of spruce, not very high, dot the environment. The magic of the vegetation lies in the array of ground flora, and the different colors and textures that contrast with the rocks.

Fogo Island, although it has gone through a major economic crisis following the imposition of quotas on cod fishing, is still kindling the light to this day. Facing the extinction of the species following

overexploitation brought about by new fishing technologies, and increased economic development characteristic of the twentieth century, the crisis started with a moratorium in 1992, virtually shutting down the industry in Newfoundland-Labrador. Since then, quotas have been imposed as fishing resumed. However, reports of diminishing stocks are again threatening the industry, which remains the major mode of livelihood on Fogo Island.

Entertaining the light has meant re-enchanting the island. Hence the story of Zita Cobb, a native islander, who chose to come back to Fogo after studying and working as a successful entrepreneur elsewhere in Canada. Through Shorefast, a three-part plan has been put into action: a sustainable fishing business, a hotel, a furniture manufacturing business. Alongside these economically creative enterprises, there is a foundation dedicated to supporting development in the arts through residencies, bringing together the local and the international.

Entertaining the light seems the only way to go in order to counter the warnings of a Pier Paolo Pasolini (1922–1975) over the disappearance of resistance in the world, the ambient void of power and the waning of fireflies.[1] Creativity *is* resistance. This remains as long as it continues to be open-ended, rather than subservient to constricting and authoritarian, or oligarchic political or economic agendas.

In the context of a world struck by the excesses of capitalism and the remains of communism, affecting daily lives, and ecological disaster, affecting the future of the planet as well, it is necessary to reinvent situations in terms of initiating fresh new environments that enable growth, but progress with a difference. Growth that includes and fosters symbolic as well as economic development.

During the peak of industrialization at the end of the nineteenth century, cities witnessed a dramatic increase in population growth due to urbanization, a shift from agrarian culture, and massive migrations, especially to North and South America. It was in this context that the idea of the garden-city emerged, theorized and enacted by thinkers and architects such as Frederick Law Olmsted (1822–1903) and Ebenezer Howard (1850–1928). Olmsted designed Central Park in New York, and the Mount-Royal Park in Montreal, but he also designed the grounds for the Chicago World Fair, and a nearby urban planned community in Riverside. Howard wrote *To-Morrow: A Peaceful Path to Real Reform* (1898).[2] Both called upon an "organic" view of nature in order to encourage and sustain the development of humanity. This idea seems to surface strongly again in the context of today's environmental crisis. Harmony between nature and mind is again top of the agenda for many forward-looking organizations, thinkers, and a growing number of entrepreneurs and governments.

1
Pier Paolo Pasolini, "Where have all the fireflies gone?" (1975).

2
Ebenezer Howard, *To-Morrow: A Peaceful Path to Real Reform* (London: Swan Sonnenschein, 1898).

3
Fondation Carmignac website: http://www.fondation-carmignac.com. "Created in 2000 on the initiative of Edouard Carmignac, Fondation Carmignac is a corporate foundation with two main focuses: an art collection of close to

What we are witnessing today, with Fogo Island as an example, is the phenomenon of an "inverted" garden-city utopia. Instead of bringing nature into the city, nature is being reinvested with new dreams, with a new sense of purpose, and restructuring aligned with the needs of our disheveled world. Fogo Island Arts in this sense is a project akin to similar art foundations that have been established recently, such as "Carmignac" in France, and "Phenomenon" in Greece.[3] Interestingly enough, all three are fostering the new *genius loci* of different islands in the world. If the garden-city concept aimed at overcoming the alienating effects of industrialization, it seems that these island foundations are fighting the current effects of globalization and excessive economic pursuits.

Édouard Glissant (1928–2011), Caribbean in origin, has magnificently described the archipelago (a collection of islands) as the symbolic locus for advancing ideas, artistic development, and cultural growth. Islands in world history are traditionally places that appear before anything else in the course of looking for new horizons. They have also been at the crossroads of peoples and cultures throughout time, living out the different stages of the Age of Discovery, that of Colonization. Now that we are in an Age of Globalization, islands seem to remain emblematic of places where roads cross, and foster cultural crossbreeding. Ideally they provide conditions for forms of counterhomogenization, and provide microcosms where the global meets the local and vice-versa. The island provides an intimate context for this to happen, in contrast to the city. Proximity is a given, considering the geographic scale. A little more than 2,200 people live on Fogo Island in a dozen communities dotted across the island—each having their own personalities, history, and specific geology.

In Fogo, I was struck by the omnipresence of "stages." These are fishermen's sheds, positioned in the water on stilts or on the shore, immediately next to the ocean. These are the places where for ages fishermen have kept their gear and still today bring back their catch and clean the fish. I see them as little theaters of action facing the immensity of the ocean. The new studios built by Fogo Island Arts, dispersed in five locations across the island, are the contemporary version of these stages, as theaters of action. Here minds from across the world pause to think out things. As the winds blow through the island, fresh ideas flourish.

Each studio encompasses a different design, closely linked to the landscape surrounding it, as they are to traditional Fogo Island architecture, the simple wooden saltboxes inhabited by generations of fishing families. The dialogue is present in another of Shorefast's realizations, Fogo Island Inn, designed by the same architect, Todd Saunders, abiding by the same principles. Aligned with nature, the hotel is situated on a hill overlooking the ocean and is visible from afar. It is emblematic of Fogo Island's renewal. A hotel is a locus for hospitality. The inn signals a concern in renewing one's relationship

300 works, and the Photojournalism Award given out annually. In partnership with the Fondation Carmignac, the Villa Carmignac, this exhibition space open to the public, was conceived in Porquerolles to showcase the collection and to host cultural and artistic activities." Phenomenon website: www. phenomenon.fr. "Phenomenon is a biennial project for contemporary art held in the Aegean island of Anafi, Greece, that includes a residency with performances, lectures, video screenings and other events, as well as an exhibition throughout the island. It is organized by the Association Phenomenon and the Collection Kerenidis Pepe. According to Apollonius Rhodius 'Argonautica,' the island was named Anafi because Apollo made it appear to the Argonauts as a shelter in a dark night, using his bow to shed light (Ανάφη is derived from ανέφηνεν, 'appeared,' is the same root as phenomenon)." The first edition took place in July 2015.

to nature, but also to people and between people. As philosopher, Jacques Derrida (1930–2004) has written in *Of Hospitality* (2000) that hospitality and culture are linked. Fogo has kept welcoming peoples of the world thanks to a generous natural environment which must be cultivated and sustained today. As is another connection, also present in Derrida's thinking, ethics is hospitality and culture.[4] Envisioning sustainability be it economically or culturally, is essentially a question of moral philosophy. Ethics is good balance, it is an ongoing concern, never achieved, always to work towards to. In today's world, it cannot be anything else than an ongoing concern. The name of which is resistance. A place having staying-power, and through constant reinvention, entertaining its *genius loci*.

Fogo Island, more precisely a hilltop overlooking Fogo village and the ocean, was one of the locations where Guglielmo Marconi (1874–1937) established in 1911 one of his wireless stations in Newfoundland following the first telegraph experiment conducted in 1901 on Signal Hill, in the city of St. John's.[5] The idea of the telegraph was to link places and peoples in distant locations by harnessing electromagnetic waves. In the Age of Internet, Fogo Island builds on its "wirelessness," a capacity to bring together local interests, and international cultural and artistic development, providing a new economic model encompassing community and engagement in forethought.

4
These links (associating architecture and ethics) were also made by Alexander Pope in his *Moral Essays* (1731–35).

5
Newfoundland and Labrador Heritage website: https://www.heritage.nf.ca/articles/society/marconi-guglielmo.php.

Todd Saunders & Roger Bundschuh: LANDMARKS: SPECIFICITIES OF ARCHITECTURE & PLACE

Todd Saunders (based in Bergen) is an architect. He founded Saunders Architecture in 1998. He has been a part-time teacher at the Bergen Architecture School and lectured and taught at schools in Norway, the UK, and Canada. He is a visiting professor at the University of Quebec in Montreal and Cornell University, New York.

Roger Bundschuh (based in Berlin) is an architect, professor, and founder of the international architecture and design firm Bundschuh. He has taught and lectured at universities including UdK Berlin, TU Berlin, Städelschule Frankfurt am Main, University of Skopje, among others. He is currently a visiting professor at the Dessau Institute of Architecture.

Roger I would like to start with a more general question with regards to the term and phenomenon of "signature" architecture. It tends to be suspected to act as a tool for acquisition of distinction and attention in terms of city and regional marketing, rather than providing a visible space. I would pose that it would be extremely disingenuous to say that landmark architecture or so-called "signature" architecture is unrelated to marketing.

Todd The original intention of those projects was extremely practical. They weren't really meant to be signature buildings, but they were rather a victim of circumstance because whatever building you put in such a beautiful place, these wide, vast landscapes, would almost always be labeled as "signature architecture." The original intention definitely wasn't meant to be about that, but from an outsider's point of view it probably does look like we were trying to achieve signature architecture.

Roger It does look like that a little, since the show quality of the studios is remarkably strong in contrast to the landscape. That would tend to reinforce the assumption that it was a conscious choice that they had a high level of specificity, which, I think, might be just a different way of saying that they are little "landmarks."

Todd Yeah, it was an unreal situation. We could build anywhere we wanted to, and of course we wanted to highlight the best of Fogo Island's landscape. We actually found nine or ten sites originally that we thought would be great. The idea was that the buildings could be like a posture piece on the landscape, showing the best of the landscape and the best of this "new" Newfoundland architecture. So in a way it was always very choreographed, I can be honest about that. It was obvious to follow that route, because you wouldn't choose a bad site if you could choose from anything, and you wouldn't practice bad architecture if you had the option to realize anything. It's almost like the perfect storm, so for the power of signature architecture in this place, the idea to attract tourists, and put Fogo Island back on the map, as well as showing a way of making new types of Newfoundland architecture. Those three things were what I was given the task to do, and signature architecture actually solved it quite well in a way, yeah.

Roger Attracting tourists is interesting. I'd like to go back to that in a moment. I was very curious to hear that you said it was "choreographed," and that was one of the things I've been wondering about, how the studios reminded me a lot of follies.

The idea of a folly in the landscaped garden (and this landscape is of course highly choreographed) is that it's essentially functionless, in the sense that it doesn't have a utilitarian function other than to celebrate its grace, its spatial position.

Todd Like a gazebo…

Roger The specific question relating to that (which I noticed when I was there) is: are they designed for working? How much do people actually work there creatively? Or is it really more of a space to sit there and reflect? Is it closer to the function of a folly?

Todd Yeah, that's a very good observation because I can answer that in many ways. The original idea of the program was that we interviewed a bunch of artists to see what they wanted, and because usually our buildings are designed for specific people that we know, but these studios were designed for people we would never meet. It was a bit of guesswork… they were artists, but we didn't know if they'd be a sculptor, or a painter, or a writer. They wanted a place where they could make art, eat, go to the toilet, very pragmatic things. Then, on the other hand, I think it was me personally that implemented that aspect and value of daydreaming. I really think there's value in daydreaming for creative people. The space you're in should inspire you. There's a German artist, Silke Otto-Knapp, she's been there for instance five or six times, she bought a house, and she returns to the Squish Studio. The second time I visited her, she had taped cardboard up on the windows and I started laughing because she told me why. She said she couldn't get any work done because she kept daydreaming, looking out the window. She couldn't produce. And I thought, is it more important to produce, or is it more important to daydream? I think the studios are meant to enable both. I believe being able to wander off in your mind is one of the reasons why they're so successful, 'cause it's not like a warehouse studio in Berlin where you don't see anything, you and your mind are there to conceive and create art. It's another world out there. The structures show you that you're connected to something, and nature is a part of that. So I mean they're not 100 percent follies, but maybe there is a small percentage there that they're like follies.

Roger It's interesting that you should say that, the "looking out," but looking out always has to do with "looking in" also. So there's two things I'm wondering about that I'd like to ask you. The English landscaped garden was a rich man's pleasure, no, amusing pleasure. I'm wondering if there's not a certain

element of this—perhaps first of all, in all signature architects, and especially—in the studios on Fogo Island. You know, they're marketed as being highly community oriented, but the question is, of course, aren't they in fact more or less a marketing tool for the rich hotel guests that come jetting in, and the international artists that are flown there?

Todd Yeah, that's probably an obvious answer that someone criticizing them would say, but once you get to know the people that actually use them, it's not at all like that. Originally, the idea was that the artists would live and work in the studios, and I said that's wrong, that would be probably more like what you were just assuming. I suggested that the artists actually live in the villages, we buy old houses and fix them up, and then they'd be able to leave. They would integrate with the community, and they could work whenever they wanted in these studios in privacy. One of the first things I was asked actually was to design houses in the villages, and I tried it for about a week, and then I said, no, "this isn't working 'cause there's nothing more beautiful than a Newfoundland house." So we bought some old houses, and artists started living in the communities. We saved a bunch of vernacular architecture, they got to know the people, so artists actually became part of the community. A lot of them have returned and are friends with people there, so from the outside you probably would think that, that it's a high-end, beautiful place to work for the elite, but I mean…

Roger First that, and there was another element I was wondering about. I promise I'll leave the English landscaped garden in a moment, but, you know, I want to run this concept of the "ornamental hermit." You've heard of this, you know, it's a feature in which the folly would not only have a grotto, but as a metaphor for the supposedly purer and more noble pleasures of the simple life, some landowners actually went as far as to engage with ornamental hermits, which is also an extremely theatrical concept. This doesn't really just concern the studios on Fogo, but relates to all of these kinds of developments, where you watch artists in production, where you kind of capitalize on the artist as a symbol of the pure, fine, more essential character. I don't want to say the noble savage exactly, but essentially something like that. There's a certain element of instrumentalization involved, and I'm wondering if that's not perhaps highlighted by the extreme visibility of these landmark structures.

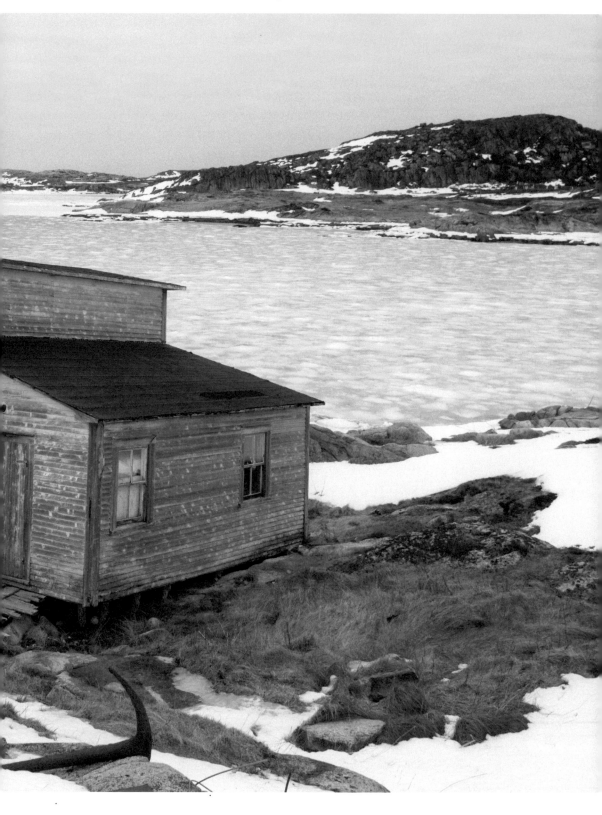

Todd

I think it's actually just out of curiosity about how an artist works. So there's a little bit of voyeurism there, where people want to look into the studios, but at the same time the structures are all situated at incredibly beautiful viewpoints, you know it yourself. You could put a cardboard box on some of these sites and it would be deemed beautiful. This singular "hermit" idea is actually interesting too, because at the time we were designing them, it was a really hectic part of my life. I'd just had my first kid, hired a team of employees, everything was really busy, so there was always a romanticism of being alone and being able to create. That's actually what I do now, in the mornings I've got a 200-square-meter studio in Norway, and I work alone from nine. I talk to my staff after one o'clock. I think this part of being alone and isolated is a product of us as architects, or as artists. When we were children we probably spent a lot of time alone drawing in solitude, but as you get well-known and business starts happening, you become bombarded by other people wanting to speak with you. So this isolation and living alone, it's fantastic. We're noticing now that a lot of our architecture is more about clients coming to us, wanting a place of their own, wanting silence. It's one of the things I notice all my friends want now; they just want a quiet place, a quiet mind, and not to be besieged by everything.

Roger

But at the same, you said one of the parts of the brief was to attract tourists. It reminds me a little of the tourist paradox, you know. There's a direct relationship between the idea of solitude, and at the same time to attract tourists. The studios in a way—and I think that has to do with a lot of landmark architecture—their task is to create a specificity for the space, for a place, and you are of course destroying a good part of that specificity because you're creating a new kind of specificity there, in, I don't know, perhaps out of some sort of Anthropocene hubris. Do we describe that as specificity though, only after we have added to it, when in fact the specificity was there before? I'm wondering, do you see this paradox involved in the design of the studios? And how do you think about this type of paradox—of the specificity of a place, or is that something you don't take into account?

Todd

Yeah, well, I think that there could be a time where these buildings I made return to more craft or traditional ways, you know, I can imagine people knitting socks or members of the community making fishing nets in them. I wonder how would they be perceived then… would that make the buildings more worthy?

Roger | I don't know. You're saying more "worthy." I mean I don't think it's a matter of worthiness. I think it's a question of the character of the architect… That's why I'd like to return to the original question, about signature architecture. If these builds were not deemed "signature" forms of architecture, if we could think of that for a moment, if they were composed of the local vernacular, you know, just another building, would they not be able to fulfil their function just as well? The specificity of their "signature" character is something that's essential to their *raison d'être*, is it not?

Todd | I think if I made another saltbox house and put it there, it would indeed have the same function practically, but it wouldn't attract the caliber of international artists sought after. We wanted something to be different. It was like a dance between the past and future, and actually what we wanted to stimulate was the mind. I think the saltbox building would do the practical part well, but it wouldn't have stimulated many people mentally outside it. Maybe we'd get 100 people applying instead of 10,000 people, so it was more of a provocation in a nice way, not to poke at someone in a soft spot that hurt. But it was actually to put a mirror up to the people's faces and say okay, that's the past right over there, and this is our interpretation of where we're going. Then the questions in between the two, that's where people start thinking again, other parts of Newfoundland have done artists' studios and nobody has ever even heard of them.

Roger | But I think that's a crucial topic (and this is now less of a question and more of an observation) because you've just said that "we wanted to be different," and then to return to this idea of specificity, I know that we do a lot of work in China, for example (and every Chinese developer is always in master planning) and in the master planning there's always a space set aside, or a volume set aside, for the landmark building. And of course, a lot of the results of these architectures which we're now realizing are obviously also architecturally very different from what you're doing in terms of quality, but I think that is the pitfall of this type of expectation that clients, or the consuming public have of certain architectures—that there's always that wish to be different, to give a new specificity to a place. That's what I meant by this Anthropocene hubris. We're looking, and we've somehow accepted that each place on earth, every new area on the planet— we have some sort of civilizational improvement on, that has to be subject to a certain specificity. I think it follows naturally from

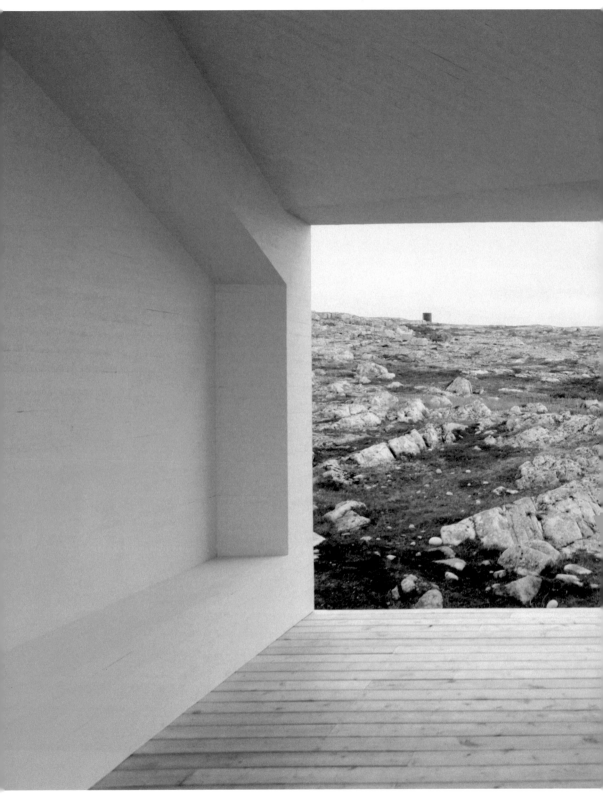

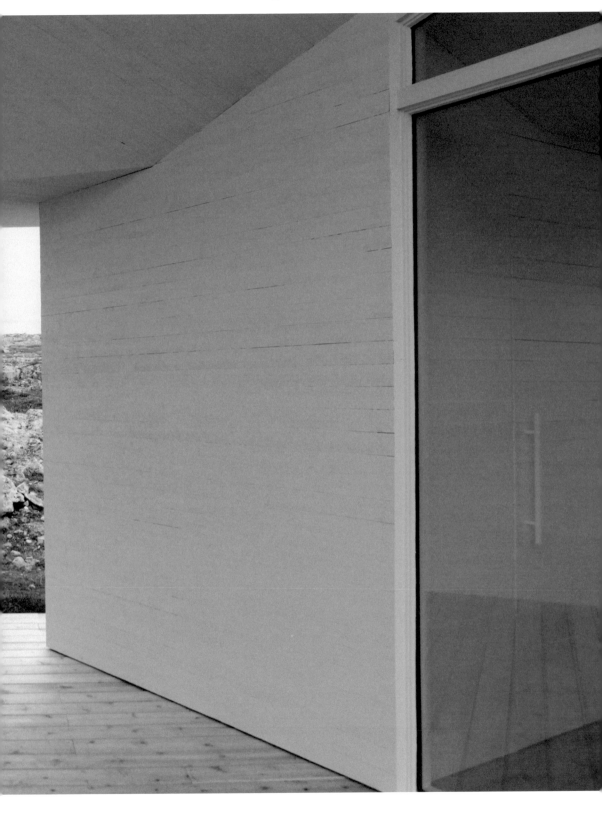

that that there's this type of "landmark" architecture expectation.
I think it's very dangerous, because—

Todd —yeah, 'cause it attaches a great deal of responsibility to
them. When it's done badly, it's done really badly, and when it's
done well, it's done really well. For example, the "Tourists' Road"
projects in Norway are quite famous. Peter Zumthor has done
two, I've done one, there are a number of others. But I believe not
all of them were executed that well, because they're supposed
to be very specific and, as it appears to me, the architect didn't
understand the place well enough. Whereas I understood
Newfoundland really well because I grew up there and knew all
about the materials. It was all intuition architecture. However if
I did a project in Turkey, as we were asked to do, I think it would
be the wrong fit, so I've backed away from numerous proposals
like this. There's a lot of different reasons why we did the studios.
The island's main concern was about people moving away. There
was 5,000 people there, and then there was 2,500 people, so it
became quite desolate. When I went there before, there weren't
any school buses running, and now when I go there are school
buses going and more children around again. The power of
signature architecture like that is: it's not about the ego of the
architect, it has a higher dimension. Turning around an economy
because of a small fifteen-square-meter building, that's the power
of architecture. My idea was to help a little small community
show the world how beautiful it is. So there's different shades of
grey on this in my opinion… I think the definition of signature
architecture isn't entirely fair for this project, I think it's just really
good architecture and I'm proud of it. There's some amazing
people whose opinion I respect a lot—who've taken that journey
over to Fogo Island and ten years ago, nobody knew the name
of the place. That's put money in people's pockets, it's created
a quilting industry, a boat-building industry, an ice-cream store,
so that's something.

Roger Let me ask you something else, at the beginning you said it
was also to attract tourists…

Todd Before we go further, may I just say that the Fogo Island
Inn only has twenty-nine rooms. It's not like attracting tourists
to New York with a 500-room hotel.

Roger Yeah, but do we really need this environmental impact of
traveling to the literal end of the earth? And returning to the
studios for the moment, why does the architecture look this way,
why does any kind of—let's, for lack of a better word, still call it

signature architecture—why is it geared more towards the visitor who has this sort of expectation of modernism, because they are visually schooled, because they need their tastes catered to?

Todd Yeah.

Roger Is there perhaps an element of, you know, cultural colonialism involved in trying to, in bringing this undoubtedly very good and clean modern architecture to educate the locals? Was that something that was at all relevant? Or was it something that you didn't think about?

Todd No, I didn't think that I needed to "educate" the locals. It was on the job that the locals actually had to educate me. I'd been traveling, I'd worked in Vienna, I'd worked in Berlin and St. Petersburg, and I was collecting a kind of repertoire, but then, looking at my own heritage, where I grew up, the beauty of simple handmade architecture appealed to me, and I wanted to celebrate it. I was asking questions.

Roger Who would you say is the main audience of your architecture on the island? For your Lookout project, also, which is similarly a highly iconic type of architectural statement, who is the audience for that as well? Is the audience not actually, in large part, the people who see your work photographed, who see it as a piece of, again apologies, for lack of a better word, signature architecture? Who is the actual audience? Notwithstanding the fact that, of course, people on the ground will be able to use it, but how do you deal with the element that there's a consumer out there who will consume the specificity of the architecture because it looks that way?

Todd Yeah, I think that is very specific to architecture constructed only to attract tourists. Three other architects competed with that intent I think. I can only imagine if some of the other ideas were built. Nothing would happen there. It would just be a waste of money. So who the audience is, yes, there's the tourists but the by-product is that it would sustain a rural area (with very little money) that was otherwise about to die.

Roger I think of these as economic tools.

Todd Yeah, but to answer the question, at least there's not one audience, and there's not one goal, there's probably ten different targets that we sought to achieve. One was to honor the simple architecture, one was to advance on tradition. Another one was simplicity, and another was to make a practical place for artists. Yet another was to realize a space where an artist could dream; another goal was to build a place where an artist would want to

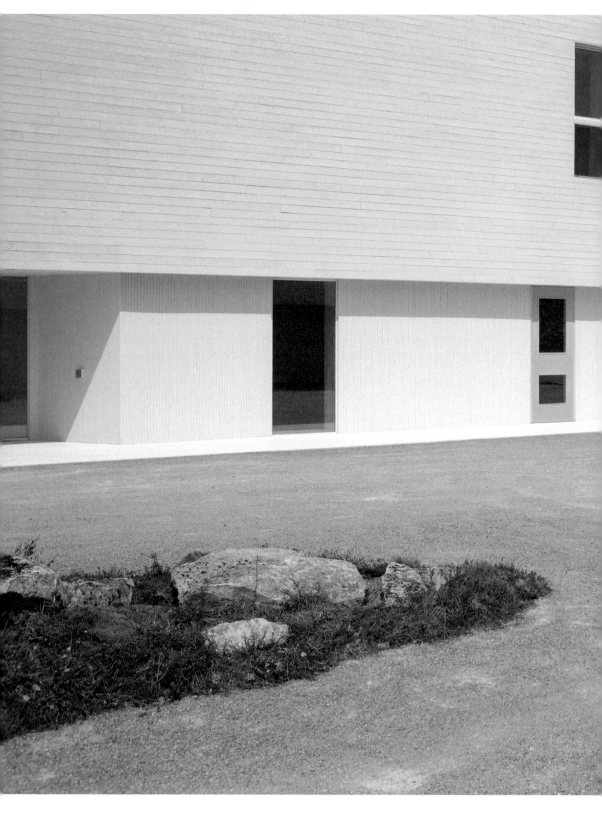

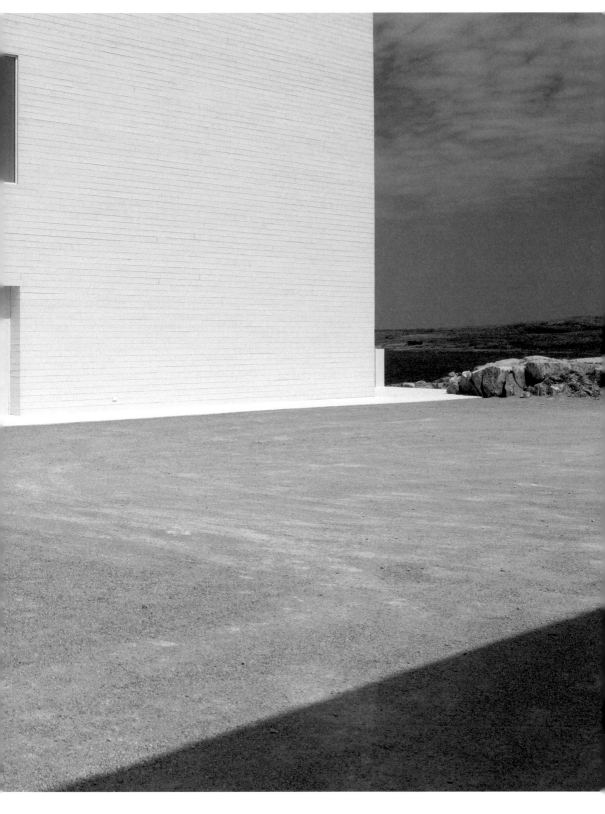

come back to. They just didn't go there and "tick it off their bucket list," so to speak. Many of these artists are still coming back. So it's partly about taking pride in the place. I grew up in a very poor part of Canada that no one respected, and I used my skills to portray it in a way that also celebrates this beautiful place. Something that residents of the island can also partake in this aspect of pride or heightened global interest and appreciation. There's beautiful food, beautiful people, so I think, yeah, there's a lot of different audiences.

Roger Let's talk a little about the transformative potential of these architectures. Do you think there is any transformative potential of the wider dissemination of images? Where do you see the added value come in through this wide dissemination of pictures? Why is that so compelling? Why is that such a necessary component do you think?

Todd I think people see the world now slightly differently, perhaps in contrast to when we began practicing… When I was doing architecture in the '90s in Berlin, for instance, it would be three months later that you might see a project published in a magazine—and now it's instantaneous. As this project was evolving it became Instagram-friendly, and it happened to many other projects too, for example with Bjarke Engels, and Thomas Heatherwick. It's the world shown through people's phones, there's a whole different way of communicating today. And, you know, some things became more photogenic—some for the wrong reasons, and some for the right reasons. But I think in our case, it worked to our advantage. They were not very expensive buildings, and they got a lot of focus due to the good intentions and foundations that they were built on. They're not there solely to make money, they're there to help the community.

Roger Well, you know what they say, the road to hell is paved with good intentions…

Todd Yeah, that's true, and it's a bit of cliché, but things have to start somewhere to pave the path to change. If you don't want to enact change you may as well give up, so I made certain decisions in my life, where I live, what type of architecture I do, and it's worked for me, for my lifestyle. It's worked for the people I've been working with. I've never heard of these buildings being called signature architecture, but I can understand why, 'cause people see them through images.

Roger The inn probably gets more publicity, due to the fact that it's also widely published outside of the architectural context, in a travel and tourism context too, is it clearly a marketing tool?

Todd It's probably a building within that frame of reference, of travel and tourism, that counts among ones that have used the least amount of money on marketing in the world. It's kind of ironic.

Roger So are you saying the marketing of these buildings was something that happened more or less by chance, it wasn't part of the brief?

Todd No, no, I don't think they could have dreamt it would be this successful to be honest. I can't either.

Roger You spoke earlier with certain disdain of urban signature buildings. Do you find that there are different requirements, demands in cities?

Todd Yeah, I think so. I've been to Casa de Musica in Porto, and I think that was very well done. I've visited the Seattle City Library too, also by Rem Koolhaas, so there's been a couple of projects I've seen that I'd certainly consider as having cultural value. There's the Grieg Hall, a concert hall in Bergen where I live in now for example, by Danish architect Knud Munk, that's actually played a significant role in shaping the personality of the city.

Roger It's curious that you should mention OMA, we talked about Beijing earlier, and the CCTV Tower, to me, is a typical example of architecture that is made with the intent of signature architecture.

Todd Yeah, that was probably the goal.

Roger Extremely dated, you know. It's a heavily fortified, defended propaganda fortress really, and then you walk through and it's fascinating, because you walk a little further and there a number of white towers by a Japanese architect and it's an extremely vibrant area that has really activated the entire neighborhood. The buildings themselves are very clean, modern buildings, but they are not that important in this context, which is a big compliment to them, because what is important there is really the space and the activation. I think the CMG Tower is a good example of what can go wrong with the signature architecture approach, and I wonder whether you see these dangers in your own design work?

Todd If a client came to me and asked me to do signature architecture, I would approach it differently. I've never been asked to do that, but I guess I am asked to do it without me knowing it. I think about how the Oslo Opera House by Snohetta is like the Aurland Lookout, I was told by a member of the government that it was the most photographed piece of contemporary architecture in Norway until the Oslo Opera House was built. It's a great piece of architecture, it's like a park for the city, so I think signature

architecture, if people take it seriously and there's a certain responsibility, then it has a role to play. But signature architecture executed poorly is embarrassing.

Roger I mean I think perhaps that's where the disdain towards signature architecture comes in.

Todd You know, we've had some people say that "you're ruining that landscape," one in a thousand comments, but Canada is huge, those little buildings are specks in the larger landscape. Those studios, the way we did them, if in five years they were gone you'd never know there was anything there. I've seen really bad projects destroy places, I think why we're getting interesting work in these really nice sites is that people see that we respect the places. Maybe that's why these tiny buildings have struck a chord.

How much time did you spend in Fogo?

Roger I was there for three weeks once.

Todd What was the main thing you felt when you left there? Or a month after?

Roger Well, I enjoyed very much the tranquility of the place, but I have to admit the main thing that I took away was something completely unrelated to architecture. I was fascinated by the rocky shore, which reminded me tremendously of a work by the German painter, Caspar David Friedrich, *Das Eismeer*, or *Die gescheiterte Hoffnung* (1823–24), the end of the hope, a shipwreck picture. So that's what I took away, the amazing natural beauty, and the similarity between the Fogo landscape and that of Scotland—some of the Scottish islands where I've been, I thought that was just… I felt there was a lot of the same feeling in that.

Todd Yeah, there is.

Roger I also took away an interconnectedness there that I thought was very poignant. Not really the architecture for me, but also perhaps because I deal with it daily, and I didn't want to deal with it at that time. I was very content to just gaze out on the ocean and turn my back on the buildings, although they of course did not deserve it.

Todd That said, that's actually the feeling. I left Berlin in 1992, because of almost the opposite feeling, because everything was touched by people, it felt as though nothing was natural anymore. I was working with a landscape architect in Vienna at the time, and then in Berlin, and it was a kind of yearning for untouched nature that really appealed to me. That's why I ended up turning my practice back towards… well, I actually have an undergrad

in urban planning, and some of my practice is moving more into urban areas now, but because when I went to Norway (I was twenty-six) and the projects I could get were in the rural areas, that was also just the way it happened. So yeah, I just had to do the best I could with these little small projects, and so it's kind of funny the way, you know, what life brings you.

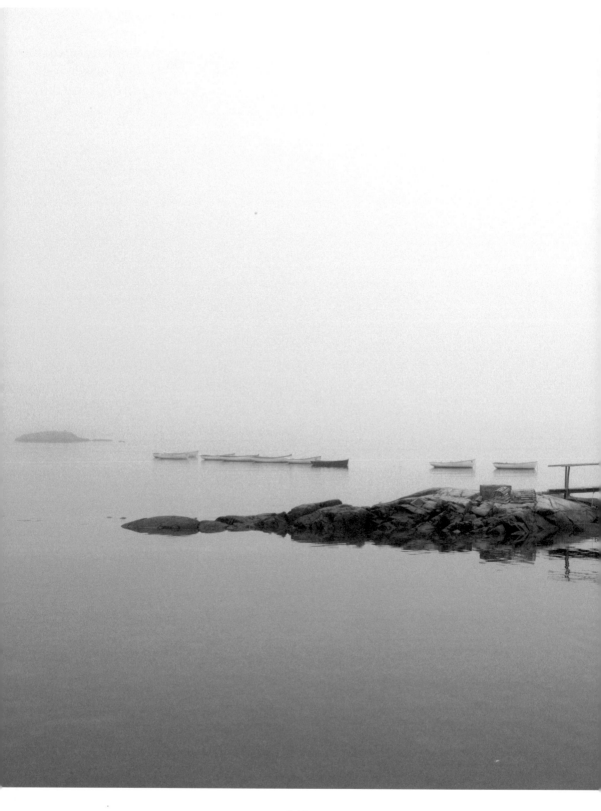

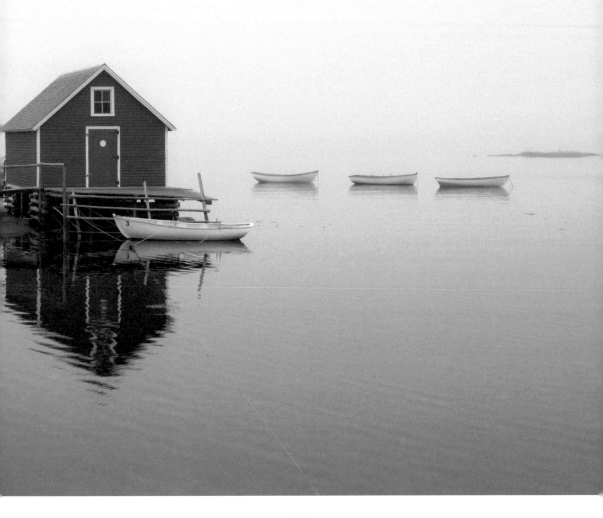

Kate Newby:
AN ISLAND IS QUITE A SELF-CONTAINED SITUATION

Kate Newby (based between New York and
Auckland) is a visual artist. She was awarded
New Zealand's largest contemporary art prize,
the Walter's Prize, in 2012, and graduated with
a doctor in fine arts from Elam School of Fine
Arts at the University of Auckland in 2015.
She shows work internationally in major group
shows and solo exhibitions.

I first ventured to Fogo Island at the end of 2012, and stayed there until the beginning of 2013. Six months in total. I'd been invited to undertake a residency, as well as make the inaugural exhibition at the Fogo Island Arts gallery at the inn. After six months I had to leave because my visa was up, and the gallery wasn't quite finished yet, so I returned the following summer once the Fogo Island Inn was open, and we installed the exhibition then.

I'm often engaging with new cities and landscapes, there is a type of flexibility in my practice where I want to be able to make work no matter where I am or what my resources are like. The thought of spending time on such a remote place—on a sub-arctic island in the Atlantic, coming originally from a South Pacific island (New Zealand), seemed pretty exciting to me.

An island is quite a self-contained situation and there's a special sense of remoteness. I think one of the things that made it feel very far away was the weather, because it's not so often that you can't do what you want, when you want. When the ocean had iced over, the delivery wouldn't arrive for the supermarket, and then the shelves would look rather empty and that felt pretty remote. However, I never felt isolated. I never felt lonely. I felt physically like I was on the end of the planet, but isolation was a feeling I didn't really have. Quite the contrary. In the beginning I thought I'd go there and read books. I didn't end up reading very much, I felt like I was continually engaged and engrossed by what was happening around me.

I got to witness things I'd never ever seen before, and have never seen ever since. The ocean freezing over with vibrant turquoise glacial boulders rolling up on the shore. Every day was a day of stimulation— so I didn't ever dive into my books, I was pretty happy to be just looking around.

I'm not really one to walk into a room and want to meet everyone, but through a natural process I became friends with some incredible people that I'm still in touch with—years later. I just followed my curiosity and met people through that. I wasn't entirely comfortable with the potential expectation to engage with the community through the program, nor try to implement some kind of community art, I was pretty hesitant to treat the residency like it was a social experiment. However, no one was saying "Kate, throw yourself at the community and form some relationships, give art a good name." I was invited to just do my own thing.

I didn't go there with an outreach agenda, but ended up working in a very involved way with the island itself. I got to work with the geologist Paul Dean who taught me a lot about the formations of the region. My exhibition was a project about rocks. There's nothing that makes more sense on Fogo Island than rocks. The whole thing is a rock; it's a pretty incredible geological situation. My project started with handmade ceramic rocks, partly informed by what I was seeing, and partly in response to my feelings and how I was spending my time. My studio was so cold in winter that I converted the kitchen at home into my studio, and I used a kiln that happened to be in an old church at the end of my driveway. I used very simple observations to create the body of work. What was really interesting to me was how the businesses on the island were named after women. There was; "Tina's," "Pat's," and "Nicole's," etc. All of the boats were named after women too. I collected these words, along with words of local places such as; "Seldom," "Wild," "Farewell," "Change," "Little Saturday," and so on, and used them to organize the body of ceramic rocks that I had made, composed of hundreds of pieces.

Another work involved the removal of the fire escape door from the newly built gallery, and the insertion, instead, of another with windows. The door faced towards the island. Not another ocean view, there were already so many of those everywhere, I wanted to put attention back towards the island and the people. The door was painted yellow. I wanted the door to feel somehow separate from the refined state of the inn. It was an escape route back to the land. When I returned for the exhibition it felt

really familiar, it was nice to be back. A lot of the community came to the opening. There was a ginormous storm that evening which felt appropriate.

Besides the stones that were presented inside the gallery, some work was also placed outside such as a wind chime that stayed there until the end of the exhibition on the property of Linda and Winston Osmond, both of whom had been a big part of my time on Fogo Island. I was continually trying to put work outside but the wind there is so strong… you have to park your car in a certain direction sometimes so that the wind doesn't take the door off. The wind chime managed to remain intact, over the entire course of the exhibition. Hung between trees and exposed to the stormy elements. It was destroyed in the end. On the very last day.

Fabrizio Gallanti:
REMOTE ARCHITECTURE

Fabrizio Gallanti (based in Montreal) is an
architect, theorist, writer, and editor. He is a
founding member of the architectural research
studio Fig-Projects and the collective gruppo
A12 (1993–2004). He was from 2011 to 2014
associate director of programs at the Canadian
Centre for Architecture (CCA) Montreal, and
the first senior Mellon fellow (2014–15) of
Architecture, Urbanism, and the Humanities,
at Princeton University, New Jersey. He serves
on the advisory board of Fogo Island Arts.

Islands are one to one laboratories: They are the perfect location for conducting experiments. One could consider the initiatives of—the Benesse Holdings, and the Fukutake Foundation on the Setouchi archipelago in Japan, the projects on the island of Stokkøya in Norway, and those of Shorefast on Fogo Island, off the coast of Newfoundland, Canada—as social experiments. Architecture has been a crucial component of these endeavors.

French philosopher and sociologist, Bruno Latour, has explained how the methodologies and protocols of the "laboratory," as an enclosed site where controlled tests are conducted by specialists, are now permeating a large part of our existence, in particular when it comes to matters of ecology, the economy, or politics.[1] As humans, we have become increasingly the initiators and the objects of such experiments, where the consequences and outcomes of economic and political decisions are not necessarily foreseen. The massive vaccination campaigns of the nineteenth century or, for instance, the surge of the sharing economy around the San Francisco area, or the privatization of railroads in the United Kingdom, can be read as exemplary of the idea of a massive trial conducted in the open, where the results and complementary effects are not entirely discernable at the beginning of each process. The results of such tests, whether negative or positive, are then taken as models, later to be applied to a larger scale: even if its influence might have diminished in the past years, the laboratory still holds universal value.

What is convenient with islands is the fact that their relative isolation within a large body of water allows for the measurement and analysis of the conditions and consequences of any initiative with a slightly higher degree of precision if compared to studying the same results on land. Historically, what went in and what came out from an island were figures simpler to calculate, and so, in the next years it will become possible to have an evaluation of the aforementioned experiments with a satisfying level of certitude.

What is happening in these remote places can be labeled as a "social experiment" because the intentions are to generate lasting and beneficial changes in the fabric of local communities, through several coordinated actions, hoping that the results will be aligned with optimistic predictions while at the same time operating without an established path to follow. The three cases are mostly characterized by four common attributes that are stronger than the local peculiarities.

[1] See Latour's reflections on the laboratory in Bruno Latour and Steve Woolgar, *Laboratory Life: The Construction of Scientific Facts* (Beverly Hills: Sage Publications, 1979).

First, the economic systems that for very long periods sustained the communities that inhabit these remote and somewhat hostile places have been disrupted, and therefore life for the inhabitants has become harsher. For instance, in the case of Fogo Island and Newfoundland, fishing as a form of direct sustenance and as a commercial activity has radically morphed because of modifications (that are likely to have occurred elsewhere) such as changes in the supply chain and industrialized fishing offshore. The same can be said of industrial activities that have become obsolete in the Setouchi archipelago. For many, these activities are no longer viable systems to make a living. As a consequence, populations are shrinking as people eave in search of better opportunities, and for those who decide to stay, things are not easy.

The second common element is that to counter such dynamics, different subjects, motivated by what could be broadly labeled as a philanthropic attitude, are investing massive resources with the prospect of altering or mitigating these conditions to help communities to stay and, ideally, grow. The spark of these massive actions came initially from private subjects, operating within a non-profit ethos, that were later dealt with by a response from public administration and the state. For the Setouchi archipelago, a holistic approach to address the dramatic changes that affected the islands slowly emerged from an initial attention to the arts. In the case of Fogo Island, it has been at the core of the mission of the actors operating there since the beginning. However on closer inspection, it also transpires that these are not just philanthropic actions in classic terms, but rather attempts to delineate alternative ways of conceiving the conditions of capitalist economy, underscoring how a partial reinvention can be fostered bottom-up from the local, opposed to the devastating forces of international economy. If these experiments will work, communities will again support themselves without the need of welfare or external aid.

The third similarity is the intention to inject novel activities that could partially substitute the ones that declined: there is always the attempt to explore a conjunction of innovative forms of tourism—bringing people and therefore resources to the islands, with careful attention to the environment, scientific research, culture, and arts. This mix between existing knowledge and resources with new programs and external

expertise is then declined and adapted differently to each site.

The fourth common characteristic is the fact that within these different conditions, the role of architectural design has been crucial, not only to conceive of and construct the infrastructure, realizing buildings and spaces to accommodate the new functions, but also as a very efficient tool of public relations, capable of transcending the strictly local context and projecting the image of these places on a global scale.

The Benesse House Museum inaugurated in 1992, on the island of Naoshima, part of an archipelago of more than 2,000 isles in the Seto Inland sea—the body of water that separates the three main islands of Honshū, Shikoku, and Kyūshū, in Japan. Historically the sites were thriving fishing communities, however several of the islands suffered from heavy industrialization which impacted the environmental conditions, to then leave large swaths of the population unemployed when factories closed.

Designed by the renowned Japanese architect Tadao Ando, the Benesse House Museum integrates a museum with a hotel—displaying the holdings of the arts collection of the Benesse CEO at the time, Tetsuhiko Fukutake. Over the years, around this kernel, other arts and cultural institutions have bloomed, particularly with the Chichu Art Museum which opened in 2004, also by Ando, where an astounding selection of paintings from Monet's *Water Lilies* series are on permanent display.[2]

For Fukutake and his main ally, Naoshima Mayor Chikatsugu Miyake, contemporary art could become a driver to attract visitors to the island and therefore inject new life in the territory. But while the initial interventions adhered to an idea of architecture steeped in rigorous minimal monumentality (of which Ando is undoubtedly a master) that echoed an idea of tycoon extravagance. The later series of interventions and activities spread over different sites demonstrates a progressive infiltration and more nuanced dialogue with the existing social fabric. A string of carefully calibrated interventions on the Inujima Island, designed by Tokyo-based architect Kazuyo Sejima, is an example of such an approach: a set of small exhibition spaces—they are based on collaborative models with local inhabitants, they often recycle and reuse existing structures, and they generate activities that are aimed to incorporate the local communities. Sometimes they are ethereal,

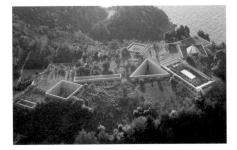

Chichu Art Museum in Naoshima, Japan, designed by Tadao Ando, photo: Iwan Baan

Art House Project: I-House in Okayama, Japan, designed by Kazuyo Sejima, photo: Iwan Baan

2
Benesse Art Site Naoshima website: http://benesse-artsite.jp/en/.

151

out of the world pavilions in glass and plastics, in the line with Sejima's most acclaimed designs, in other cases they are careful and mimetic restorations of heritage constructions. Beyond their execution, based on interesting collaborations between residents and incoming students from Japanese universities, they continue to mobilize the expertise and work of locals, as is the case of the "Inujima Life Garden," inaugurated in 2016, where research on marine vegetation and sustainable agriculture is continuously conducted.

Currently, 700,000 people per year visit the archipelago, attracted by the various initiatives supported by Benesse: whether these numbers indicate that the experiment has been a success is a matter of careful reading.[3]

The trajectory of Shorefast on Fogo Island if mirrored is almost the opposite of Benesse. If in Japan, a huge cultural capital, the Fukutake's collection, was moved to a remote location to generate powerful attraction and then, later, a more granular sequence of initiatives sprouted there, on Fogo Island, the first moves were of limited scale yet with an astute use of architecture as a device to establish the island's notoriety. Todd Saunders initially designed four small arts studios, with evocative names such as "Squish" or "Tower," conceived to welcome guests within an international residency program, launched in 2008, under the umbrella of Fogo Island Arts.[4] Each of the small pavilions were built with the use of local techniques and materials while at the same time adhering to a cosmopolitan ideal of an austere and elegant architecture, quite angular in its appearance juxtaposed to the rugged beauty of the oceanic landscape. It seems almost that the careful architectural composition of the studios, and the precise framing of the views surrounding them was envisioned with the perspective generated by the photographic camera in mind. They were conceived to elicit the concentration and focus of the artists temporarily using them, and so they are spartan in their interior finishing yet extremely generous with space and light. Their uncanny otherness has propelled Fogo Island across international media, paving the way for a curiosity that was later instrumental in attracting sophisticated visitors there, hosted in the Fogo Island Inn, a large hotel, also designed by Saunders. All revenues of the inn are then reinvested locally through a not-for-profit model.

3
An extended survey of the initiatives on the Setouchi archipelago is included in Akiko Miki and Lars Müller, ed., *Insular Insight. Where Art and Architecture Conspire with Nature Naoshima, Teshima, Inujima* (Zurich: Lars Müller, 2011). It includes an articulated evaluation of the effects of the Benesse program by scholar Mitsuhiro Yoshimoto.

4
The book by Hong Kong–based collective MAP Office, *Our Ocean Guide* (Venice: Lightbox, 2017) is based on the experience accumulated through different arts residency programs and research projects located on islands, including Fogo Island Arts, with a series of commissioned essays, also dealing with the architectural strategies there.

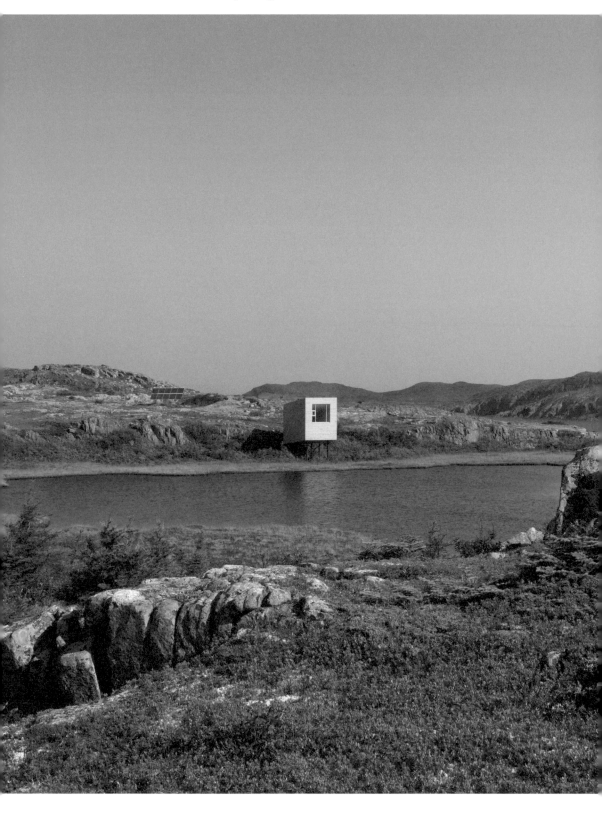

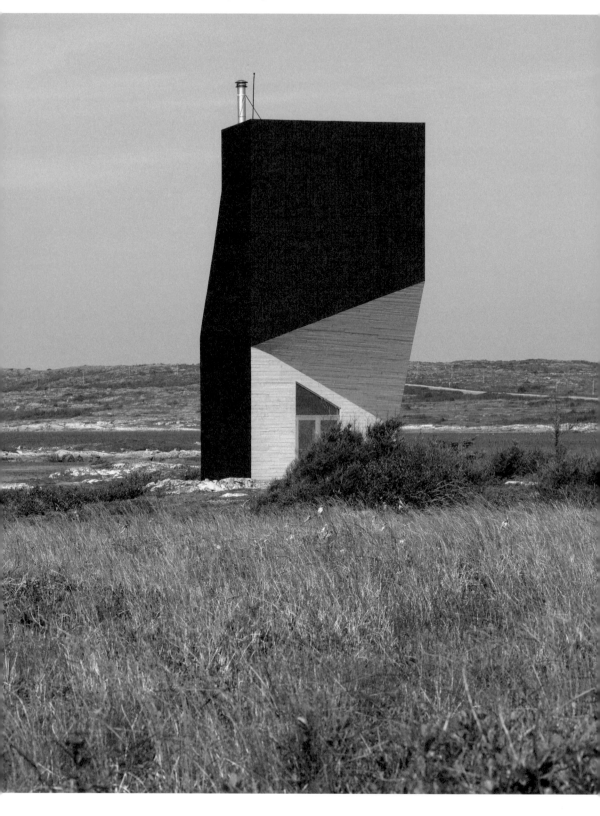

While in Japan, architecture had to respond, especially in the initial phase, to the necessity of protecting highly valuable content (the term used was "arts shrines"), in the case of Fogo it has been thought instead primarily as a visual enhancer of the extreme geography of the site, perceived as the key element of allure for travelers. The architecture on Fogo plays a tricky balance between tradition and novelty: while the geometry and language—a large use of glazed surfaces, for instance, would not be found in the vernacular building types—are alien to the local traditions, the grain and texture of the materials, and the detailing are instead familiar. It is an architecture that reflects the island condition, as it uses ingeniously what is available on site.

An analogous architectural approach has been deployed on the Norwegian island of Stokkøya, but under an entirely different predicament. While in Japan and Newfoundland, architecture has been part of complex interchanges with inhabitants living there since centuries, on Stokkøya, instead it serves to support the surge of a new community, in a place almost never inhabited before. "Bygda 2.0" is the name of the project, meaning "Village 2.0," pursuing the almost utopian attempt to transfer dwellers from the city to the countryside, providing an environment to

The Squish Studio in Tilting

develop alternative lifestyles (in all cases, one cannot not wonder how these projects would exist without the Internet and fast connectivity that have reached these sites). The long-term goal of the initiative, launched by entrepreneurs Roar Svenning and Ingrid Lanklopp, is to achieve a certain critical mass of inhabitants to activate a local sustainable economy, based on the intersection between scientific research and utilization of local resources. It is logic, then, that the first building is different from in the previous cases: a large structure, perched over a cliff dominating the ocean called "Bygdeboksen," (the Village Box) hosting a coworking space for regular and drop-in tenants, a makerspace, workshop and a kitchen/food laboratory, with a 300-square-meter hall for events. Designed by Pir II, it ingeniously assembles a timber structure with cladding in iron sheets and polycarbonate, pragmatic solutions to be found in agricultural and naval construction in the area. The design carefully incorporates considerations about the energy consumption and climatic balance, while, once again, it smartly relates to the landscape in a spectacular way, altering its geometry so as to highlight the best views.

A microbrewery and a baker have already become tenants. Houses, designed by Pir II, as well as by other international architects, are offered for rent and purchase with an estimated objective of thirty dwellings, scattered on the island, as a sufficient mass to activate a small community. In the communication of Bygda 2.0, the the project is described as a "living laboratory."[5]

 In the past years, we learnt of these places through the circulation of the polished pictures of the spaces that have materialized there: artworks on a cliff, gatherings under a glass ceiling, overlooking roaring waves, small wooden shacks covered in snow. While still distant places at the end of long journeys, these islands are also accessible in real-time virtually, via the media system that wraps all of us. Analogous initiatives aimed at relaunching economies of remote sites such as these, but devoid of a legible physical presence, are occurring in many other places worldwide but often go unnoticed. As in the experiments discussed, consequences are unpredictable: one can read a potential richness that goes beyond the sole attraction of tourists to relaunch the local economies. Exchanges occur between locals and the transient population of visitors that in the medium and long term will stimulate the slow surge of novel cultural forms, of unexpected alliances and of hybrid experiences. No one will be unchanged. The openness to the world generated by these initiatives is already beneficial in two ways, for those on the islands, for those getting there and in a few cases, deciding to stay.

 To return to the balance of what goes in and what goes out of an island, we can assess that pictures travel very well, as in the past, sardines, salted cod, or crafted products used to. It might not be enough, but perhaps it is an early indication that these experiments might have already had a positive effect.

[5]
For an overview of the project, see Francesca Oddo, "Creatives Needed," *Abitare*, no. 574 (May 2018).

View of the *Bygdeboksen* by Bygda 2.0 in Stokkøya, Norway, designed by Pir II Architects, photo: Pasi Aalto

Willem de Rooij & Kitty Scott:
IS IT ALL JUST RESIDENCY HOPPING?

Willem de Rooij (based in Berlin) is an artist who works in a variety of media including film, photography, and installation. He is professor of art at the Städelschule in Frankfurt am Main (since 2006), and a tutor at De Ateliers in Amsterdam (since 2002). He serves on the advisory board of Fogo Island Arts.

Kitty Scott (based in Toronto) is a curator at the Art Gallery of Ontario. She was the co-curator of the Liverpool Biennial 2018. She was a core agent for Germany's dOCUMENTA (13) in 2012, and she has acted as: director of visual arts at the Banff Centre; chief curator at the Serpentine Gallery, London; curator of Contemporary Art at the National Gallery of Canada, Toronto; and she currently serves on the advisory board of Fogo Island Arts.

Kitty Hi Willem, I know you've recently been traveling, and home for you is Berlin, so shall I begin by asking: Where are you at the moment?

Willem Hi Kitty, yes: I am currently in Salvador de Bahia, Brazil…

Kitty The Global South. The Goethe-Institut Salvador-Bahia opened its residency program two years ago, in 2016, with the thematic orientation of the "South." It is part of the larger "Episodes of the South" project, which sought (through debates, research, exchange programs, artistic and academic works that used new points of view or ways of thinking about Germany, Europe, and the world) to experiment with "disorientation, wherein geographies turn to liquid and the definition of axes such as East/West, North/South" are diluted. Where are you staying? And what is it like?

Willem Correct. I am staying in an apartment above the Goethe-Institut, in the Vila Sul. There are four very luxurious apartments. I have a bed, a bookshelf, a desk, a sofa, and a bathroom, and I share the kitchen with three other residents. My windows look down to a beautiful courtyard with lots of tropical plants and monkeys.

Kitty It sounds incredibly grand, palatial, even, what with the courtyard, exotic plants, and monkeys. (I like monkeys!) Perhaps we can return to this image a little later, but first I'd like to continue by asking: Why are you there?

Willem That's a good question—because I'm not an artist who usually "does" residencies. Many artists travel to participate in residencies all over the world, but I am really not one of those artists: I have been fortunate enough to be able to organize my own travels every time I was compelled to visit a certain location in relation to my work. As a thinker I am quite slow and not all that flexible; I can't just go to any place and "be inspired"—I really need a particular reason to travel for research. I guess that is why this is only the third residency I've chosen to do.

Kitty I'm surprised to learn you've only embarked upon three residencies so far in your long-standing and established career. It's almost slightly ironic that we've planned to talk about residencies—an activity that's not exactly attractive to you personally.

Willem I think residencies are very attractive if there is a purpose, not if they just happen.

Kitty Young artists appear to be enthralled by them, so many artists travel the globe for the purpose of an extended stay on

a residency program. Simultaneously, the list of residencies available seems to continually expand. At a time when there are so many artists graduating from art schools, and the field becomes more and more competitive, residencies do offer an alternative track where an artist can develop away from commercial and exhibition-making contexts. As a teacher, do you encourage younger artists to take these routes?

Willem There is not one answer. It depends on the residency, and it depends on the artist. If the residency is a good fit for a particular reason, I think that is striking. However, I also try to talk with young artists about how to finance as well as reserve the time and space necessary for their work, independent from institutional structures. In any case, for artists who do not have the means to travel, or who cannot afford to spend sufficient time in their studio, a residency can provide invaluable opportunities.

Kitty I entirely agree. However as you've just said (due to the fact that you have been lucky enough to travel independently and afford studio time)—for you it's also about a suitable fit—which leads us back to why you've chosen to embark on only three residences. When you look at the top tier residency programs in the world, they differ greatly. These differences are connected to location, access to studio space, and required facilities. In Banff, Canada, the residents live and work high above a tourist town. On Fogo Island, artists live in small towns and have local neighbors. Artists are provided with the opportunity to integrate in a completely different way. Given your experience, how do you understand the FIA residency? Why was it interesting for you?

Willem I don't count my visit to Fogo Island among the residencies I have done. Fogo is small community in an overwhelmingly stunning natural setting, but nature doesn't really inspire me as an artist. I grew up in a constructed place: in the Netherlands, the only raw nature there is the sea (which I do know something about). I like to be in an urban environment, so when I was asked to participate in the FIA residency, I was not sure how I could promise to be productive in that space.

Kitty Why was it that you visited Fogo Island in the end? How did it happen that you traveled to go there, and how did you find it?

Willem Because I liked the ideas behind the project, I visited for two weeks in 2012. Although it turned out to be a place where I couldn't immediately formulate new work, I found the social sphere of Fogo Island and many aspects of the residency fascinating, and a longer relationship developed out of my time there.

Kitty I'm interested in how the situation is somewhat different for
 your current residency. What are you doing in Brazil? What
 makes the purpose of this residency specifically relevant for you
 in contrast to others?

Willem When I received the Goethe-Institut's generous invitation to
 come to Salvador, I realized that this two month trip would allow
 me to conduct deeper research into particular topics that have
 occupied my thoughts since the mid–1990s: a number of Dutch
 artists visited the North of Brazil in the seventeenth century, and
 the images they made have fascinated me for many years.

 Earlier this month, before this residency started, I traveled to
 Suriname on my own account. I always wanted to go to this for-
 mer colony of the Netherlands. It is a Dutch-speaking nation that
 is culturally more geared towards the Caribbean (where Dutch
 is also spoken on some islands) than towards its neighboring
 countries on the mainland. There are approximately one million
 Surinamese people in the world, and 50 percent of them live in
 the Netherlands, so even after Suriname gained independence in
 1975, the ties between the two nations remain very close. I grew
 up learning about Suriname's culture and (a rather one-sided
 version of) our shared history.

Kitty That's a remarkable percentage, and it's fantastic that you
 were able to go there on your own account beforehand. In terms
 of the residency invitation, it seems very much dependant on
 concrete connections for you, such as your specific interest in
 works made by Dutch painters during the Golden Age or *Gouden
 Eeuw*—which have already been on your mind for a long time.
 Perhaps the appeal is also the period of time offered, which grants
 longer to focus and reflect on your research. What did you do
 while you were in Suriname? And how long were you there for?

Willem I was there for around two weeks. My main goal was to
 research some details concerning the Dutch colonial project,
 in particular the conditions around the production of a number
 of images made in Suriname in the eighteenth-century. At the
 same time I wanted to meet local artists, and learn more about
 their work and the context they operate in. Highlights were the
 open studios at the Nola Hatterman Art Academy in Paramaribo,
 and the opening of the 2018 Moengo Festival of Visual Arts,
 organized by local artist Marcel Pinas. Pinas founded a number
 of interrelated initiatives to revitalize the area (it depopulated
 after bauxite mining stopped around ten years ago), with a
 special focus on knowledge production and preservation around

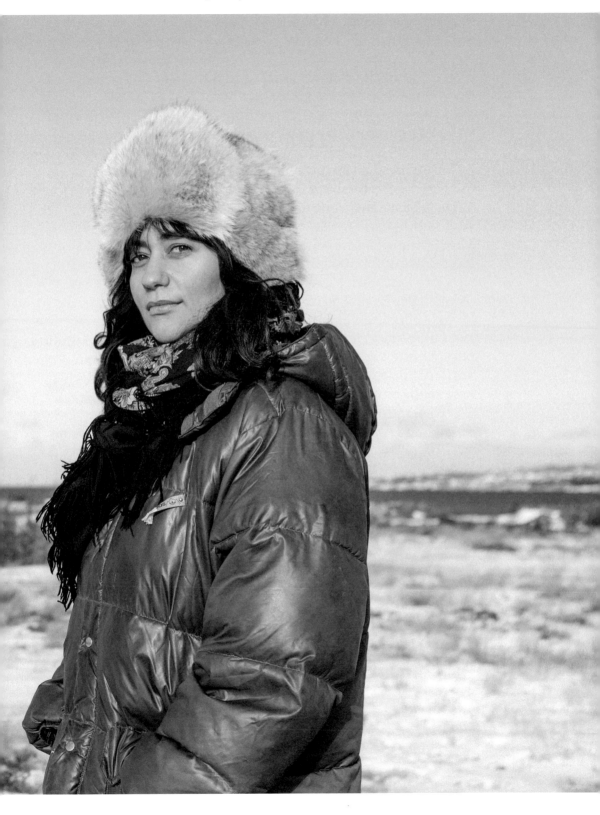

the locally important Maroon culture carried by descendants of enslaved West Africans who fled forced labor on Dutch-owned sugar and coffee plantations. The Tembe Art Studios (TAS) receives local and international resident artists who are invited to produce work in and about Moengo, often in dialogue with the local community. The Contemporary Art Museum Moengo (CAMM), currently the only museum for contemporary art in Suriname, collects and displays these works as well as works by Surinamese artists unrelated to the residency. Finally, the Moengo Festival is an annual event alternating festivals for music, visual, and performing arts in three-year cycles. This year's edition of the festival was set in and around the Polyclinic Moengo (an abandoned local hospital) and featured works by more seasoned and well-known artists (Bernard-Akoi Jackson, Dirk van Lieshout, Rinaldo Klas), as well as emerging positions (Annemarie Daniel, Ruben Cabenda, Neil Fortune, Seravin Pinas, Raquel van Haver, Marcel van den Berg). The local scene is still quite connected to the Netherlands when it comes to funding possibilities, and The Moengo Festival is important and unique not only because of its level of artistic ambition, but also for its broader international scope.

Kitty It seems like it was a busy and highly engaging time. Indeed, the local scene sounds extremely vibrant and the motives of figures such as Marcel Pinas (in organizing the Moengo Festival) could certainly be deemed similar to motives behind Fogo Island Arts—to find alternative ways to revitalize the area and existing community. Your self-directed research is fascinating, and given the colonial context immensely pertinent to the structural imbalances that shape contemporary geopolitics. Did you manage to complete the work on the eighteenth-century images you were researching?

Willem No. It's a project that I have been working on for a long time, and it is nowhere near completion. That part of this trip unexpectedly expanded into something more than what I had first envisioned. I thought I would only be working on this project in Suriname for two weeks, but it also moved into my time in the north of Brazil.

Kitty Is the travel to Salvador therefore an extension of this research in Suriname? Or more generally an extension of your overall research?

Willem I'm trying to see if what I am learning and experiencing in the northeast of Brazil about this part of the African diaspora

could be extrapolated to what I know and what I want to know about Suriname. There seem to be many similarities between what happened in the state of Bahia and how the culture of the diaspora developed and evolved in Suriname. I'm wondering what those similarities are.

What impresses me in the north of Brazil is the breadth of discourse. Obviously, the black community is very sizeable in Brazil—especially in the north—so there is literally a critical mass. The resonance of this cultural presence is impressive to me, not only from what I notice in daily life or in the cultural expressions of this state, but also in how history is canonized, how objects are exhibited, and how art is talked and written about. I recently saw the exhibition "Histórias afro-atlânticas," at the São Paulo Museum of Art (MASP), about the visual cultures of the Afro-Atlantic diaspora curated by authorities in that field (Adriano Pedrosa, Ayrson Heráclito, Hélio Menezes, Lilia Moritz Schwarcz, and Tomás Toledo). I just thought about how incredible it would be if an exhibition like that could take place in the Netherlands, how empowering for all kinds of stakeholders it would be to place that part of Dutch history in a broader context. Afro-Brazilians fight for visibility and equal rights, just like Afro-Dutch citizens. Sadly, the histories of the Dutch colonial project and the Dutch slave trade are not properly canonized, neither in education nor in cultural institutions.

Kitty
What made you specifically agree to the residency in Salvador? You've mentioned how it relates to your interest in Suriname, but perhaps you could talk a little bit more about why you're in Brazil?

Willem
I grew up looking at the work of seventeenth-century Dutch artists commissioned to paint the landscape and the people here. A child in London who is interested in art may see paintings by Tintoretto or Holbein at the National Gallery, but in the Netherlands, my first direct, lived experiences with painting were at the Rijksmuseum in Amsterdam—an institution that collects only Dutch art. There, my only view to the world outside was through looking at the works of local artists that had travelled abroad, like Frans Post. He was among the first landscape painters to depict the Americas. The Dutch episode in Brazil is a very short one, about forty years; during this period, Post made a concise and consistent oeuvre of very high quality works. Another Dutch artist who worked in the north of Brazil is Albert Eckhout. He produced, idealized, and exoticized images of both enslaved West Africans

and indigenous people, and fruits in the framework of natural history, as well as allegorical works. My fascination with the landscapes these two artists depicted is one of the reasons why I've always fantasized about the north of Brazil.

Kitty Are you looking at the landscapes to retrace steps? Or is it more about being in the space where they worked?

Willem Exactly. I want to be in the space where they worked. Collections of Eckhout's works are not present in Brazil, but a lot of Frans Post's paintings have remained in this country, which is quite unusual for art that depicts former colonies. A strong collector base for the work of Frans Post, and the necessary financial means, have created a unique situation in which the largest clusters of his work are actually found in Brazil. I have already viewed five paintings in one collection of the MASP in São Paolo, and I'm traveling to Recife to see another large grouping. By the end of this trip I will have seen about twenty Post pieces within a month, which is a rare thing.

Kitty What are you looking for when you look at these paintings? Perhaps it's better to rephrase this: How do you look at the paintings?

Willem It is something that grows over time. There are a number of publications I am reading at the moment that have helped me a lot, including a catalogue raisonné by two Brazilian authors (Pedro Corrêa do Lago and Bia Corrêa do Lago). But what I always like to locate in the work of seventeenth-century artists are the typologies—how the images rhyme. I'm also very moved by cultural translations or mistranslations: If I can see how a painter who was trained in the Netherlands was conditioned to look at the skyline of Haarlem, how does that sensibility translate to these landscapes? In the case of Post the landscape of Pernambuco is a pristine industrial utopia, in which human figures serve to illustrate the success of the colonial enterprise. I'm always interested in Dutch artists who travel or work abroad, and in seeing what that Dutchness does to their work.

Kitty What is "Dutchness"? Obviously I understand it points or touches on some form of national sentiment, but I'd like to hear your precise thoughts on what distinguishes Dutchness for you in their work?

Willem In the case of Frans Post, it has to do with form. He was a contemporary of Jacob Isaacksz van Ruisdael, a painter who was very much invested in the relationship between the landscape and the sky, and in the position of the horizon. Van Ruisdael went

to great lengths to find horizons that were unusual to his natural surroundings. The dunes around his native city Haarlem are among the few places in the Dutch landscape where one finds a higher viewpoint to look down from. He was always excited about those moments when it was possible to look down, which I can identify with: I love high buildings. One also sees it in the work of Post, a fellow Haarlemmer.

In general, I can't say what Dutchness is—I find nationality a rather elusive identity marker. In the time of Eckhout and Post, Dutchness had to do with colonial, imperial expansion, and it had to do with commerce.

Kitty What happens when you visit a former colony of your country? While this can be a very positive experience, did you meet any resistance? If so, how do you process this?

Willem I experience all sorts of mixed emotions going to Suriname or to any other place where my extraordinary privilege is obvious—which it always is. No one in the world can say they are not a part of the colonial story, and I think it is that shared story that makes for a special relationship.

Kitty What kind of role does a person like you inhabit when you travel?

Willem I'm an artist, trying to connect with colleagues. I'm also a tutor, I teach at the Städelschule in Frankfurt and the Rijksakademie in Amsterdam, both environments to which the international character of both the student population and the faculty are central. From that perspective I'm always on the lookout for exchange and for talented young artists who are interested in further learning.

Kitty What makes this particular dialogue urgent at such a moment?
Willem At the beginning of my art studies at the Rietveld Academie in Amsterdam, in 1989, the Berlin Wall fell, and I thought that the world, and the art world (at that time I still believed there would be only one) would open up. I was, and still am, an avid supporter of the European project as an antidote to localism and nationalist politics and policies. Exchange and artistic investment beyond the former West for me was never a choice, but simply a consequence of our daily reality. As a mentor of young artists I see it as my duty to discuss different models of what an artist's life can look like, and to continuously reflect on how "the art world" does not exist.

Kitty In addition to sharing knowledge, what are the concrete things you have to offer young artists?

Willem The Rijksakademie has been at the forefront of global exchange from the early nineties, hosting at least 50 percent of non-Dutch artists from all continents each year. When I started working at the Städelschule in Frankfurt in 2006 there was one female professor and "international" meant artists from Scandinavia or the UK—which was already quite unique in the German art school landscape of those days. I am proud that the Städelschule by now has made a quantum leap towards a broader and more realistic view of the complex of interrelated art worlds that today defines our professional reality.

Kitty Where did you complete your first and second residency?

Willem There is a legendary psychiatric hospital in the Netherlands that became notorious in the 1960s for conducting experiments with drugs and sex that "got out of hand" in the public opinion. After several reorganizations and development projects, an artist's residency has operated out of the hospital pavilions for the last twenty years. I worked there together with Jeroen de Rijke for three months in early 2000. Although we experienced the place very differently from the start, we knew early on that we didn't want to interfere in the lives of the patients there, but we wrote the script for a film that we produced later that year in Jakarta, Indonesia (*Bantar Gebang*, 2000). The residency was a very important time for me because of the way we were able to come away from it with a clear idea of what we wanted to do. We managed to focus, and conduct a lot of research and planning in an efficient way.

The second residency was the DAAD (Deutscher Akademischer Austauschdienst) Berlin artists-in-residence program. When I arrived in Berlin in 2006, I knew nothing of the city and had never been attracted to it. But, like many others who have done the DAAD residency, I got connected in Berlin and have never left.

Kitty Is there anything that you would take away from those experiences as being particularly compelling?

Willem The few residencies I have done have changed my life. The residency in the psychiatric clinic resulted in a piece that is very important to me, and the DAAD residency literally changed my life because it made me move to Berlin, where I have lived for the last twelve years.

At DAAD, the space that is given to the artists is remarkable. On the one hand, there are very skilled staff who are able to assist on whichever professional need a guest might have, but on

the other, the basis of the program is that what you do in that city is nobody's business—you're entirely free. If there is a way to connect your activities to DAAD, either through their gallery program or in another way, you're welcome to pursue that, but it doesn't have to happen at that moment. At DAAD, I began working on an exhibition I presented four years later at the Neue Nationalgalerie called "Intolerance." It was important for me to link that exhibition back to the DAAD residency because it felt connected to that time. When the show was finally held in 2010, DAAD contributed to the production of the catalogue, which was half of the exhibition. That was a very meaningful connection for me, and that is another thing that they do very well: they search for output that is meaningful. They don't do it because they have to. I think that is a very healthy way of looking at art and artists and studio practice, as well as what matters to artists and to the public. Because DAAD is publicly funded, I think there is a very sharp understanding of what the mission is of that place.

Kitty Why did you choose to go to Berlin?

Willem When I went to Berlin I did not have a specific project to work on. I wanted to leave Amsterdam because the climate of increasing nationalism in that city since the late nineties made me feel very claustrophobic. When I left in 2006, it was mainly because I had a hard time understanding what was expected from me as a "local"—how to fulfill that role was confusing for me. Of course I still feel very connected to the Netherlands, but at this moment in my life it is still easier for me to be Dutch at a distance.

Kitty You have talked about the works that have arisen from particular residencies, such as the film about Indonesia and the exhibition "Intolerance." Can you tell a little more about some of the other, residual consequences of previous residencies you have participated in?

Willem In the case of Berlin, I decided to live in that city, so the residency could not have been more impactful. There have been major consequences to my life and work by relocating to a different country. I guess people are inclined to fantasize about what their dream place is—and for me Berlin was never that place. I hardly knew about Berlin before moving there, but it has been very good to end up living in a city that was not my dream town: I did not have overblown expectations so Berlin does not have to fulfill any projections of mine. At the same time, it has done a lot for me that has been special and fantastic, and I'm entirely grateful for it.

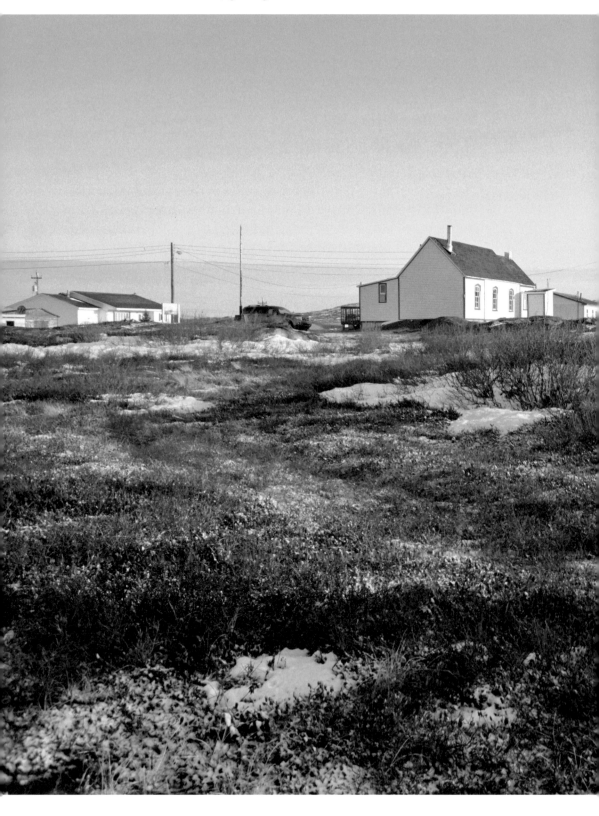

Abbas Akhavan:
THERE IS SO MUCH ROOM FOR DISTANCE

Abbas Akhavan (currently based in San
Francisco on a long–term residency) is an
artist whose practice ranges from site-specific
ephemeral installations to drawing, video,
sculpture, and performance. The direction
of his research has been deeply influenced
by the specificity of the sites where he
works: the architectures that house them, the
economies that surround them, and the people
that frequent them. He is the recipient of
Kunstpreis Berlin (2012), the Abraaj Group Art
Prize (2014), the Sobey Art Award (2015), and
the Fellbach Triennial Award (2016).

Abbas Akhavan, *Untitled*, 2013–ongoing
Ink on photodegradable paper, 6 (63 x 44 cm)
Photo: Samuel de Lange

The following letter is an excerpt of Abbas Akhavan's correspondence with Vassilis Oikonomopoulos, first published in *Abbas Akhavan* (Milan: Skira / Dubai: Works on Paper, 2018) edited by Amy Zion, with texts by Saira Ansari, Omar Kholeif, Marina Roy, Vassilis Oikonomopoulos, and Francisco-Fernando Granados.

September, 2016
Fogo Island

Dear Vassilis,
[…] Today, it was particularly calm and foggy. I am living in a tiny turquoise saltbox house at the edge of a rocky landscape on the Atlantic Ocean. I am spending two months here, and I am nearly halfway through.

You're correct about my work habits on the island. I don't really work in the landmark studios. I rarely visit them. My previous visit to Fogo was similar. I just stay in this small house by the water—somewhere so alien to my upbringing. The first time

I arrived on Fogo, I wanted to call my mother and tell her that I finally "made it." Not because I had been offered something financially grand or decadent but because of the quiet I was granted: access to a modest house sitting by the shoreline that is just past these wild purple flowers swaying in the wind.

Every few days, I make a small drawing. I use ink on photodegradable paper made of stone. The paper is laid flat with a slight elevation at the top. I pool water and ink at the top of the page. The liquid pool is large enough that it wants to run down the slight slope of the paper. Using a brush, I pull the ink into less direct paths, drawing out its run to the bottom by making grid-like horizontal and vertical lines. Once at the base of the sheet, the ink sits for ten hours or so until it dries. For now, this is all I have in mind.

As for what I am doing here, in general, labor is relative, productivity is hard to measure, and this place facilitates something like no other: I am given permission to sit and do nothing. Somehow, this is one of the hardest

179

tasks I have ever taken on. I say this while I'm mindful of my current privileges as an artist. Nonetheless, watching time pass by for two months has proven so far to be very taxing yet incredible.

Some things here are reliable: the wind, so stubborn that trees grow crawling close to the ground; the water always washes up on these soft pink boulders; and, every night, a sunset. And in this space where I can sit still, I have given up—for now—the desire to learn or gather or get more done. I am here to witness this landscape and, in this heavy boredom, I might man-age to look closer at things often neglected. We are so focused on momentum and productivity, but I am simply trying to listen. Days are long, weeks fly by quickly. I don't drive here, so my objectives, like my movements, are slow and sedentary.

When speaking to friends or people I meet here, I'm often asked about my objectives. I tell them that I have no obligations, that I am trying to do nothing, to work through the boredom, to get empty, to recalibrate expectations of

productivity. But despite what I say, they advise me to meditate a lot and focus and to not do this or that, to not watch TV. Within their advice, they are encouraging and measuring productivity. They are trying to guide me to figure out what emptiness means, but my ambitions are otherwise. I am just trying to feel empty. I am not trying to get to the bottom of emptiness.

So, to answer your question, do I have a specific process? Not really. But I am hoping to arrive at wherever I am headed, through unfamiliar paths.

Last time I was living on Fogo, I would write in the morning, make tea, meditate every so often, read very little, go for short walks, and, after watching the sunset, I would use my writing as kindling to make a small fire. After eating supper, I would listen to music, occasionally have a solo dance party, and go to bed.

Don't be charmed by these stories. They sound beautiful in three-hour chunks, but when those three hours repeat for thirteen hundred hours, it becomes a different experience. So, I write often but not with an aim. I consider

it akin to sweeping, trying to gather thoughts out of my mind and herd them along with detritus and loose change, pushing things around with a pen on paper. I am trying to learn to see this landscape. My presumptions about this place are pictorial rather than experiential. I am learning to decipher the proximity of sound and how it travels. Here, you rarely hear noises near to your ears; they mostly come from far away. There is so much room for distance. Here, you see the weather come about from miles away, and you can watch as it goes over your head and keeps going. Here, the moon cannot be overlooked or forgotten. And at some point the landscape is no longer visual, it physically wraps around you, like a fog.

Recently, while walking, I saw a sea urchin. I often see them along the water. But this one looked slightly odd. After closer examination, I noticed that the object was actually an old blue plastic hairbrush. I realized then that the shape of the urchin is the consequence of the ocean's temperament and that round shape is symbiotically beneficial for the urchin's

mobility and survival. The hairbrush, bearing the markings of corrosion caused by waves crashing over pebbles, looked in texture and shape just like an urchin. All that to say that this landscape does just that. It slowly alters you.

It's remarkable, this sky, these rocks, it all exists and has existed for something like 420 million years. Always here and completely regardless of my presence, and yet when I am here, I take it all so personally. As though it is all synchronized so perfectly for my pleasure.

You asked, is there a point at which I know that a project is taking shape? I am not sure if these sorts of questions have answers, at least not clear ones. In my experience, things surface in form or content in ways that are not chronological or totally strategic, like a compost pile where unpredictable ideas germinate. Sometimes, while planning one work, something more pressing comes through, something I have been thinking about passively for a long time but have been pushing back. Often the works are more effective when they don't feel like "great ideas."

Monika Szewczyk:
IS SHOREFAST A WORK OF ART?

Monika Szewczyk (based in Berlin) organizes
exhibitions, writes, and edits. She has taught
at Emily Carr University in Vancouver
(2002–2007); Piet Zwart Institute in Rotterdam
(2008–2012); Bergen Academy of Art and
Design (2011); and the University of Chicago
(2012–2014). She was a curator at the University
of Chicago (2012–2014); head of publications at
the Witte de With Center for Contemporary Art
in Rotterdam (2008–2011); and a member of the
curatorial team of documenta 14. She serves on
the advisory board of Fogo Island Arts.

*Artworks extend the realm of human domination
to the extreme, not literally, though, but rather by
the strength of the establishment of a sphere existing
for itself, which just through its posited immanence
divides itself from real domination and thus negates
the heteronomy of domination.*
– Theodor W. Adorno[1]

*The foundation by its very nature, is a public benefit
economic system. And I imagine the form of the foun-
dation to be the appropriate form for the whole social
organism, for its production and its consumption.*
– Joseph Beuys[2]

On the vast contemporary art landscape, it is possible
to register the varied work of corporations. Sometimes
the evidence is banal; i.e. most artists file taxes
according to the same principles as small businesses,
enabling a certain distance between private persons
and the enterprises that transact the production,
promotion and sale of artwork. Sometimes, there is
deep and mutual investment; for instance, Charles
and Ray Eames' *Powers of Ten* (1977), a seminal video
work commissioned by the IBM Corporation uses the
commissioner's computerized imaging technologies
as well as the lakefront in Chicago, very close to where
the company built a landmark office tower designed
by Ludwig Mies van der Rohe.[3] The dialectic of
corporate and artistic activity becomes all the more
interesting when artists take on the mechanisms of
incorporation as a medium or artistic method. And by
considering some concrete examples of this phenome-
non, it becomes possible to ask if certain corporations
are thereby also works of art.

More than semantics are at stake here. The roles
of corporations continue to evolve, with formidable
social and environmental consequences. If we look
back, we realize that corporations predate modern
nations, organizing all aspects of life, including
people's relation to each other and to non-human
entities, both natural and supernatural. Founded in
1670, by an English royal charter, the Hudson's Bay
Company came to dominate all forms of social life in
its quest to maximize profit (for its shareholders in
England) from the highly lucrative yet increasingly
competitive fur trade found in the region they called
"Rupert's Land," or "Hudson's Bay."[4] The charter
stipulated trading monopolies for all waters flowing
from the Bay, which extended to the West Coast of

1
Theodor W. Adorno, *Aesthetic Theory*, ed.
Gretel Adorno and Rolf Tiedemann, trans.
Robert Hullot-Kentor (London: Continuum,
2002), 77.

2
Joseph Beuys, with Johann Phillip von
Bethmann, Hans Binswanger, Werner
Ehrlicher, and Rainer Willert, *What Is Money?
A Discussion*, trans. Isabel Boccon-Gibod
(West Sussex: Clairview, 2010), 68.

3
The American designers Charles Eames
(1908–1978) and Ray Eames (1912–1988)
"first created this documentary short in
1968. The film was called *A Rough Sketch for
a Proposed Film Dealing with the Powers of Ten
and the Relative Size of things in the Universe*.
In the spirit of iteration for which they are
known, they rereleased it in 1977, under the
name *Powers of Ten*. The film is an adaptation
of the 1957 book, *Cosmic View*, by Kees Boeke,
and more recently is the basis of a new book
version. Both the film and book adaptations
follow the form of Boeke's seminal work;
however, they feature color and photography
rather than black and white drawings. In 1998,
Powers of Ten was selected for preservation in
the United States National Film Registry by
the Library of Congress for being "culturally,
historically, or aesthetically significant." Eames
Office, LLC website: http://www.eamesoffice.
com/education/powers-of-ten-2/ (accessed
September 20, 2018).

4
The Charter imparted control in the Hudson's
Bay area and in all the areas surrounding
waterways that flowed from the inland sea,
effectively putting the company in control
of vast swaths of North America stretching
to the Rocky Mountain Range.

North America. Once the world's largest landowner, the Hudson's Bay Company became the largest private landowner within the dominion of Canada founded in 1867.[5] Around this time, the Company also transitioned its fur trading posts to more broadly stocked retail outlets that persist (albeit in a significantly mutated form) to this day.[6] It is now self-described as a "diversified global retailer focused on driving the performance of high quality stores and their omnichannel offerings and unlocking the value of real estate holdings." It controls Hudson's Bay, Lord & Taylor, Saks Fifth Avenue, Saks OFF 5TH, Galeria Kaufhof (the leading department store group, in Germany), and Belgium's only department store group, Galeria INNO.[7] Understanding this corporate entity's complex social impact depends greatly on the lens one uses. There are of course people who make strong and categorically different claims over the territory that Canada took over from the Hudson's Bay Company. Indigenous cosmogenies challenge notions of ownership with ideas of belonging, and move beyond the human realm to encompass non-human beings as subjects with sovereignty.[8] Rarely (if ever) however is such plural and reflexive historical work conducted by the corporation itself.

THE CONSCIOUS CORPORATION

We glimpse significantly higher degrees of self-reflexivity in the case of certain artists whose works take the form of corporations. MadeIn Company, the creation of the Chinese artist Xu Zhen, is a key case in point, in part due to the conflations of artist, corporation, and indeed nation (China as a global manufacturing giant is all the more present through its conspicuous absence at the end of the Company's English name).[9] The first production of MadeIn that I encountered, shortly after the Company's inception in 2009, was presented at ShanghArt Gallery in Shanghai.[10] Entitled "Contemporary Art from the Middle East: Seeing One's Own Eyes"—the enigmatic subtitle a sure signal of heightened self-reflexivity—it struck me on first take as a group exhibition. And even after learning that one artist had conceived all the works (working in productive dialogue with studio assistants and manufacturers), it remains clear that this was an upturning of the "solo show," that well-rehearsed celebration of art as the creative force of a single individual.

5
Hudson Bay Company wikipedia entry: https://en.wikipedia.org/wiki/Hudson%27s_Bay_Company (accessed September 20, 2018). Note: the company's motto on its coat of arms, *pro pelle cutem* (skin for leather), is likely a reference to the Book of Job in the Old Testament, *Pellem pro Pelle* (skin for skin). Such insignia often tie the company's earthly work to divinity.

6
Hudson's Bay Company (HBC) website: "Our History," https://www2.hbc.com/hbc/history/.

7
Hudson's Bay Company (HBC) website: "Our Company," http://www3.hbc.com/hbc/about-us/.

8
See the National Film Board of Canada (NFB) production, *The Other Side of the Ledger: An Indian View of the Hudson's Bay Company* (42 min, 1972), co-directed by Martin Defalco and Willie Dunn (the latter a member for the NFB's all-indigenous production unit called Indian Film Crew established in 1968). Available at National Film Board of Canada Institutional website: https://www.nfb.ca/film/other_side_of_the_ledger/. My own understanding of the resistance of Indigenous economic imaginaries to the perplex pressures of colonial capitalism is greatly indebted to discussions with Candice Hopkins and her published writings. See Candice Hopkins, "Outlawed Social Life," *South as a State of Mind*, no. 7 (documenta 14, no. 2), online at https://www.documenta14.de/en/south/685_outlawed_social_life (accessed September 20, 2018). See also Candice Hopkins, "The Gilded Gaze: Wealth and Economies on the Colonial Frontier," *The documenta 14 reader*, ed. Quinn Latimer and Adam Szymczyk (Munich, London, New York: Prestel, 2017), 219–50.

9
In Chinese, the name implies more the sense of Unlimited (没顶公司), again playing on corporate structure.

10
ShanghArt Gallery website: http://www.shanghartgallery.com (accessed September 20, 2018).

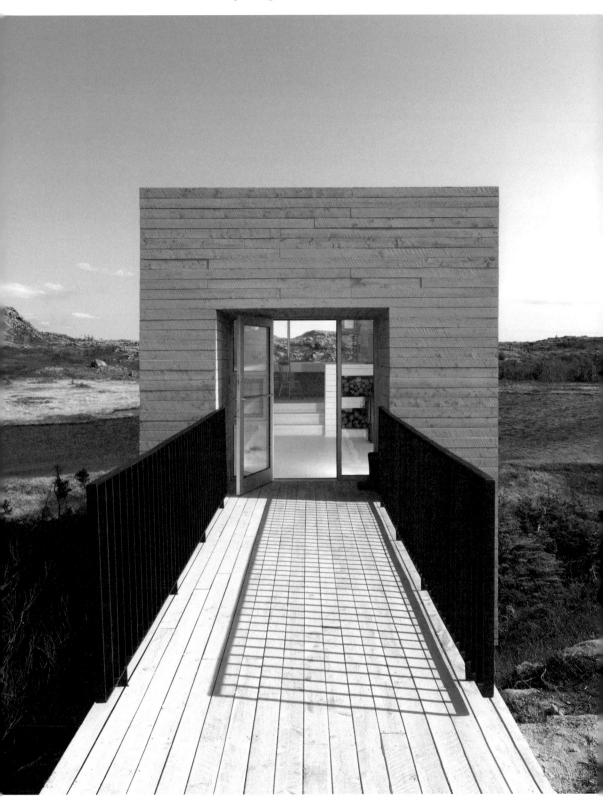

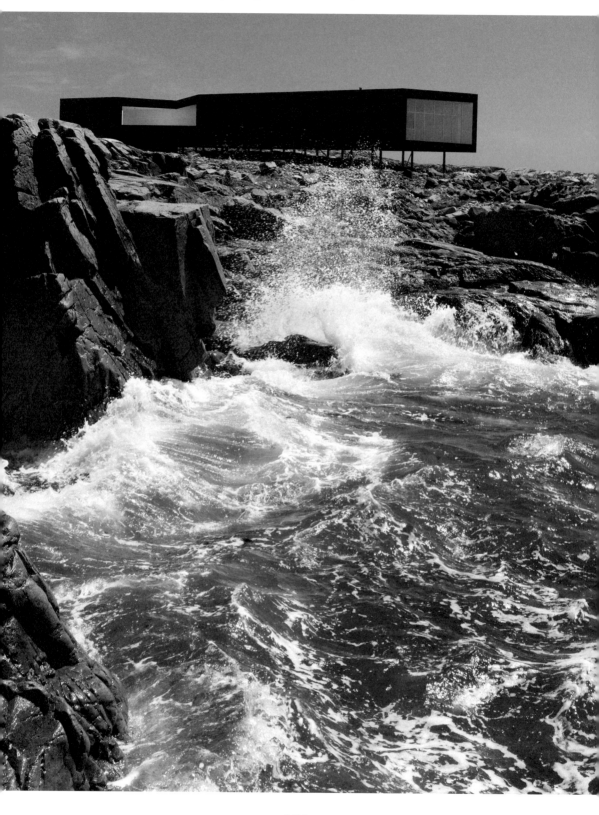

MadeIn Company's first exhibition may be broadly interpreted as a demonstration of how cultural identity becomes a commodity (which itself is far from a simple thing, pace Karl Marx). The artist himself speaks in expansive terms about his chosen frame: "An art company is not a regular company, but it's also not an artist studio, so results are hard to measure. It's like Apple, which announces its earnings every quarter but is not only interested in how much money it makes—Apple wants to have a cultural impact, for people not only to pay attention to its products but adopt its style." Significantly, a corporation becomes an aesthetic as much as an economic model.

This post-individual art is precisely what MadeIn aspires to advance: "Last year, I had a conversation with art historian Liu Mingjun about this shift from making particular works of art to something more akin to articulating a cultural sensibility."[11] There are different ways that the artist goes on to characterize this sensibility. MadeIn's art, while made in China, is not concerned with signifying as Chinese, knowing full well that this national or ethnic branding is applied less to Western contemporary art than relatively new players in the field, mostly from former colonies of the West. All the while, it subtly shadows China as a corporatized nation requiring a frame of reference beyond Westphalian sovereignty, which it should be noted arose from exhaustion with thirty years of (Christian) religious war. We may question if corporate culture is therefore partly filling the spiritual vacuum of the secular nation state. MadeIn Company's "ambiguous manifesto," *Physique of Consciousness* (2011–ongoing) involves researching various faith- and philosophy-based methods and practices from disparate cultures and civilizations, then synthesizing them into a hybrid calisthenics routine for dissemination via video, performances, and installations. Synthesizing various beliefs systems on the level of physical activity gives a deeper meaning to the term incorporation.

MadeIn has persisted in its focus on making, creation, materialization, affecting the worldly realm, while increasingly infusing its production with meditations on Heaven and Consciousness.[12] Four years after its inception, the MadeIn Company (re-)released Xu Zhen® as a brand.[13] In the realm of contemporary art, exhibition lists, formulaic artists' bios, and the tendency to pack complex endeavors

11
Xu Zhen and Philip Tinari, "Moving in a Bigger Direction," *Parkett*, no. 96 (2015): 148–55. Nicolaus Schafhausen and I included a work from "Seeing One's Own Eyes," in an exhibition we co-curated at the Dutch Culture Center in Shanghai in 2010, entitled "Nether Land," while he was director and I was head of publications at the Witte de With Center for Contemporary Art in Rotterdam.

12
I have written more extensively on the implications of this approach. See Monika Szewczyk, "MadeIn Heaven," *Parkett*, no. 96 (2015): 164–70.

13
Although I doubt the connection to former presidential candidate Mitt Romney, or American corporate law, is direct for the artist (as he speaks of his own lived experience of Buddhism, and the Daoist or Christian practice among friends when discussing *Physique of Consciousness*), it is worthwhile to consider his branding gesture as a way to materialize Romney's much-debated quip during his bid for the US Presidency in 2011, "Corporations are people, my friend." Romney's statement went viral amidst deep public worry about the implications of corporate personhood and the 2010 ruling of Citizens United vs. Federal Elections Commission that lifted the ban on corporate spending for political messaging (previously reserved for individual citizens). Romney was speaking to a heckler at the Iowa State Fair, August 11, 2011.

into sound-bites, not to mention the terminology of the gallery "stable" all hint (not very subtly) at human commodification. By incorporating and trademarking his own name, MadeIn Company's Xu Zhen® is clearly asserting this shift in subjective consciousness. Yet he may also be looking for possibilities to move beyond or to the side of individual subjectivity, as evidenced by this assessment of fellow artists: "[Sigmar] Polke started from the perspective of 'I,' wanting to express something through art, whereas for [Jeff] Koons, the self seems to become unimportant. That is the direction I hope to move in."[14]

THE UNDEAD CORPORATION

To extend the line of thought and action wherein building a corporation surpasses the notions of the individual human ego and of the nation, it is useful to consider the work of Yugoexport. She is an avatar of the garment manufacturer Jugoexport (original and copy are pronounced identically). The original was incorporated in 1953 under the laws of the former Yugoslavia, within the ethos of self-management developed during Josip Broz Tito's leadership of the nonaligned socialist republic. Jugoexport dissolved fully last year after struggling to stay afloat with the debilitating restructuring of company debts, and the shift of garment manufacturing offshore following the violent dissolution of Yugoslavia. The founder of Yugoexport, artist Irena Haiduk, was born in this state's capital, Belgrade, but—as her unpublished text "Against Biography" implores—the account of her personal trajectory is not as crucial for her as the narration of her corporate creation, which involves human and non-human agents on equal terms.

Registered in the US, where corporations are people, and headquartered in Belgrade, Yugoexport was launched in 2016, in Paris, with a performance that told the story of an ensemble of clothing and accessories for the working woman referred to as the Yugoform.[15] The black variant of the Borosana, an ergonomic shoe developed at the Borovo factory in Vukovar (now Croatia) over the course of nine years (1960–1969) for nine hours of comfortable standing labor, plays a key part in the "Yugoform."[16] Haiduk began collaborating with Borovo already in the noughties and the resulting work of art, *Nine Hour Delay* (2012–58), experiments with the distribution of the black Borosana shoes to female-inclined workers of arts organizations.[17]

[14] Zhen and Tinari, "Moving in a Bigger Direction," 152. Several of MadeIn's expertly manufactured works exist in material dialogue with the pop transcendence of Koons's oeuvre. And it is pop, in the work of Andy Warhol onwards, that plays most consistently with the transformation of self into product, just like everything else.

[15] Yugoexport's Paris launch in 2016 was dedicated to Yugoslav fashion designer Aleksandar Joksimović whom Haiduk appreciates for declining a position at Christian Dior in order to continue his work at Yugoslavia's Centrotextil. There he developed contemporary designs synthesizing his studies of Byzantine Era textiles as well as south Slavic folk dress codes.

[16] The choice of singular black unifies all the women wearing Yugoexport's Borosana issue and moves beyond color-coding of the original production line, which accentuated class and wage divisions: blue for blue-collar workers, such as maintenance staff, and white for nurses and doctors, and employees that are more educated.

[17] Haiduk's enigmatically titled and dated work spells out an imagined delay in the dissolution of Yugoslavia as each activation of the work, involving the production and distribution of black Borosana shoes (sizes 35–42) to female-inclined workers of an arts organization, prolongs the productive use of an enterprise incorporated during the Yugoslav era. For further information, see Irena Haiduk website: https://irenahaiduk.com/work.

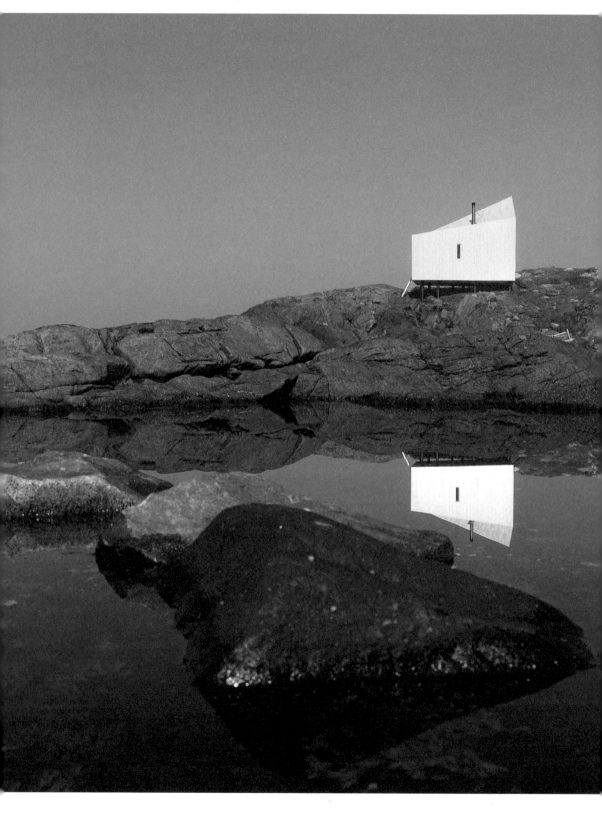

To produce dresses and other portable items, Yugoexport recruited skilled garment workers from the disbanded Jugoexport, delaying their retirement beyond the dissolution of their employer. Notably, Jugoimport, the corporation founded in 1949 for the needs of the Yugoslav defense industry, thrives to this day under Serbian government ownership, answering the rising global demand for armaments. Meanwhile Yugoexport is gradually building its own "Army of Beautiful Women," comprised of female-inclined individuals, who do not engage in conventional warfare or notions of womanhood and whose beauty is measured by confidence and comfort rather than any adherence to a fixed picture.[18]

Haiduk challenges us to perceive Yugoexport in the shady provinces beyond the realm of the Western image—the default currency of that branch of art which stems from the twin developments of humanism and colonial capitalism. While the West's images celebrated the divinity of white human forms (epitomized by ancient Greek and Roman marbles, albeit stripped of the bright pigments which enlivened them in Antiquity), they framed entire populations (of non-Western people, animals, things, minerals and materials) outside the realm of self-determination.[19] These groups have typically been shown as objects or subordinates to the subjects of Western kingdoms, nations, and images.[20] Shunning such limited notions of the subject, Yugoexport is created as a living entity. She is in the business of advancing a tradition of storytelling that harks back to the blinded guslars who sustained Southern Slavic traditions under Ottoman occupation through sung epics. Haiduk refers to Yugoexport as a "blind, non-aligned, oral corporation," which does not mean that storytelling is its sole purview but that each item produced comes alive through stories, and multiple meanings and uses.[21]

Yugoexport also tends towards fuller use of existing laws, infrastructures, materials and technologies. This resourcefulness permeates *Frauenbank Servers for .Yu* (2017), made in collaboration with the artists Daniel Sauter, and Jesus.D, and launched at the Whitney Biennial for American Art in 2017. In the gallery, it exists as a mirrored tower containing a server that hosts *Frauenbank* (2017), described as: "a blockchain smart contract named after the first women owned and operated banking cooperative from 1910 Berlin." Its description online bears repeating in full:

18
Outfitted in the Yugoform, members of this army practice such poise in the walking performance entitled *Spinal Discipline*. *Spinal Discipline* (2014–) is an exercise, first performed as part of Yugoexport's extensive presence within the documenta 14, for which I was a curator, and which also incorporated the above-mentioned *Nine Hour Delay*, and a reconfigured presentation of *SER (Seductive Exacting Realism)*, a sound work, meant to be heard in complete darkness, which is based on an interview the artist conducted with Srdja Popovic, a consultant and founder of the student group OTPOR! (meaning resistance) that helped to depose Slobodan Milošević in 2000, and the consultancy CANVAS (Center for Applied Nonviolent Action and Strategies).

19
Or, as Yugoexport's Articles of In-Corporation phrase it: "The Western relation to art comes from its treatment of all things, including humans, as expendable raw material. This is why the West wastes them away by sucking the life out of them to become art, things must be dead and drained of all utility then, the West can step back and look at a thing made solely for contemplation." This segment of documents, also entitled *How to Surround Yourself with Things in the Right Way*, is reproduced here by permission of the artist. The full eight articles are relayed orally by members of the Army of Beautiful Women, and have also been etched into marble for the making of rubbings, a customary treatment of ancient epigraphs that emphasizes Haiduk's notion that history cannot be perceived (packaged) from a distance but must be known incrementally through contact in proverbial or real darkness.

20
Kerry James Marshall, a key mentor of Haiduk's when she was in graduate school at the University of Illinois in Chicago, has built his painting practice around an astute revision of Western painting, positing black figures in the complex roles of protagonists previously reserved almost exclusively for people of visibly Western European heritage.

21
In giving things greater agency, she connects to animist traditions found throughout the countries of the non-aligned movement and beyond.

"Frauenbank is structured as a decentralized autonomous organization on the global Ethereum network, where operations are recorded and verified in a public ledger called the blockchain. By joining the Whitney Frauenbak.YU network and using the Frauenbank app, female-identified visitors are guided through the process of acquiring membership and taking part in the future of the cooperative. The immutable peer-to-peer contract equalizes power within Frauenbank where each member claims one vote regardless of the number of shares held. At the Whitney Museum, contributed financial assets are put towards the purchase of Serbian land, owing to a 2017 law permitting foreign acquisition of public and private real estate. Frauenbank generates a cooperative space and a new kind of property that is neither private nor public, grounded in former Yugoslavia's digital and physical domain."[22]

The state of Yugoslavia is not so much expired as reconstituted as a corporation, existing in the physical realm and online, wherein humans collaborate with block-chain technology to reclaim parts of the state of Serbia. The servers in the museum are also working in the service of Frauenbank as an unfinished story of financial self management by women. We can understand the procedure as the pursuit of a story with real world impact. Taking advantage of the blurry definition of who or what entity may purchase real estate in Serbia, Yugoexport moves (well beyond the reflexive function of art) towards intervention in the legal status of actual territory. Asked what Yugoexport might do with the land purchased via Frauenbank, Haiduk offers a question in turn: "Amidst the vast abuse of offshore purchasing powers to relegate parts of the Serbian countryside to dumps, cargo holding zones, single resource extraction and what Rem Koolhaas has termed 'junkspace,' what would it mean for this place to be understood instead as a landscape?"[23]

THE INCORPORATION OF ANY THING

What is a landscape? N. E. Thing Co., founded by the artists Iain and Ingrid Baxter in 1966, and officially incorporated in 1969, addressed this question in expansive ways that become all the more pertinent with today's expansion of corporate agency. At the height of their activity, in 1969, the Company took a Canadian Council–funded trip from their headquarters in North Vancouver, British Columbia to the country's

[22] Daniel Sauter website: http://danielsauter.com/gallery.php (accessed September 20, 2018).

[23] Summary of a conversation with the artist on September 16, 2018.

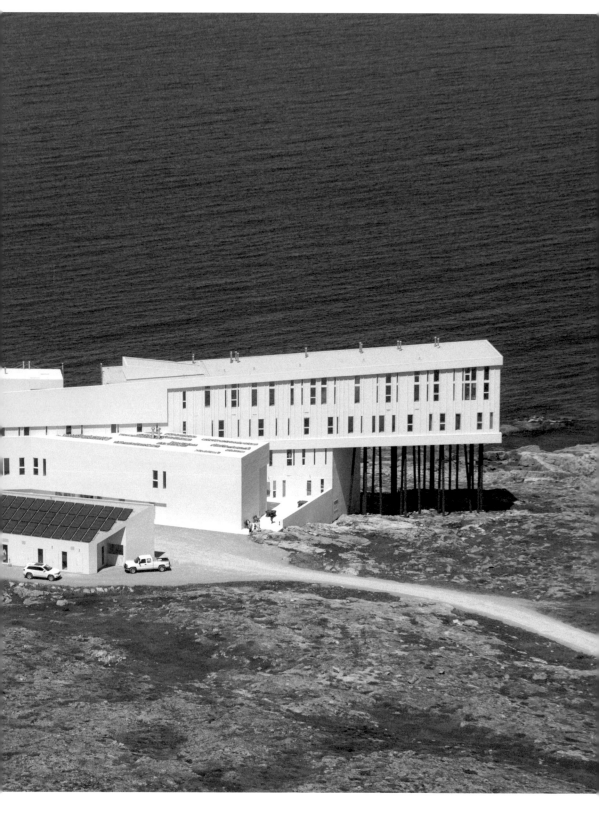

easternmost edge on the Avalon Peninsula in Newfoundland. There, their cross-country exploration (with several strategic stops along the way) ended in a simple yet grand gesture of installing the sign: "YOU ARE NOW IN THE MIDDLE OF A N.E. THING CO. LANDSCAPE" This claiming of territory was certainly conscious of the long tradition of Canadian landscape painting, with household names such as Emily Carr and the Group of Seven or, after World War II, the Manx painter Tony Onley.[24] Significantly, this tradition begins in the territory traversed by the artists-as-corporation well before the foundation of Canada, with the commissions to draftsmen and painters by the all-powerful Hudson's Bay Company. The HBC would celebrate its 300th anniversary in 1970; and it would mark the occasion by concluding a program begun in 1913, whereby some 100,000 calendars were produced annually as key vehicles for disseminating Company-sponsored landscape images, all variously emphasizing the HBC's dominion in the land.[25] In sharp contradistinction, the N.E. Thing Co.'s gesture was nominal, invoking as many images as there were imaginations coming into contact with the sign that marked the middle of an ambiguous landscape. If the artists did not quite answer "What is a landscape?" with a clear image or a map, they brought the question firmly into focus.

The photographic images that N.E. Thing Co. did produce were often framed in the aesthetics and accessories of administration and surveillance, tending towards the deadpan and banal, ranging from piles of various materials to fronts, flagships, and vestiges of other small, medium, and large businesses as well as other works of art. Anything and everything was categorized into three distinct departments: ARTs, ANTs and ACTs, acronyms standing for Aesthetically Rejected Things, Aesthetically Neutral Things, and Aesthetically Claimed Things.[26] Ironically, amidst this broad range of just about anything, artworks were often rejected aesthetically in favor of more modest phenomena: "Piles are not pretentious—they are being beautiful and doing their thing," wrote Iain Baxter in the introduction to N.E. Thing Co.'s *A Portfolio of Piles* from 1968.[27] A pin issued in 1972, with the text "ART is all over," could be read *both* as the end of art as we know it, and the vast expansion of art's possibility.

That same year, at documenta 5, Ben Vautier's sign placed above the portico of the Fridericianum

24
Ingrid Baxter invokes Onley in her interview with William S. Smith, "Corporate Aesthetics: Ingrid Baxter of N.E. Thing Co.," *Art in America* (April 8, 2014), online: https://www.artinamericamagazine.com/news-features/interviews/corporate-aesthetics-ingrid-baxter-of-ne-thing-co/, (accessed September 20, 2018).
25
See Andrea M. Paci, "Picture This: Hudson's Bay Company Calendar Images and Their Documentary Legacy, 1913–1970," a thesis submitted to the Faculty of Graduate Studies in Partial Fulfillment of the Degree Requirements for the Degree of Master of Arts, Department of History (Archival Studies), University of Manitoba / University of Winnipeg (December 2000), online: https://www.collectionscanada.gc.ca/obj/s4/f2/dsk3/ftp04/MQ57568.pdf (accessed September 20, 2018). The 300th Anniversary Year also saw the publication of a fourteen–print boxed set by Bulman Brothers of Manitoba featuring prints of HBC commissioned paintings "documenting" important events from the exploratory voyage in 1669 until 1942.

26
Kevin Griffin, "This Week in History: N.E. Thing set out to subvert the visual status quo," *The Vancouver Sun* (September 9, 2017), available online at https://vancouversun.com/news/local-news/this-week-in-history-n-e-thing-set-out-to-subvert-the-visual-status-quo (accessed September 20, 2018).
27
From N.E. Thing Co., *A Portfolio of Piles* (Vancouver: Fine Arts Gallery, University of British Columbia, 1968), loose leaves. See also Nancy Shaw, "Siting the Banal: The Expanded Landscapes of N.E. Company," originally published in *You Are Now in the Middle of a N.E. Thing Co. Landscape* (Vancouver: UBC Fine Arts Gallery, 1993). Available online: http://vancouverartinthesixties.com/essays/siting-the-banal (accessed September 20, 2018).

read: *Kunst ist überflüssig* ("Art is superfluous" yet also, more literally, "over-flowing"). Inside, Joseph Beuys's *Büro für Direkte Demokratie durch Volksabstimmung* (Office for Direct Democracy by Referendum), made room for an enduring lecture performance or "permanent conference" wherein art flowed into society, ecology, economy and politics.[28] His infamous maxim *Jeder Mensch ein Künstler* (Each person is an artist) gains currency around this time.[29] It is worth noting how capitalism and its critiques maintain a shared totalizing (universalizing) logic. These were still the days when state socialism was a viable option (let us not forget this is the heyday of not only Russian Communism but increasingly Maoism). The tendency to view everything as art, everyone as an artist, went hand in hand with the tendency to incorporate everything into the purview of either the capitalist or the socialist economy.[30]

With today's dominance of globalized, financial capitalism, conceptual art is often read as a critique of this system. What the curator and critic Lucy R. Lippard called "the dematerialization of the art object" is too quickly understood as a rejection of the commodity, even if the world of finance teaches us that concepts (like money or futures or identities) are highly marketable.[31] What may be lost inside this critical prism is a sense of N.E. Thing Co. as an artistic entity interested in operating as a business.[32] The socio-economic imaginaries of the artists that moved beyond or beside picture-making and other art objects—towards the establishment of social structures and that sense of "anything and everyone," require more nuanced analysis.

By incorporating and moving beyond individual agency towards shared authorship (mainly between two persons bound by marriage but others also contributed), the N.E. Company contributed to expanding the horizons of art. Might it also have something to show us about the corporation? When the company disbanded in 1978 with the divorce of its co-presidents, it underscored both that family, economy, and art were deeply entangled, and that these traditional foundations of culture and creation were undergoing profound revision and realignment. This transformation continues to this day. And it may be asked whether the mechanisms of art have thus far been sufficiently applied to reconsider the workings of corporations.

28
For an impression of the era's questioning of the boundaries of art, as expressed during the documenta of 1972, see Dirk Schwarze, "Fast die ganze Welt der Bilder," published online: https://www.documenta-archiv.de/de/documenta/112/5 (accessed September 20, 2018).

29
For further discussion of Beuys's controversial and often contradictory view of art and society see Emese Süvecz, "Joseph Beuys—Organization for Direct Democracy by Referendum," published online: https://casestudiesforeducationalturn.blog.hu/2011/05/24/joseph_beuys_organization_for_direct_democracy_by_referendum. This case study for a seminar of the Free School for Art Theory and Practice (itself a legacy of Beuys's and Henrich Böll's Free International University for Creativity and Interdisciplinary Research in Düsseldorf, established after Beuys was fired from the Düsseldorf Kunstakademie for forgoing the rigorous admissions process and opening up his class to everyone) also suggests that Beuys was a proponent of "third way" economic and political organization, and thus between or beyond both free market and state directed economic models.

30
The exclusionary potential of universalism is neatly demonstrated by the Tate Gallery label for a poster announcing Joseph Beuys's lecture on March 3, 1978, at Humbolt Haus in Achberg, which mistranslates the statement *Jeder Mensch ein Kunstler*, as "Every man is an artist." See: https://www.tate.org.uk/art/artworks/beuys-joseph-beuys-every-man-is-an-artist-ar00704. Meanwhile, the more correct "Every Person is an Artist," has also been challenged. The German art sociologist Andreas Reckwitz quotes Beuys as saying: *Jeder Mensch ein Plastiker (SIC!)*, with reference to Georg Jappe, *Nicht wenige sind berufen, sondern alle: Interview mit Joseph Beuys über ästhetische Erziehung*, in *Kunstnachrichten* (Luzern, 1973). This documented variation is importantly more evocative of Beuys's notion of Sozialplastik or social sculpture.

31
Lucy R. Lippard, *Six Years: The Dematerialization of the Art Object from 1966 to 1972* (Berkeley, CA: University of California Press, 1973).

32
See the interview conducted by William S. Smith, "Corporate Aesthetics: Ingrid Baxter of N.E. Thing Co.," *Art in America* (April 8, 2014). Available online: https://www.artinamerica magazine.com/news-features/interviews/corporate-aesthetics-ingrid-baxter-of-ne-thing-co/ (accessed September 20, 2018).

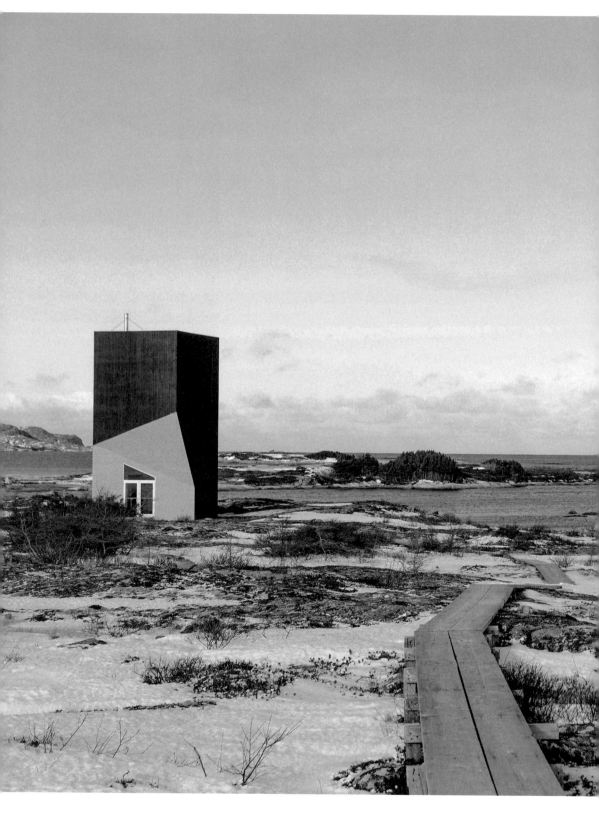

ART AS ANCHOR
AND ANCHORED

Shorefast is a Canadian charitable foundation firmly anchored to Fogo Island in the Province of Newfoundland and Labrador. It is a family business headed by locals, Zita Cobb and her brothers Tony and Allan. It draws revenues from the operation of an inn, a store, and a partnership with a cod-fishing cooperative that has slowly and partially revived the island's historic economy following total collapse due to shortsighted big net fishing. A significant part of Shorefast revenues are funneled into Fogo Island Arts, an organization that combines an international residency, exhibitions program, and wide-ranging dialogues that bring art, economy, community, and sense of place into stronger relation. As a member of the FIA advisory board since 2013, I have observed it at close range, and participated in several editions of the public and semi-public Fogo Island Dialogues, which occur on and off the island. If the cultural landscape of Fogo Island Arts has expanded far beyond the small rocky island in the Atlantic, which lends it a name, belonging to a place (to borrow the telling phrase used for one of its signature projects) remains FIAs challenge to global contemporary art.[33]

In the field of contemporary, the last three decades have seen an "Easyjet-set" worldview of cheap mobility without a firm local anchor giving way to stronger investments in cultural diversity. Yet regional cultural influence on the global arena has tended to follow Western economic interests; MadeIn and Yugoexport have emerged as art corporations wise to such patterns of shifting cultural investment. China and the Middle East, Eastern Europe after the fall of the Berlin Wall, as well as select scenes in Latin America and Africa, are all granted greater attention in the contemporary art arena, with their re-emergence as open markets or sources of raw material, cheap labor, and captive consumers. The tendency of the global economy and financial capital to treat people as numbers, and to detach them from their sense of strength and of belonging to stories and territories (some call this soul and organize zombie parades to signal its loss) is devastating. It has awakened nativist ghosts that last roamed with this fury after the Great Depression of the 1930s, an earlier crisis brought on by the greed of colonial monopoly capitalism. Fogo Island is a microcosm in this volatile system. Yet its small scale and resilient community have proven agile

33
We may also think of the development of "international style" in the architecture and art in the 1930s with its seemingly desire to create connections across vast regional differences. Yet these calls came mainly from protagonists in Western Europe and North America, all rejecting—yet heavily indebted to—the classicism which had been exported globally from the Mediterranean to diverse regions under the influence of a colonial world order that dates back to 1500s AD. Getting rid of the Doric, Corinthian, or Ionic ornamentation did not get rid of the infrastructure of empire.

in facing economic and political forces of sublime
scale and complexity. In virtual space, on Shorefast's
website, Zita Cobb asserts:

*OUR MISSION IS TO BUILD CULTURAL AND
ECONOMIC RESILIENCE ON FOGO ISLAND.
WE BELIEVE IN A WORLD WHERE ALL BUSINESS
IS SOCIAL BUSINESS.*

And further:

*WE EXIST IN RELATIONSHIP TO THE
WHOLE: THE WHOLE PLANET, THE WHOLE OF
HUMANITY, THE WHOLE OF EXISTENCE. IT IS
OUR JOB TO FIND WAYS TO BELONG TO THE
WHOLE WHILE UPHOLDING THE SPECIFICITY
OF PEOPLE & PLACE.*

There was a time when a big difference could
be detected between the operating logics of art and of
most businesses. Business tended to exploit resources
in ways that maximize income vis-a-vis investment.
The bottom line reigned. But as Xu Zhen observes,
businesses increasingly wish to create a culture.
This may still come from a desire to predict consumer
behavior, in times of increasing competition for their
attention, yet it would be naïve to see things so one
dimensionally. Certain businesses, such as Shorefast,
are moving closer to art, understood as the place of
resourcefulness, of articulating beliefs (i.e. living them),
of creating and recreating notions of value. Rather than
the extraction of non-renewable resources for a profit
measured in currencies that tend to read anything and
everything numerically to ensure easy exchangeability,
Shorefast shows how businesses build value systems
that surpass numerical measure and equivalence.
They can articulate an altogether different landscape.

After the last round of reviews for residency
applications to Fogo Island Arts, I came away
wondering what it might mean for N.E. Thing Co.
(were it still active) to visit Fogo? After all, their
imaginary corporate landscape had its temporary
middle not too far away on the Avalon Peninsula.
Their nuanced combination of art and business
would greatly contribute to the work under way on
and off the island in the name of Fogo Island Arts.
While this visit is no longer a possibility, thoughts of
it alter the course of my initial question: Is Shorefast
a work of art? Provisionally I set ART aside and
propose that with its social consciousness, its sense
of belonging, and its creation of value rather than
merely monetary profit, Shorefast is surely an ACT,
an Aesthetically Claimed Thing.

Ieva Epnere:
OF COURSE, AS ALWAYS; TIME IS A VERY IMPORTANT THING

Ieva Epnere (based in Riga) is an artist who works with photography, video, and textile. She employs personal and intimate stories as points of departure for her artistic reflections on identity, history, tradition, and communal rituals.

In my artistic practice I often like to work with the given environment. On Fogo Island, from the very beginning, I had the idea to try to involve the local community in my work. When I was on Fogo for the first time (three weeks in September 2017), time was too short to get in contact with many people, however during that period I had the chance to explore the island and its landscape. I went on hikes together with a geologist in residency, Scott Schillereff, and the local Peter Decker, who is an Outdoor Adventure Guide at Fogo Island Inn, both experiences helped me to better understand this place.

In June, 2018, I had an opportunity to return to Fogo Island and continue to work further. I really enjoyed the process of exhibition-making, even though the time frame was quite limited.

At the beginning, Iris Stunzi and Alexandra McIntosh from FIA helped me to get in touch with members of the local community, but later of course it was much easier, after several meetings, more and more people became involved, and they then helped me with further contacts. All of the people I met were very open and helpful.

Of course, as always, time is a very important thing, nothing happens immediately, you need time to get to know people, to spend time with them, to explain your idea, and so forth. I was very lucky that in this relatively short period I was able to see some results and share in this achievement with the people I collaborated with.

I was happy to see almost all of the people involved at the opening, I imagine some of the participants of my project visited the FIA gallery for the first time, and I very much hope that it will become a tradition for them now, to go and see films and other projects organized by FIA.

I am also extremely grateful to all of the local artists who agreed to participate and contribute an artwork for my exhibition (every month one local artist exhibited one artwork, and each unveiling was accompanied with a little concert by a local musician).

For me, the experience of being away and the possibility to work in different countries and in different contexts has been very fruitful, even though sometimes it felt like almost too many new impressions, looking back, all of my "most important" works were created soon after, or started during an artist residency.

As I am based in a part of the world which is not in the center, like Brussels or Berlin for instance, I often feel that the exchange of information is not enough, the main problem is that the art scene is very small here. The situation has become better since the first Riga Biennial (Riboca 1) launched—because of this event there is some "fresh air" and movement in the local art scene.

Of course I can only speak from my own perspective, but for me the chance to have some time away from home, local problems, and the possibility to experience another culture was very insightful, it also helps to see things differently, more critically, and with more distance. In addition, a very important aspect is this exchange of thoughts and experiences with other artists, which I believe can happen in most residency programs.

Ieva Epnere, *Brianna*, from the series *On water, wind and faces of stone*, 2018, Color photograph

Brigitte Oetker, Helke & Thomas Bayrle:

OVER THE SAME AMOUNT OF TIME

Thomas Bayrle (based in Frankfurt am Main) is an artist whose work often combines traditional craft techniques with computer-generated art of the Information Age. He was professor at the Städelschule in Frankfurt am Main (1975–2005). His work has been shown at, among others, documentas 3, 6, & 13 (1964, 1977, 2012), the 50th & 53rd Venice Biennales (2003, 2009), and the 16th Sydney Biennial (2008). He has had a number of major solo exhibitions.

Helke Bayrle (based in Frankfurt am Main) is a painter, graphic artist, and filmmaker. Since 1992, she has filmed the installation of exhibitions at Portikus, Frankfurt am Main, and her entire archive is available to the public online: http://www.portikusunderconstruction.de. Her work has featured in many international institutions.

From June 20 to September 2, 2018, Thomas Bayrle had a major retrospective at the New Museum, New York. The day after the opening, we met in Gander, Newfoundland, and traveled together from there to Fogo Island, where he and his wife Helke spent a total of four weeks. They lived in one of the houses of Shorefast, and Thomas Bayrle also had a studio to work in. On September 4 we met at their house in Frankfurt and spoke about their stay on Fogo Island…

Brigitte You've done a lot of traveling. What were your specific experiences of Fogo Island?

Thomas There's something wonderfully boring about the island—boredom considered as a positive container.

Brigitte As an artist, how does one experience rural spaces as compared with urban ones?

Thomas As a slowly swelling and subsiding continuity perhaps, as a thread of energy that needs no artificial attractions. Thanks to the quietness you can think differently, because there's less nervousness.

Brigitte How was your encounter with *the unfamiliar*?

Thomas It takes a while to really arrive in a new place. For me it has been like that everywhere. For the first week—after the hard work in New York, and before that in Vienna—I was exhausted. At first, it was nice just to go for walks by the sea.

Brigitte Do artists get anything out of being in a different place, apart from a vacation?

Thomas People usually expect a vacation to offer inspiration, too. I think that's probably a mistake: you have to engage with the place, whether it's New York, Guangzhou, or Fogo Island, and not expect anything specific. It's important to have metaphors for how to get past normal tourism to other levels. For me, the metaphor would be a *woven fabric* or network where thousands of units interlock and interconnect. Like a rug.

Brigitte What do you think of artist-in-residence programs in general? What's your own experience?

Thomas At first, it all feels somehow contrived, annoying. And you ask yourself: Why should anything special happen here? And so forth. And then you tell yourself: Just keep going! In most cases, the results are the same, but with *a different coloration*. We very much enjoyed the freedom on Fogo Island. In 1970, we stayed at Villa Massimo and it all felt too controlled. We kept running away to Rome. It was a great time: Villa Massimo means financial independence. And at the same time, out on the street: *Dito dito, orgasmo garantito…*

Brigitte The mass society and its forms of organization are key themes in your work. Did your experience on Fogo Island alter, influence, or expand your view of these issues?

Thomas I've never applied the concept of mass exclusively to people or industrial production. Through weaving, I always intended to include ways into the micro- and macrocosm of nature. As a child, I was fascinated by bees, a murmuration of starlings, fish, parking lots, and soccer pitches, they appealed to me emotionally. And they inspired me—beyond organic and inorganic forms—to make grids, skins, and bodies.

Brigitte What meaning did this residency have for your work as artists?

Helke I was so fascinated by nature that I was almost always outside, taking photographs or making films, rather than spending time in Thomas's studio. Carnivorous plants, lichens and mosses, juniper, trees—a dream for me and quite different from the city, there's something very elementary about it, the wind, the changing weather, the sunsets, all so primordial, this island is a powerhouse! It's also great that the residency was relaxed in the sense that there's no obligation to deliver, no need to do an exhibition. Although Thomas did have a public talk with Nicolaus, while you were there, and later, I showed several of my films in the cinema of the Fogo Island Inn.

Thomas I did things I would normally never do. I worked and drew like I did fifty years ago. Context, which is often a constraint, lost its importance. What seems forbidden elsewhere was done, repeated, rekindled—I didn't want to hold the line and the context. You stop thinking in terms of career, you let things slide, just doing what's fun. I sat down in the landscape and made drawings, like I did decades ago, really naïve—almost laughable. Today, people are more likely to take a photograph and then continue to work from that. On this island you can be *primitively fresh* somehow, you achieve a directness—in contrast to the predefined lines of the process usually linked with the work. I didn't care if anything came of it, and that was great fun. Drawings of *undergrowth in the shape of Vespas*—a silly idea, I thought! Today I'll make Vespas—out of random weeds or stones. That was relaxing! Here in Frankfurt there's no way I could do that—it wouldn't be right and it wouldn't work. Here I think about my own routine of production and reproduction. The best thing was that I felt I could throw things away. Messing about on a table and not thinking of art…

Brigitte What happens now that you're back? Did the residency make any kind of a more long-term impact on your work?

Thomas Right now, I'm applying this mentality to a large work, two by two meters. Usually, I've always proceeded piece by piece, this time I'm trying something different. For instance with a Pietà—a frequent motif in my work. Often I've rubberstamped, making or copying a gesture that already exists, maybe after Leonardo. Now I switch, finish one section, then abruptly do another in a different way. Previously I would always think carefully: Are you going to do the arm like this, the abdomen like that? At the moment, I don't think at all, I make the arm, the abdomen, and between the two I put something else. Formal and technical aspects get tangled into a lump, one that may be exciting. Okay, that's Fogo Island…

Brigitte Zita Cobb speaks about a kind of knowledge that is locally anchored and that gets lost when individuals or even everyone leaves their homeland (in the 1960s, there were plans to resettle the entire population of Fogo). What's your view on this?

Thomas Fogo Island really is a special mixture. It appears wild and full of life. And the inhabitants also seem to have retained their authenticity, with a special confidence. And now Zita comes along with her foundation that is changing everything here and steering it towards a new future. One of the things she does is to buy old houses, restore them, even making changes to the architecture. In this way, Shorefast is physically present at various locations across the island. We lived in one of these houses. It's more rugged there, not so clean-cut in every detail. Working, reading, frying fish, cooking, eating. For four weeks. Simply living and working, and then keeping or throwing things away. With Shorefast, I think Zita is working on something genuinely different. She struggles, fights, takes care of *everything*. Her main interest is not in ownership, but in a *life project* that she is pursuing doggedly and with great focus. And she doesn't care what other people think. What she's looking after is not her foundation but something more complex. It's not just about the houses, studios, and so forth. It's about a woven fabric that gives direction to all of her ideas and actions. Unlike a normal investor, she understands this island not as real estate, but as complex nature, an unusually pure view. She operates with a highly complex sensitivity, reacting to thousands of tiny details that add up to a magnificent piece of nature. Yes, this woman, Zita, is not merely a manager.

211

She runs from one place to the next, in person, taking every-thing equally seriously. I often saw her running, from the post office, into the shed, onto the cliffs, to the ice cream parlor. A genuine, good, crazy manager, farmer, and visionary who loves this island and affirms it—but she does sometimes say no, if she doesn't feel like doing something. On the day we arrived, I saw a cemetery in a very lonely place among some rocks by the sea. I immediately asked myself: Would you want to be buried here? My answer was: Not really. By the time I left the island I though it wouldn't be bad—to be here—with the sea in the background. I saw that as a sign that I'd already come substantially closer to the place.

Brigitte What do you think home means for people today?

Helke It depends: the loss of one's homeland is terrible! My grand-mother had to leave Gdansk. Out of her sense of homesickness, she described the city to me in such loving detail that when Thomas and I first went there in 1984, I was able to give him a guided tour…

Brigitte That's very moving. I wonder, on that note, of the relation-ships that people make and have with places special to them, what are your thoughts on what art can bring to Fogo Island? What can art accomplish?

Thomas The artistic concept for FIA was developed by Nicolaus Schafhausen, who brings his extensive experience with art to the project. I know him from Stuttgart, when he was running the Künstlerhaus Stuttgart in the 1990s. And from Frankfurt, of course, where he staged some monster exhibitions at the Kunstverein. The first Steven Prina exhibition in Germany, for example, where he almost caused the first floor of the Kunstverein to collapse under the weight of tons of rubble. What he did was never boring! Nicolaus's most important quality is probably his total lack of fear. He persuaded us to go straight to Fogo Island after my opening at the New Museum, which wasn't what we were actually planning to do. He sat down at our kitchen table here in Frankfurt and said, "Just come!" He and Zita, with their sharp intelligence, are achieving great things. The way they complement each other is truly wonderful! When we came to Fogo Island, it took us a while to find where the other artists were living. They are spread across the island, planted like flower bulbs, mixed in with people who have always lived with and from the sea. These people suddenly notice: our homeland, our houses are

worth something, other people are going out of their way to come here. This is the crucial mix. There's something about it like sowing new seeds.

Bruce Mau:
IT'S ALL A RELATIVELY NEW WAY OF THINKING

Bruce Mau (based in Chicago) is a designer, innovator, visionary, and author dedicated to applying the power of design to transforming the world. He was creative director of Bruce Mau Design (BMD) (1985–2010), and serves as chief design officer of Freeman. He is the co-founder and chief executive officer of the global design consultancy Massive Change Network (MCN).

I place the project of Fogo Island Arts, and that of Shorefast, within the broader world of design. I visited Fogo Island about two years ago, and presented the enterprise in an exhibition I curated last year, called "Prosperity for All," because I think of it as a kind of proto-typical model for the future of holistic design.[1] Design that comprehensively considers the ecology of a specific site, the ecosystem of that environment. What it demands is an end to excess.

If humanity is going to be here in anything like the immense scale of occupation that we currently represent, then that's the direction in which we'll have to think. We must reach a way of understanding the challenges we face. That said, I think that the means in which FIA / Shorefast have been working and reflecting—are markedly different from other comparable arts programs, or economic development projects. For too long we have pushed things away that we can't resolve. What is happening on Fogo Island is by contrast a determined effort to think holistically about how to find a way of life that is equitable, abundant, sustainable—and joyful.

The challenges we are facing should be thought of in terms of one total design problem: to find a way of living in unison with the environment of the place, the ecology, while allowing a flourishing economy. In my opinion, the future of design lies precisely in raising the bar to a higher order of complexity. I think it is the future of life on this planet.

I'm a designer and that means I don't have the luxury of not finding solutions. From my perspective, drawing from my experience and daily practice—I need to find solutions. I've made my work to help people solve problems, but I'm often reminded of something that Einstein supposedly said: if he had one hour to change the world, he would take fifty-five minutes defining the question. If questions are templates and transferable, the answers are local and yet also global. In other words, I think the questions that are being asked on Fogo Island can and should also be addressed elsewhere. It made me think and ask the same of my own home town. One of the things I was struck by when I first arrived on Fogo Island was how familiar it was. It felt like being home. I grew up in Canada after all, in Northern Ontario, in a comparable landscape, but with fresh water not the ocean. It had similarly severe weather conditions, and quite an extraordinary, yet remote landscape.

One of the things that I do in my work is to go the opposite way from most classical design practice—which is to make the design brief more concise: to isolate the problem. Conversely, I almost always work toward making the brief more complex. I really want to make the project as difficult as possible to attempt to fully understand the type of context. Doesn't this make things more problematic you might ask? How to resolve the fact that when more questions are raised, less answers or solutions are solved? Perhaps this is true to some extent, but be that as

1
The exhibition "Prosperity for All" took place in Toronto, and ran from September 28 to October 7, 2017, within the framework of the first edition of EDIT: Expo of Design, Innovation and Technology, a project of Design Exchange (DX), Canada's Design Museum: https://www. dx.org/. In partnership with the United Nations Development Program (UNDP) this ten day expo of installations, workshops, and hands-on experiences promoted and celebrated world-transforming design.

it may, I feel passionately about the fact that we need to keep asking questions while finding solutions—ideally, we ought to do both.

For example, given the context of Fogo Island, if the thought to create a specialized fishing company emerged, the parties involved must acknowledge that the questions would not just be about: *How do we make money?* The questions should also be concerned with asking: *How does making money fit into this ecosystem? How do we do it in perpetuity? How do we do it in a way that we can realize this forever, sustaining an ecology and an economy?*

I am aware of the "asset-based community development" methodology partly employed by Shorefast, but I'm also convinced that the initiatives and the whole project can't be entirely summed up by this either. Shorefast uses business models that are geared towards achieving social ends. I'm encouraged by the recent "cauliflower" program. The idea of the cauliflower helps to portray holistic thought. I find it a very interesting metaphor for how the project grows, how the decision processes are made, the offshoots from actions are taken into account by the various parties involved and contribute to constantly reevaluating the impact on the whole. Of course, the outcomes are not always unequivocally positive, but exuberant caution would bring all progress to a standstill. The question always remains how to make the most of the situation, what to aim for, and how best to envision this.

One obvious impact of FIA and Shorefast's activities is an increased carbon footprint, due to increased travel. This is at odds with their otherwise eco-friendly vision. The project of FIA entails that international artists have to board airplanes to get to the island for their residencies. The Fogo Island Inn was created to sustain the economy through geotourism, however it inevitably follows that many of the interested tourists will also require to fly to visit the island. Is this expenditure of fossil fuels a contradiction, then? Is it an untenable cost to everyone—and everything—else?

I think it's certainly a clear example of the interconnected complications or "cauliflower offshoots." Crystal clear in portraying the tensions—the network of connections and relationships that arise which are of global magnitude. We are all walking contradictions, the task is how to try not to be. What remains a question, when exercising these thoughts through, is how actions are offset or justified by the benefits created, or how to mitigate the costs and effects that are imposed.

It seems as though FIA / Shorefast are trying to evaluate and minimize the negative impacts. One of the ways they are doing this is related to scale. From the outset, in fact, FIA did not build a huge artist residency complex, nor did Shorefast build a hotel with 400 rooms, both of which would result in an immediate boost to the economy, yet require an awful lot of people to get onto planes as well as cause

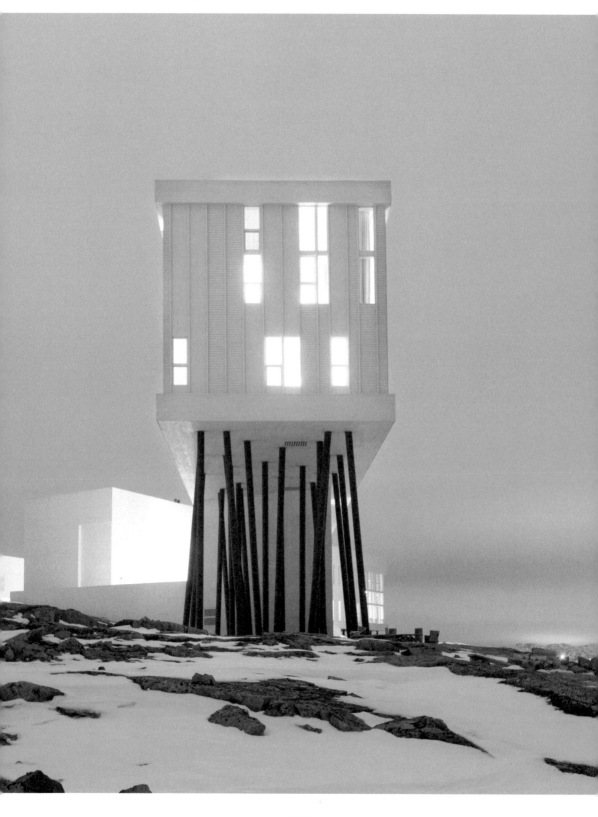

significant disturbance to the livelihood of local residents. The studios are small and limit the number of artists that can stay. The Fogo Island Inn has a business model: with twenty-nine rooms it is priced to a point that requires fewer people. It's interesting that they have been incrementally increasing the minimum number of nights people can stay in recent years, and plan to continue to do so. This would entail fewer airplane trips, and the longer stay may foster stronger relationships between guests and hosts. However, the fact that visitors are predominantly affluent people, able to afford such prices and the longer stay, introduces another tension and raises questions about who has access to the island.

What things are valuable, what is worth saving, and at what ecological cost? These are the ethical and moral questions that should affect everyone today. If the Shorefast project is devoted to realizing welfare for the people of the island, while preserving the natural environment, then I think it's on the right track, as long as considerations of what we call "externalities" continue to be taken into account.

I think it's all a relatively new way of thinking to be honest. If you consider what we did for the last many hundreds of years, we cut problems out from their context. We isolated the problem, and then we designed a solution to that problem. It was a one-to-one relationship and that's been the distinctive mode of design strategies for a very long time. We asked: *How to understand this thing as a discrete entity?* As if a discrete thing was possible when in fact, reality is a complex ecology of interaction.

When we solved the problem of speed and invented the car (because we wanted to move faster, we wanted that experience, we wanted that impact), we solved it with an internal combustion engine. We didn't think about the geopolitical transformation of the planet that this would cause. Ultimately, the impact on the climate and the re-conception of our transportation systems was immense. It's interesting what the car does, the effect the car alone has had. We didn't foresee any of that. The design problem was movement—speed.

Today the design problem is movement in the context of all of life. We don't want to lose the beauty of speed and all of the possibilities that it gives, but how do we manage this in a sustainable way? These considerations push design thinking. We have to develop methods and systems for resolving problems of this complexity. Solutions might involve a different kind of understanding of our place in the world, a different outlook, a different methodology. Fogo represents this new spirit and seeks a new way of understanding these complexities. You cannot magically solve everything, but it is at least worth asking: *What's the best we can do?* I am inspired by this approach. There is no definitive answer, but I think there are some decisive questions.

All this is the outcome of holistic thinking, of thinking about the bigger picture. Thinking about a particular problem, and identifying related questions, is intrinsically related to one's practice. I had an absolutely extraordinary experience when we realized the "Massive Change" exhibition in Vancouver.[2] It was based on a quotation by the British philosopher and historian Arnold Toynbee, known for his twelve-volume oeuvre, *A Study of History*.[3] Writing in the aftermath of WWII, he did not think the twentieth century would be remembered primarily for probably the worst killings in history, or the explosive kinds of technological innovation these killings produced, including rocket engines that would take us to the moon, while also providing for the threat of mutually assured destruction (MAD). The twentieth century "will chiefly be remembered by future generations […] as an age in which human society dared to think of the welfare of the whole human race as a practical objective."[4] I completely identify with this project.

Perhaps I would have phrased it differently, but in a nutshell, that quote sums up what I'm interested in. What is more, I think "the welfare of all humankind" is precisely what most designers are interested in. The term "practical objective" suggests to me that he saw the problem as a design project; not a utopian vision, but something that we can actually do. The exhibition "Massive Change" began as a research project to evaluate Toynbee's proposition. After all, fifty odd years had passed. For me, he was right. After the launch of the project, I gave a presentation in a high school followed by a Q&A session. One of the students took the microphone and said; "I think you're not thinking big enough." I was dumbstruck, and confessed "I can't imagine anything bigger!" I did my best to explain my fascination for the welfare of all humanity as a practical objective. The student, however, replied, "Well, take out 'all of humankind,' and put in 'all of life,' that's our project, that's the twenty-first century project!" I was blown away: She was absolutely right—I had a blind spot. The thought that we owned nature was outdated. We could no longer limit the solution to our own existence; it had to be expanded to all of life.

There's only one thing on the planet, it's life. Life has an experiment going and we're one of the experiments. We don't have perpetuity guaranteed: We're not guaranteed to be here indefinitely. We are here so long as we are stewards and find a sustainable place in the ecology. For the most part we have done precisely the opposite.

I'm just starting a project on the oceans. In my preparation work, I came across a shocking quote, which goes something like: "we treat the oceans as both our pantry and our toilet." In Canada, we use a related figure of speech: "to drive your car into the ground…," and that is literally, what we do: We drive our cars until we cannot use them anymore, and then we push them out into the field, and leave them there as if somehow they will magically disappear. We put our heads

2
The international touring exhibition "Massive Change: The Future of Global Design" opened in Vancouver and ran from October 2, 2004 – January 3, 2005. It was organized by The Vancouver Art Gallery in collaboration with Bruce Mau Design, and the Institute without Boundaries. Massive Change Network website: http://www.massivechange-network.com. The Vancouver Art Gallery website. http://www.vanart-gallery.bc.ca/. Institute without Boundaries website: http://institutewithout-boundaries.ca/.

3
Toynbee, Arnold. *A Study of History: Abridgment of Volumes I-VI* (New York: Oxford University Press, 1947).

4
Mau, Bruce. & The Institute without Boundaries. *Massive Change* (London: Phaidon Press, 2004), 15.

in the sand. As a child, I came across Chevrolets in the forest. How on earth did this Chevrolet get here? Similarly, how did we get Enron? How did we get the financial crisis? How did we destroy the ecologies that sustain us? We had a total disregard for the "externalities" our actions were causing to others. We are finally realizing there is no exterior, there is no outside and no other. We are one ecology, we are one ocean, we are one humanity: We are one life.

The political climate today is desperately trying to move backwards: re-establish boundaries and borders, when in fact the world, life, and knowledge, are going in the opposite direction. For me, the initiatives of Shorefast and FIA appear to be driven by the motivation to make new maps of how we belong to the world, and how we fit in the world. Naturally, the connective tissue takes center stage and becomes the focus of inquiry. When you see the whole as a web—or indeed, a cauliflower—then you become highly conscious of the little connections that hold places, persons, and contexts together.

Design has been, and still is very much concerned with two broad sets of questions. The first considers what the object should look like, what its aesthetic and functional value is, and finally its cost. The second set of questions is much larger and more challenging: *How to design a better connective tissue?* I believe we must all become more aware of the impacts, positive and negative, of the things that surround us. The connective tissue can in many ways provide answers to how we live together.

To take money as an example. We are connected by the financial and business systems that we are part of. They are part of the architecture in which our lives are embedded. It is them that connect me to, for example, a Chinese citizen through the object that they produce, that is shipped, and that I later buy. The madness of the financial and business systems is of course, that they were not designed with the wellbeing of life, whether human or ecological, as their primary aim.

Do objects therefore need to have meaning? I don't think they have meaning in the sense that the thing has intrinsic value. The thing just exists in the history of the world. When I see the objects of Fogo Island, I hear the story of Fogo Island. The story that is passed on through generations, through the boat-makers to the people who made the chair I am currently sitting on. So the meaning is neither intrinsic to the person nor the thing, but rather the story that connects them exists in the person. Great design has a way of putting into the thing a way of finding the story.

There are a lot of different ways to think about it, but if you think about where the world is going—in terms of automation—and the ability to replace repetitive activity, basically anything that is routine will be subject to automation. Routine is not exclusive to physical labor too, so we think of robotics being applied to manufacturing, to an assembly

line, then eventually these functions will be replaced by robotics and that is inexorable. In a positive sense, we're replacing things that are routine with machines, and liberating people to do something else… that's the optimistic outlook. But that routine can also be applied to legal work, accounting work and so many other forms of occupation that are apparently immune to being automated.

While automation has many promising aspects, some things just cannot, and should not, be made routine: creativity and invention, for instance. The more that we see the digitization and the automation of the world advance, the more desperate we will be for authentic, beautiful, creative physical things. Perhaps this will be seen as a cry for embodiment in the disembodied age, but I'd say it's actually closer to a kind of rejection, a response to a sort of infinite digitality, to a world that you fly through with no resistance. I think that long-term, the physical element with an authentic story is actually going to become more and more important.

We are currently in an era where everything counts. I mean this in all senses of the word. In my experience, when I work with big companies on big projects, I enjoy talking to people in different departments. It's funny, when I talk to the design departments, they have no idea what's about to happen, of what is coming at them. When I talk to the accountants, they know exactly what's going happen next because they have a schedule with everything that we're throwing away, and everything that we have to redesign. The concept of externalities in accounting allows us and gives us license to do the worst things. I put accountants at the heart of how we get out of the mess that we are in. All practices should strive toward a higher order of complexity. We certainly must find new ways of quantifying our future because the way that you quantify it is the way that we will understand it, and if we fail to understand it we'll fail to design it.

Change is measurable and seeing is believing. In other words, you cannot create change unless you can measure it, both qualitatively and quantitatively. There are extraordinary new methods of quantifying quality and so in some ways the biggest opportunity of the era of transparency is qualification that we are actually able to see what's going on, to measure it, and begin to design the outcomes that we want.

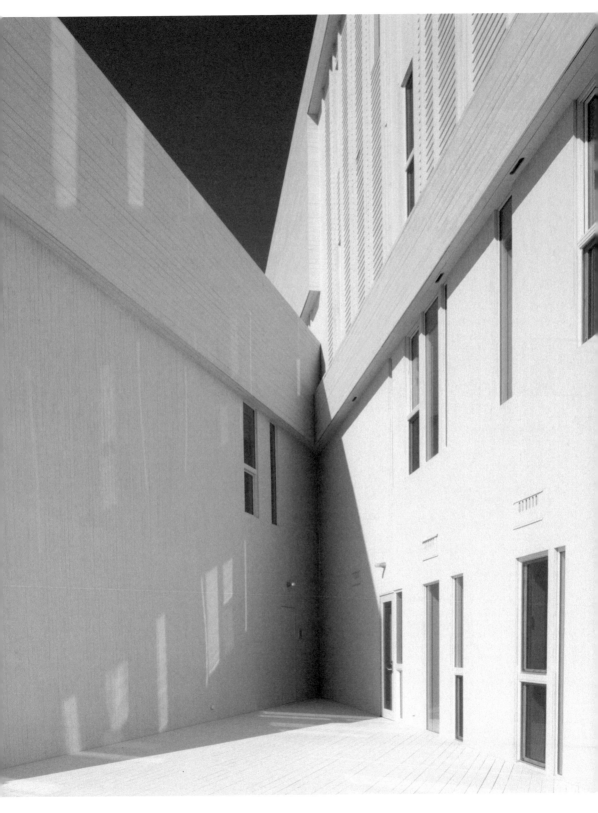

Assemble:
THE PINK LETTER

Assemble were invited to visit Fogo Island and potentially realize a project with Shorefast. Three members of the collective, Amica Dall, Adam Willis and Anthony Engi Meacock, flew first to St. John's from London, and met with Nicolaus Schafhausen, Alexandra McIntosh, Candice Hopkins, Monika Szewczyk, and Fabrizio Gallanti for "Fogo Island Dialogues: Singing the Skillful Community" Before continuing their travels to Fogo Island, they were able to attend the event at the Memorial University, which addressed the communal activity of singing as a way to explore issues of community and cultural traditions, as well as sovereignty and political agency.

On their return to London, after having shared their stories and thoughts of the trip with the other members of the collective, the group undertook another phase of research, and through discussion developed an array of perspectives to envisage and pinpoint propositions for reflection.

The following pink letter and project proposals portray their innovative and heartfelt response to their experience. The insightful assessment and commentary on how to approach both existing and speculative problems for the community and the environment of Fogo Island was outlined, on behalf of Assemble, by Amica Dall (in her own hand), providing a glimpse of their inventive practice, as well as future prospects for FIA and Shorefast.

Assemble (based in London and founded in 2010) is a multi-disciplinary collective working across architecture, design, and art. Their practice retains a democratic and cooperative working method that enables built, social and research-based work at a variety of scales, both making things and making things happen.

Assemble
19 Collett Road
Bermondsey
London, SE16 4DJ

2nd August 2018

Nicolaus Schafhausen and Eleanor Taylor
Fogo Island Arts
210 Main Road, Joe Batts Arm
NL A0G 2X0, Canada

Dear Nicolaus and Eleanor,

First of all, we wanted to say thankyou to you, and all your colleagues for both inviting us to Fogo Island and for making our time there so enriching, invigorating and dense in possibility. The Island, its landscape and histories have dissolved into and extended our thinking as we have returned to our day-to-day concerns here in the office.

We are really grateful for the expansive welcome and the straightforward and ample kindness we recieved throughout

P.T.O

our visit.

In an attempt to return like-for-like, we have decided to be very straightforward about our responses and present them in relatively undigested form. Most of our thinking is built on direct learning from you, your colleagues and their friends, so much of it will be familiar. But we hope there is something useful in the re-presentation. We have tried to be relatively concrete and focused, but this is really an exercise in containment – the ideas should be read as provocations and starting points, condensations of much less organised, rambling, wide-ranging and tentative thought processes.

We very much hope this is the beginning of a long adventure.

With best wishes.

Amica, Adam and Anthony.

Finite Resources: A Conversation Starter.

We are interested in the problem of finite resources.
Most particularly, the way in which resources which
once seemed abundant, inexhaustible and self renewing
can suddenly reveal themselves to be precarious,
faltering and subject to collapse.

The collapse of the cod fisheries in the North Atlantic
is a case in point. But on Fogo Island, that pattern
is repeated or refracted in less tangible ways, for
example, a way of life which once seemed timeless,
secured by the continuity of the generations, has come
close to disappearing for good, which puts at risk the
previously continually renewing material and built cultures.

For the purposes of this conversation, we are most interested
in resources which are currently thought about as if
they where either abundant or self-renewing

but which we see as under threat from over exploitation. These things don't fall into neat categories, and are rather a network of inter-related, codependent material and immaterial actors and relationships. However, we have done our best to chop them up into discreet themes or ideas.

Our idea in doing this is to start a conversation about how these resources might be protected, replenished and renewed long before any real threat is felt, hopefully before they are in genuine danger of over exploitation.

We have set out some lists and diagrams in what follows, and these are really just traces of our on-going thoughts and conversations.

FINITE RESOURCES

IMAGINATIVE/CULTURAL

AUTHENTICITY + LIVED EXPERIENCE

- Personal connection to best way of life
- voice, cadence, attitude, accent, assumptions/lack of
- particularity of world views, ideas + perspective from generations of relative attitude
- social structures + ideas
- deep knowledge + craft

CONNECTION TO LAND & SEA

- intimacy with land, animals and landscape
- mutual dependence with immediate material world/knowledge of scarcity
- bodily + intellectual connection to land/sea/landscape
- deep social + cultural structures + practices around our landscape

CONCRETE/PHYSICAL

LAND + OTHER NATURAL RESOURCES

- right to build
- right to host tourists or run tourist activities
- unpopulated space
- structure + scale
- space in between of communities
- wild life

LAND USE + OCCUPATION

- low density occupation
- lack of light pollution or deep darkness
- tranquility + quietness
- distance between people
- unoccupied space

PROTECT + REPLENISH

ISLAND ECONOMY

How can Fogo Island become self sustaining and more towards a more circular economy?

- Material reuse
- energy
- water + waste
- food production + processing
- building technondogy / adaptive retro ft

Can Fogo become a world leader / example of community owned infrastructure adapted for zero nett impact on Climate?

↳ other small island nations?

PROTECT + REPLENISH

LAND REFORM

How can we make sure that decisions about how land (and buildings) are owned, occupied and developed are made in the best interests of the long term future of the island as a whole?

- Fogo Community Land Trust?
- Co-operative Planning Process
- Masterplan of policy for sustainable levels of development + land use, to be reviewed regularly (5 years?)

Learning from innovation elsewhere
- Isle of Eigg, Scotland
- Tupak Amaru, Mexico etc etc.

237

PROTECT + REPLENISH

SCHOOL

How can Fogo Island retain a genuinely productive
economy, that can scale? How can it protect the
value of craftsmanship, excellence in production,
teaching and learning in a way which can _grow_
under its own steam, rather than relying on value
from elsewhere?

- Internationally significant carpentry school
 developing its own culture of skill / pride /
 relationship to materials

A way of attracting people who can renew and
extend skill base in the _long term_,

generate its own income +
value

PROTECT + REPLENISH

TOURISM

How do cultures + economies that rely on tourism undo themselves? How much is to much? When does value get displaced + diluted, rather than shared? How can tourism be managed in the long terms in a culturally + socially sustainable way?

- learning from experience of others inc.
We Are Here Venice, Tourism Concern, Indigenous Peoples Movement, Green Colonialism Movement, etc.

↓

trip / tour / research archive, collaborative research project, news center for sustainable tourism

↓

local ownership + economic benefit not the same as social + cultural resilience & replenishment

Colophon

Jahresing 65
Annual of Fine Arts

What do we know?
What do we have?
What do we miss?
What do we love?

Edited on behalf
of the Kulturkreis
der deutschen
Wirtschaft im BDI e.V.
(Association of Arts
and Culture of the
German Economy
at the Federation of
German Industries
in BDI)

Editors
Brigitte Oetker
Nicolaus Schafhausen

Editorial Team
Brigitte Oetker
Nicolaus Schafhausen
Maximilian Steinborn
Eleanor Taylor

Copyediting &
Proofreading
Maximilian Steinborn
Eleanor Taylor

English Translation
Nicholas Grindell

Graphic Design
Boy Vereecken
Antoine Begon

Printing
Cassochrome
B-8790, Waregem

Image Credits
Courtesy the artists,
photographers,
and FIA

Acknowledgments
Peter Decker
Margaret Decker
Bettina von Galen
Tatjana Günthner
Elisa Nuyten
Iris Stünzi
Markus Weisbeck

© 2019 the editors,
the authors, the
artists, Kulturkreis
der deutschen
Wirtschaft im BDI
e.V., Sternberg Press

Shorefast
shorefast.org
Fogo Island Arts
fogoislandarts.ca
Fogo Island Inn
fogoislandinn.ca

ISBN
978-3-95679-473-5

Sternberg Press
Caroline Schneider
Karl-Marx-Allee 78
D – 10243 Berlin
sternberg-press.com

k Kulturkreis der
deutschen Wirtschaft
im BDI e.V.

 49° 37' N, 54° 12' W

shore**f**ast

SternbergPress